U0015577

How to

How to use graphic design to sell things, explain things, make things look better, make people laugh, make people cry, and (every once in a while) change the world

How to 設計經典

設計大師麥可‧貝汝帶你用設計改變世界

麥可‧貝汝（Michael Bierut）著

劉佳澐、陳柏霖 譯

How To 設計經典：設計大師麥可‧貝汝帶你用設計改變世界

How to use graphic design to sell things, explain things, make things look better,
make people laugh, make people cry, and (every once in a while) change the world

作　　　　者	麥可‧貝汝（Michael Bierut）
譯　　　　者	劉佳澐、陳柏霖
企 畫 選 書	賴曉玲
責 任 編 輯	張沛然

版　　　　權	吳亭儀、江欣瑜
行 銷 業 務	黃崇華、賴正祐、郭盈均、華華
總 　編　 輯	徐藍萍
總 　經 　理	彭之琬
事業群總經理	黃淑貞
發 　行　 人	何飛鵬
法 律 顧 問	元禾法律事務所王子文律師
出　　　　版	商周出版　台北市 104 民生東路二段 141 號 9 樓

電話：(02) 25007008　傳真：(02)25007759

E-mail：ct-bwp@cite.com.tw　Blog：http://bwp25007008.pixnet.net/blog

發　　　　行　英屬蓋曼群島商家庭傳媒股份有限公司城邦分公司

台北市中山區民生東路二段 141 號 2 樓

書蟲客服服務專線：02-25007718　02-25007719

24 小時傳真服務：02-25001990　02-25001991

服務時間：週一至週五 9:30-12:00　13:30-17:00

劃撥帳號：19863813　戶名：書蟲股份有限公司

讀者服務信箱 E-mail：service@readingclub.com.tw

香 港 發 行 所　城邦（香港）出版集團有限公司　香港灣仔駱克道 193 號東超商業中心 1 樓

E-mail: hkcite@biznetvigator.com　電話：(852)25086231　傳真：(852)25789337

馬 新 發 行 所　城邦（馬新）出版集團 Cite (M) Sdn Bhd

41, Jalan Radin Anum, Bandar Baru Sri Petaling, 57000 Kuala Lumpur, Malaysia.

Tel：(603)90563833　Fax：(603)90576622　Email：services@cite.my

封 面 設 計　李東記
印　　　　刷　卡樂製版印刷事業有限公司
總 　經 　銷　聯合發行股份有限公司　新北市 231 新店區寶橋路 235 巷 6 弄 6 號 2 樓

電話：(02) 2917-8022　傳真：(02) 2911-0053

■ 2022 年 10 月 27 日初版

城邦讀書花園
www.cite.com.tw

線上版回函卡

Printed in Taiwan

定價 1500 元

著作權所有，翻印必究
ISBN 978-626-318-438-1

Published by arrangement with Thames & Hudson Ltd, London

How to © 2015, 2018 and 2020 Michael Bierut

Written and designed by Michael Bierut

Production management by Sonsoles Alvarez with Chloe Scheffe

Production supervision by Julia Lindpaintner

Design supervision by Hamish Smyth

Editorial consulting by Andrea Monfried

Copy editing by Rebecca McNamara

Revised and expanded edition

Production management by Lauren Fox with Camila Pérez

Design supervision by Britt Cobb

Copy editing by Rebecca McNamara

This edition first published in Taiwan in 2022 by Business Weekly Publications, a division of Cité

Publishing Ltd, Taipei

Complex Chinese edition © 2022 Business Weekly Publications, a division of Cité Publishing Ltd.

國家圖書館出版品預行編目 (CIP) 資料

How To 設計經典：設計大師麥可‧貝汝帶你用設計改變世界 / 麥可‧
貝汝（Michael Bierut）著；劉佳澐、陳柏霖 譯 .-- 初版 .-- 臺北
市 : 商周出版 : 英屬蓋曼群島商家庭傳媒股份有限公司城邦分公司發
行 , 2022.10
　面； 公分

　譯自：How to use graphic design to sell things, explain
things, make things look better, make people laugh, make
people cry, and (every once in a while) change the world
ISBN 978-626-318-438-1(精裝)

1.CST: 貝汝（Bierut, Michael.) 2.CST: 平面設計 3.CST: 作品集

964　　　　　　　　　　　　　　　　　　　　111015374

目次
Contents

先求和諧，再求獨特。

──威爾遜‧皮克特（Wilson Pickett）

NORMANDY HIGH SCHOOL WAIT UNTIL DARK

FRI. & SAT: NOV. 17 & 18, 1972

$1.00
8.00 PM

如何在偏遠地區成為平面設計師

序

左圖
我的第一件大量印刷
的平面設計作品，是
我們高中的海報製
作《盲女驚魂記》
（*Wait Until Dark*）
，一部關於一名盲女
受到犯罪集團威脅的
懸疑戲劇（因此是眼
睛）。我仍然記得看
到它掛在我高中的
每個走廊上的那種
激動。

從有記憶以來，我就一直想成為平面設計師。

那時我才差不多五、六歲左右，某個週六，我和父親搭車準備去理髮，等紅綠燈的時候，父親指著附近停車場裡的一輛起重機。「很好看吧？」他問道。「什麼東西很好看？」我説。「看看車子上印的『Clark』。」原來他指的是車身上的商標，但我還是不懂。「有沒有看到字母L把字母A抬起來？」父親解釋：「就像起重機的動作一樣。」

我目瞪口呆、激動不已，彷彿有個驚人的祕密在眼前揭開一般。這種情況很常見嗎？是不是到處都隱藏著這些小小的奇蹟呢？又是誰創造了這些細節呢？

我在俄亥俄州加菲爾德高地的聖德蕾莎小學讀一年級時，老師就發現我很會畫畫。這可不是件小事，我是個好學生，但在60年代克里夫蘭郊區，如果太愛念書，其他孩子就會覺得你很奇怪，甚至有一點點鄙視你。會畫畫就是另一回事了，就像有魔法一樣。我不太擅長運動，而且通常沉默寡言，畫畫讓我好像突然能在同儕之間脫穎而出。修女們説這是「上帝賜予的天賦」，而我也竭盡所能地發揮。幸運的是，父母也非常鼓勵我，他們幫我買了各式各樣的畫畫工具，還越來越多，有炭筆、粉彩和軟橡皮擦，甚至還幫我報名每週六早上在克里夫蘭藝術博物館（Cleveland Museum of Art）的美術課，那可是世上最偉大的文化機構之一。讀國中時，我已經可以逼真地畫出任何東西，所有人都認定我長大後會成為一位藝術家。

我用藝術來交朋友（有時甚至可以避免被霸凌），某次學校一位可怕的小混混，就要求我在他的筆記本上畫一個百威啤酒的商標，我認真地畫了很久，用一整套Speedball牌的鋼筆畫出逼真的「Fraktur」字體，最終完成了他想要的，帶有金屬質感商標。

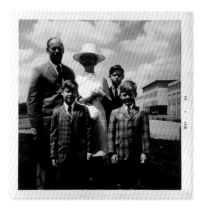

上圖
拍攝於1969年的復活節星期日，俄亥俄州帕馬市。我與父母李奧納德及安瑪麗一起站在後方，前面則是我的雙胞胎兄弟羅納與唐納。

上圖
我的父母幫我報名了克里夫蘭藝術博物館周六上午的美術課，圖為我臨摹透納（J. M. W. Turner）的畫作《上下兩院的大火》（*The Burning of the Houses of Lords and Commons*），這是博物館的其中一件館藏，當年我只有七歲。

九年級時出現了一個轉捩點，我被指派為學校的舞台劇做海報。我星期五早上交了作品，當天下午就印好了，等到了星期一早上，我畫的海報已經掛滿校園。那是我第一次體驗量產的驚人效果，看過我海報的人，比實際去看舞台劇的人還要多。後來我發現，我並不只是想畫出一幅畫，然後被掛在某個地方的牆上，比如掛在克里夫蘭藝術博物館裡。我更想要創造一些有功能的東西，人們隨處可見，卻又與他們沒有直接關聯。當時我也不知道怎麼解釋。

我不知道海報和商標的起源是什麼，也不認識任何目前活躍的藝術家，不知道可以去問誰。如果繼續找答案，我可能會猜測像專輯封面這樣的東西，就是由真正的藝術家設計出來的，比如弗朗茨・克萊恩（Franz Kline）或勞勃・勞森伯格（Robert Rauschenberg），搞不好是他們決定暫時放下原本的工作，跑去設計封面賺些外快。有一天，我在學校圖書館裡悠哉地逛著職涯資源中心，其實那是一個浮誇的名稱，因為它不過是個書架，架上就只有一套相配的書，名叫「職涯目標叢書」，其中包含了《烘培業求職》、《乾洗業求職》、《家政服務業求職》等，其中一本引起了我的注意，名叫《平面設計與藝術業求職》（*Aim for a Job in Graphic Design/Art*），作者是尼爾・藤田（S. Neil Fujita），我打開這本書，然後察覺到，這就是我要的未來。

書中介紹了許多不同的人，都在從事我想做的工作，還收錄了許多作品，像是廣告人喬治・洛伊斯（George Lois）、雜誌設計師露絲・安塞爾（Ruth Ansel），還有電視劇美術指導盧・多弗斯曼（Lou Dorfsman）。我發現這些讓我著迷的工作都有相同的職務內容，那就是平面設計。我學到了全新的知識，還覺得意猶未盡，於是跑到當地的公共圖書館，在目錄卡中查了這個名詞，結果只找到了一本書，也就是瑞士設計大師阿明・霍夫曼（Armin Hofmann）的《平面設計手冊：原理與實踐》（*Graphic Design Manual: Principles and Practice*）。

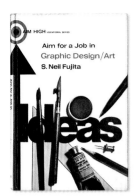
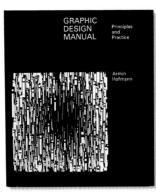
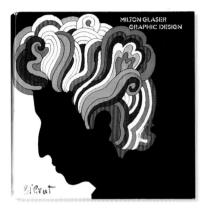

上圖
這三本書改變了我的
人生，分別是尼爾·
藤田的《平面設計與
藝術業求職》、阿
明·霍夫曼的《平面
設計手冊：原理與實
踐》，以及米爾頓·
格拉瑟的《平面設
計》。霍夫曼與格拉
瑟都是知名設計師，
藤田則是個無名英
雄，事實上，他設計
了哥倫比亞唱片公司
的商標，和馬里奧·
普佐（Mario Puzo）
小說《教父》（*The
Godfather*）的書
封。

回想起來，我當時完全被那本書迷住了，即便書中盡是對瑞士巴塞爾工藝美術學校（Kunstgewerbeschule）課程的枯燥描述，最後淪落到俄亥俄州帕馬郊區某座小小圖書館的書架上，但當時，我整個人為之一振。我努力汲取其中的知識，無論是點和方塊的黑白研究，或者重新設計歐洲燈泡包裝的練習。據我所知，那座圖書館裡，我是唯一一位反覆閱讀這本書的人。之後我告訴父母，聖誕節我唯一想要的禮物，就是這本書。

感謝我的母親，她打電話給鎮上的每一家店，奇跡似地找到了一家書店才剛剛進貨。到了聖誕節早上，我打開包裝，卻發現母親白忙了一場，因為她買成了米爾頓·格拉瑟（Milton Glaser）的《平面設計》（*Graphic Design*）。那是一本240頁的厚書，作者是圖釘工作室（Push Pin Studios）的聯合創辦人，內文無拘無束，應用許多不同的手法，沒有一絲教條。我的職涯正是由這三本書推動的，一本東岸業界老手的實用指南，一本瑞士理論家的嚴謹宣言，還有一本則是傑出藝術家筆下炫目的創作世界。那時我才剛滿18歲，並不認識業界任何一位平面設計師，但我卻已經知道自己未來的志向。

我高中的專任輔導老師在俄亥俄州的另一端找到了一間適合我的大學，也就是辛辛納提大學設計、建築與藝術學院（University of Cincinnati's College of Design, Architecture, and Art），其中有一個需要讀5年的平面設計學位。求學期間，學校奉行的是瑞士工藝美術學校的極簡主義，而不是圖釘工作室那種充滿活力的世界觀。我接受了一套宛如新兵訓練營的視覺訓練，修正自己原本的壞習慣，學會設計、字體排印、色彩和排版等基礎知識。想像力與活力或許是與生俱來的特質，但精確與技藝僅能透過反覆練習才能掌握。教授們的教學非常嚴格，若不遵循他們的帶領就難以畢業。我最後拿到的是理工學士學位，這間學校傳授的設計基本功就像物理定律一樣邏輯嚴密、自成一格且優雅正統。直到後來我前往紐約，才找到了熱情的力量。

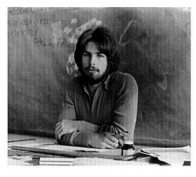

左上圖
1976年左右，我在
辛辛納提大學設計、
建築與藝術學院的工
作室裡沉思。

右上圖
辛辛納提大學畢業
後，我已經學會運用
Helvetica字體與模組
化網格排版系統。我
並不擅長攝影，也沒
有告訴老師，這張照
片是我當時的女友桃
樂西拍的。1980年我
和桃樂西結婚了。

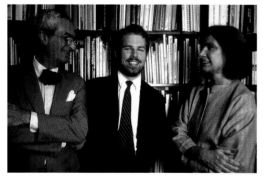

上圖
我為義大利設計大師
馬西莫・維涅里與蕾
拉・維涅里工作了十
年，他們就像我的父
母一樣，而他們的
工作室就是我第二
個家。

回想起來，馬西莫・維涅里（Massimo Vignelli）喜歡我的作品集並不奇怪，因為每一頁都是無襯線體；每個版面配置都採用模組化網格排版襯底。畢竟，正是這位備受推崇的設計大師將「Helvetica」字體引入美國，為紐約地鐵系統繪製出極其工整的幾何地圖，還幫全美所有國家公園都設計了專屬手冊，從阿卡迪亞到優勝美地全都有一本。馬西莫和他的妻子蕾拉・維涅里（Lella Vignelli）在曼哈頓有一間辦公室，並在這裡完成了許多令人讚歎的商標、海報、書籍、室內設計和產品。1980年夏天，我和高中時代交往的女朋友桃樂西結婚，兩人一起搬到紐約，我加入了維涅里設計公司（Vignelli Associates），成為最年輕的員工。我非常尊敬馬西莫，當時真不敢相信自己這麼好運。但我也知道我老闆的個人觀點十分強烈，他旗下的設計師也都要遵循明確的審美規範。所以我打算在那裡待滿18個月，然後再找其他工作。

結果我一待就是整整十年。雖然公司以嚴格的現代主義著稱，但馬西莫和蕾拉帶領團隊的方式非常溫暖，工作室裡總是充滿了聊天、歡笑的聲音，還有各種令人興奮的專案。設計是一項神聖的工作，加入這個產業，就表示你要對抗愚蠢與醜陋，把案子委託給我們的客戶，也同樣在對抗這些東西。我很擅長模仿，甚至有點強迫症，而這對我的工作很有幫助。我最早上過的平面設計課，就是小時候在圖書館裡看書臨摹別人的作品，現在，我幾乎可以完整模仿出馬西莫那種精準無誤的風格。他開始信任我，即便後來我的想法慢慢開始與他不同，他也持續鼓勵我。過了十年，我開始管理公司的平面設計業務，但我越來越想知道，如果我獨立了，我會想做出什麼樣的作品？

就在一位名叫伍迪・皮特爾（Woody Pirtle）的同行邀請我共進晚餐後，答案出現了。伍迪是我們紐約辦公室的合作夥伴，來自五角星設計公司（Pentagram），這間公司獨特的組織結構十分有名。公司的合夥人之間沒有階級制度，所有人都是平等共事，大家各自管理一個小設計團隊，並且共用這間跨國公司的所有資源。

本來只是閒聊我的未來發展，後來卻演變成另一個轉捩點。喝咖啡時，伍迪問我有沒有興趣加入五角星設計，成為新合夥人。他問的真是時候。我喜歡大型辦公室的忙碌感，獨資企業

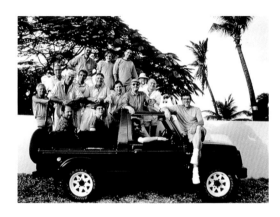

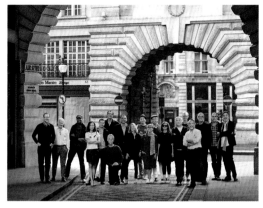

上圖
新團隊：1990年，我成為五角星設計公司紐約辦公室的最新合夥人，並首次前往安地卡參與國際會議。我坐在卡車後方，周圍是麥文·科蘭斯基、柯林·富比士、西奧·克羅斯比、大衛·希爾曼、尼爾·沙克里、約翰·拉斯沃思、肯尼斯·格蘭吉、琳達·辛里克斯、伊坦·馬納斯、伍迪·皮特爾、約翰·麥康諾、基特·辛里克斯、艾倫·弗萊徹和彼得·哈里森。開車的人則是彼得·薩維爾。

下圖
最近期的一次合夥人大會，2014年舉辦於倫敦。由左至右：亞培·米勒、約翰·拉斯沃思、艾迪·歐普拉、任黛珊、盧克·海曼、哈利·皮爾斯、麥可·格里克、羅倫佐·亞皮瑟拉、寶拉·謝爾、安格斯·西蘭、瑪麗娜·韋勒、我、艾蜜莉·歐柏爾曼、多明尼克·里帕、威廉·羅素、丹尼爾·威爾、D·J·史托特·納雷許·拉姆查達尼及賈斯圖·奧勒。

有種孤立感，已經沒有什麼吸引力。五角星設計結合了獨立自主與共同合作，汲取兩種工作型態中最好的部分。我考慮了一個晚上，和桃樂西商量了一下便同意加入。1990年秋天，我開始了第二份工作。

我的第二份工作可能就是我最後一份工作。我已經在五角星設計待了將近二十五年。而且很大程度上，我正在做我一直想做的事。我依然記得起重機上的商標，也記得在學校圖書館打開那本書的震撼。我當時並不懂其他人是如何創造出這些東西，他們的想法從何而來？從產生想法到實際完成，中間又有哪些過程？我們要怎麼知道這些想法有效呢？人們又是如何被說服並接受這些想法呢？難道有什麼魔法嗎？平面設計能做到的是否有限？還有，我該怎樣才能做到？

從九年級畫出第一張海報開始，我發現這些問題有許多可能的答案。即便沒有任何一個答案會是最終解答，但每一個都會很有趣，沒有人能告訴你該怎麼做，然而，一旦你做出決定，最大的樂趣就是找到該如何做。

如何「動手」思考
四十年的筆記本

左圖及上圖
三十多年來，我去任何地方都會帶著筆記本，這些本子通常都被我用得殘破不堪。

1982年8月12日，我打開一本標準7.5×9.75英吋的筆記本，一邊講電話，一邊做記錄。我已經忘了筆記本是從哪來的，可能是在維涅里設計的工具櫃裡找到的，當時我在那裡工作了兩年多。

從那之後，這就變成一種習慣，甚至可以說是一種制約，一直持續到今天。少了筆記本，我就沒有辦法參加會議或打電話。有些設計師的速寫本非常精美，但我的不是，或許其中幾頁看起來像是出自設計師的手筆，有圖畫、字體研究、正在實踐的視覺構思，但大部分都寫滿了待辦事項、待回覆的電話、預算計算和會議記錄。大學期間，我就發現寫下來能幫助我記住這些東西。但矛盾的是，這表示其中也有很多筆記，是寫過之後就再也用不到的。

雖然我是個不錯的繪圖員，或者說曾經很不錯，但在數位時代，繪圖可能已經不再是一項有用的技能，如何詮釋遠比如何畫出來更加重要。回顧過往的筆記，我對於本子裡偶爾出現的圖畫感到驚訝，而且畫出這些圖像時，我是如此期待能將它們付諸實踐。此外，在密密麻麻的條列式筆記中，我總會快速加上一個圖表，還有代表接下來整個專案的初步草圖。

第一次聽說個人數位助理（PDA）的概念時，我心想，噢，就是有點像我的筆記本吧，只差不是用電腦而已。而且，iPad的尺寸幾乎和筆記本一樣，這也絕非偶然。後來，如同大多數的設計師，我也開始依賴數位裝置，但依然會隨身攜帶紙本筆記，用來寫日記和畫速寫，這能帶給我安全感，就像個老朋友一樣。2013年8月20日，也就是自從我使用第一本筆記本開始後的第31個年頭，我已經累積使用了100本筆記，希望還會有下一個100本。

我花了一段時間才找到最喜歡的筆記本，早期的本子大多是線條或方格，但我不太喜歡。過去數十年間，我花了許多時間試用各式各樣的空白筆記本。這些是我1995年畫的草圖，我們準備為布魯克林音樂學院的下一波藝術節做設計（請見第44頁）。

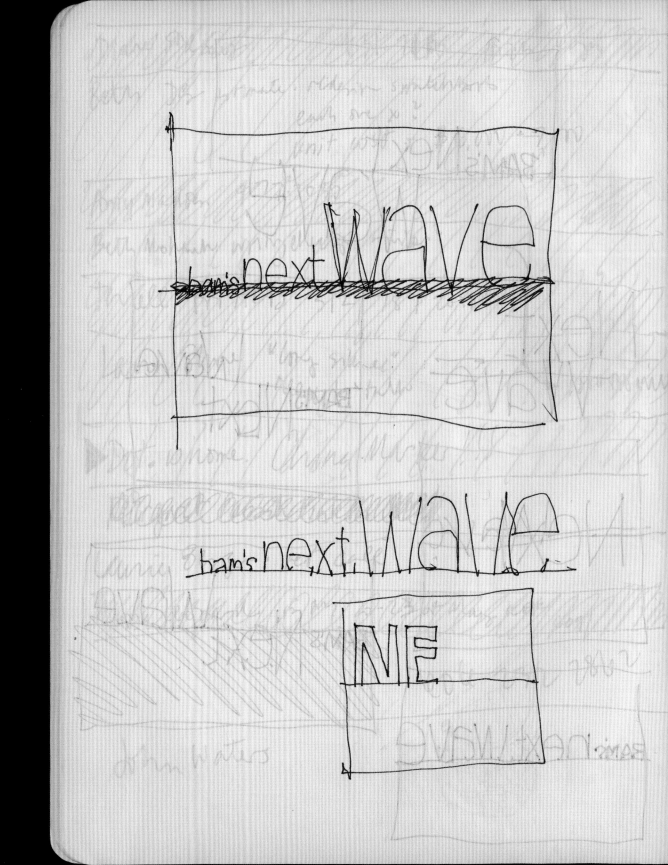

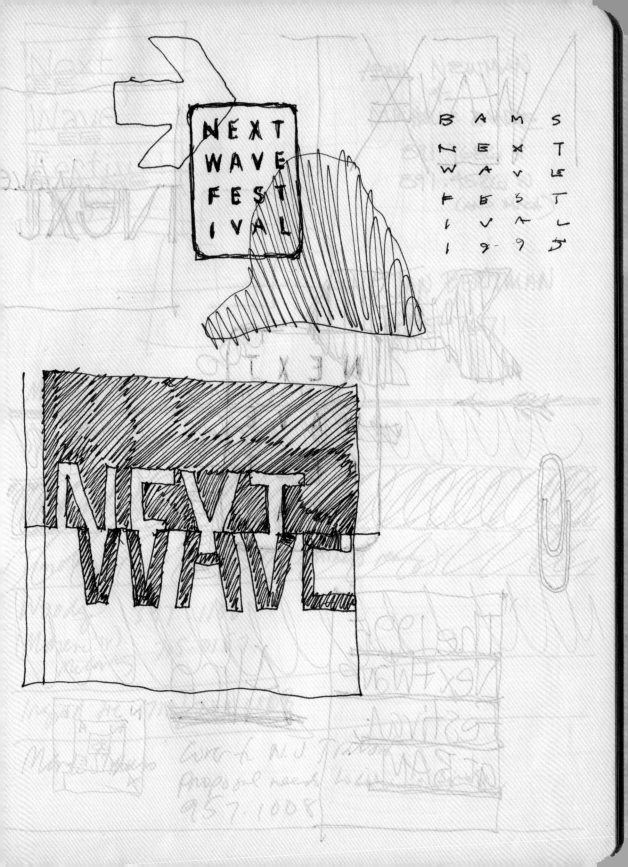

我的筆記本頁面上通常都是會議記錄、電話號碼和各種算數表格，這兩面可能是我開會太無聊時畫的，因為最後的成品海報看起來跟這些草圖完全不同（請見第63頁）。

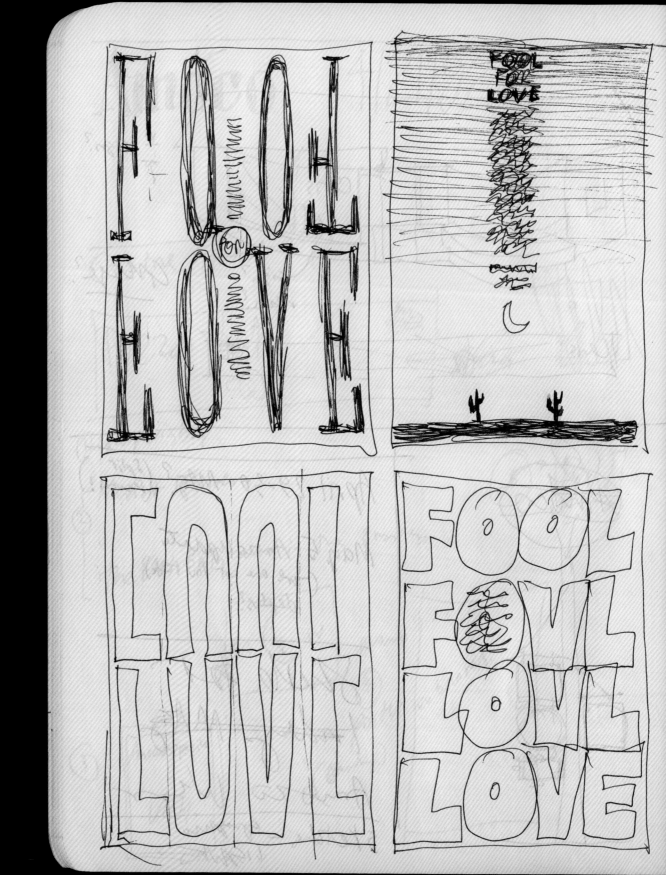

FOOL FOR LOVE. PRESENTED BY PANTRY

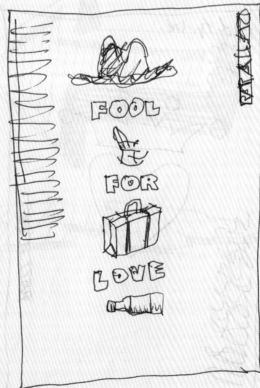

同事討論薩克斯第五
大道精品百貨包裝
時畫的（請見第112
頁）。

有時一份詳細的草圖就能幫我汲取出腦中的想法。我們為建築師查爾斯·摩爾（Charles Moore）的耶魯大學研討會設計海報，最後採用了更簡潔的版本（請見第144頁左下圖）。

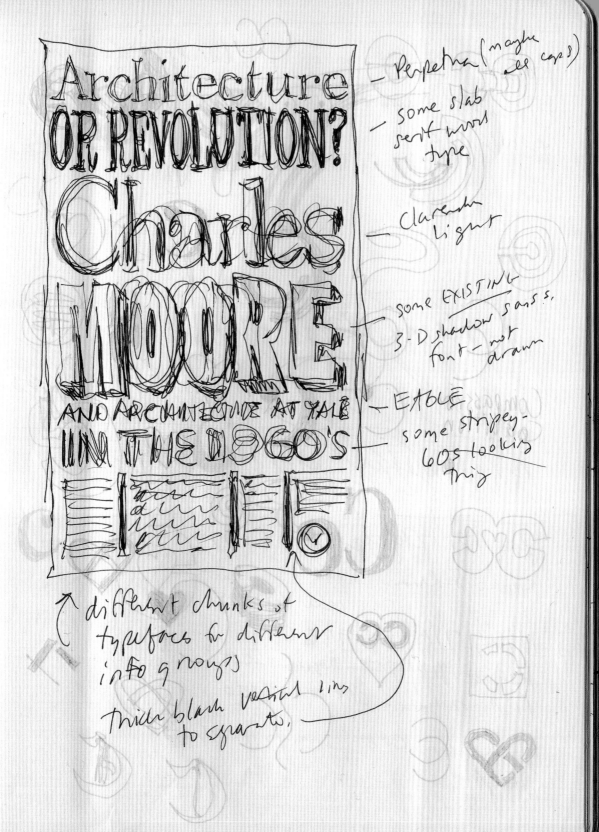

Architecture
OR REVOLUTION?
Charles
MOORE
AND ARCHITECTURE AT YALE
IN THE 1960'S

— Perpetua (maybe all caps)

— some slab serif wood type

— Clarendon Light

— some EXISTING 3-D shadow sans s. font — not drawn

— EAGLE some stripey-60s looking thing

↑ different chunks of typefaces for different info groups

thick black vertical lines to separate.

我為《紐約時報》某個案子畫的草圖（請見第156頁）。另一面則寫了一些待回的電話清單，看起來我打了四通電話才解決這個問題。

Rethinking Design #4)
Deliver Oct 4 M)— sked

Jackie to → at work till 2/14
 m vaction 2/15 - 2/23
 starts 2/26

United mtg w/ 2/4/97
 John Rubadou

Cargo - Scott to send
 cargo

Shuttle 737/300 + 500's

 Richmond Childrens
 Museum.

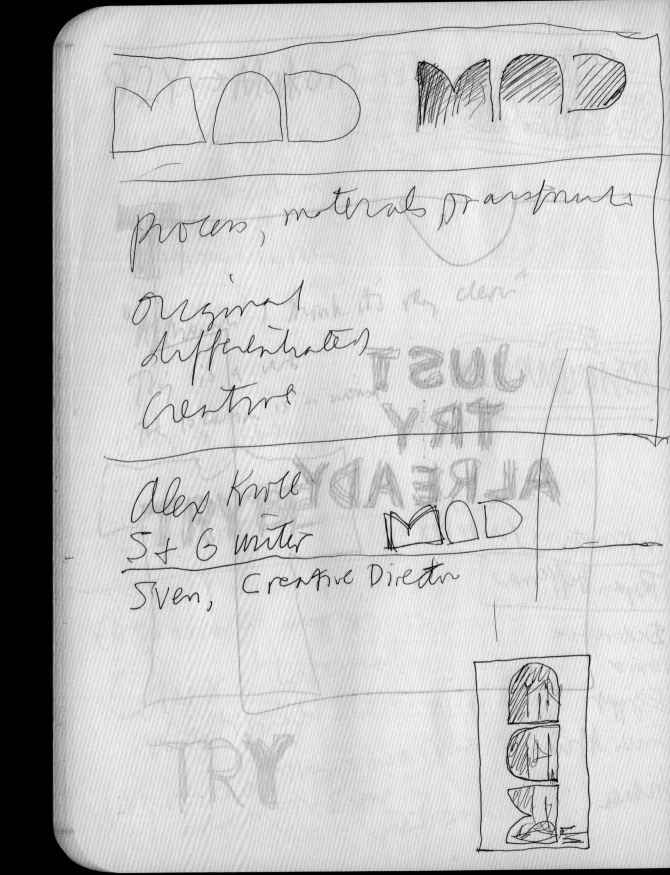

stripes

hand drawn
scribbled

cut paper

Deboss?
Emboss

右圖
為版面設計而畫下的
格子通常沒什麼吸引
人的地方，這是我
為《告示牌》雜誌排
版畫的草圖（請見第
220頁）。

30

14 cols ⟶

2 6 6 2 4 4 4

quarter column charts

2 3 3 3 3

右圖
這兩面紙張上畫的是
麻省理工媒體實驗室
商標的各種排列組合
（請見第310頁）。

labs

mit
media
lab

gov001

affective
computing

civic
media

modern
machines

x 22

centers

mit
media
lab

center for
terrestrial
sensing

or

mit
media
lab

center for
terrestrial
sensing

light
same size

initiatives / SIGS / labs

re-think
food

or

re-think
food

w/
wordmark

initiatives + joint programs (as endorser)

light

joint
program
of

mit
media
lab

an
initiative
of

mit
media
lab

32

fellows

directors program

unit
threeclouds
lab
director
fellows
program

OR

unit
weits
lab

director
fellows
program

red

bold + red (or other color)
grey

在一開始嘗試失敗好
幾次之後，我在突然
間想到用更簡單的概
念，為羅賓漢基金會
圖書館倡議設計出識
別商標（請見第338
頁）。在設計過程
中，產生比實際所需
更多的想法，讓我確
信自己走在正確的道
路上。

Reinventing the ~~existing~~ public
school library for New York
City's ~~public~~ children

The LIBRARY initiative

L?BRARY

Pin mounted
+ flat

modelled
+ flush
mounted

die
cut

7:50 Balthazaar. Friday

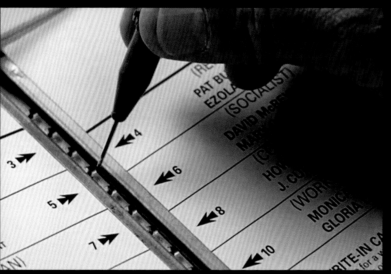

左圖
蝶形票並不是新發明，但這種設計的缺陷曾使2000年大選陷入混亂。

上圖
泰瑞莎‧樂波兒是21世紀最具影響力的平面設計師。

下圖
當時花了一個多月才確定選舉結果，但15年後仍有爭議。

如何用平面設計毀滅世界

美國平面設計協會
American Institute of Graphic Arts

Palm Beach County, Florida	Official Ballot		November 7, 2000	General Election
Electors for President and Vice President Choose one group.			A vote for the candidates will actually be a vote for their electors.	
President	Vice President		**Political Affiliation**	
George W. Bush	Dick Cheney	▶	**1** Republican	○
Al Gore	Joe Lieberman	▶	**2** Democrat	○
Pat Buchanan	Ezola Foster	▶	**3** Reform	○
Ralph Nader	Winona LaDuke	▶	**4** Green	○
James Harris	Margaret Trowe	▶	**5** Socialist Workers	○
John Hagelin	Nat Goldhaber	▶	**6** Natural Law	○
Harry Browne	Art Olivier	▶	**7** Libertarian	○
David McReynolds	Mary Cal Hollis	▶	**8** Socialist	○
Howard Phillips	J. Curtis Frazier	▶	**9** Constitution	○
Monica Moorehead	Gloria La Riva	▶	**10** Workers World	○

上圖
新的設計方案使用了
相同的格式,證明了
混亂是能避免的。

2000年秋天,泰瑞莎·樂波兒(Theresa LePore)遇到了一個問題。當時她並不是個有經驗的平面設計師,而是佛羅里達州棕櫚灘縣的選舉總監,此時,她面臨了世上每位平面設計師都曾面對過的挑戰,也就是文字太多,空間不夠。通常會發生這種情況,是因為文字不能刪減。全國大選即將到來,她手裡的素材是總統與副總統候選人名單,不可能刪改。棕櫚灘縣的投票機有專用的票卡,選民只要在候選人的名字旁邊打一個洞,就算是完成投票了。

但這一年的候選人太多,無法全部放進欄位裡,於是樂波兒想出了一種新排版方式。她把名字交錯排列在洞孔兩側,第一組候選人的名字放在左邊,第二組在右邊,第三組在左邊,以此類推。結果這項設計在選舉日卻成了大問題。選票左邊的第一組是喬治·布希(George W. Bush)和他的副手,如果你想投他們一票,就打第一個洞,這沒有問題。但假如你想投的是布希下方的艾爾·高爾(Al Gore),你打了第二個洞,那就打錯了,因為第二個洞孔的候選人被放在選票右側的第一列,是極端保守的帕特·布坎南(Pat Buchanan)。

搞混了吧?你不是唯一一位。《棕櫚灘郵報》(*Palm Beach Post*)後來推估,有超過2800位高爾的支持者錯把票投給了布坎南。後來,經過一個多月的重新確認和計票,終於定出勝負,而佛羅里達州的最終結果正是取決於棕櫚灘縣,布希以537票的優勢贏得了這個州。根據計票,我們可以說是泰瑞莎·樂波兒的設計把總統大位交給了小布希。

相較於建築與產品設計,平面設計看似時效短又無害,正如大家所說的,反正糟糕的排版也不會害死任何人。但在樂波兒的例子裡,她本來只是在執行一項瑣碎又煩人的工作,要將候選人的名字好好排進紙張裡,最終卻影響了全球數百萬人的命運。這個例子如此戲劇化,最後被我當成了美國平面設計協會的海報元素。

人類透過文字和圖像交流,而優秀的平面設計師知道如何讓這些元素變得更加有效。而且,有時這真的至關重要。

(REPUBLICAN)

ORGE W. BUSH - PRESIDENT
CK CHENEY - VICE PRESIDENT

(DEMOCRATIC

GORE - PRESIDENT
E EBERMAN - VICE PRESIDENT

Desig

RF BROWNE PRESIDENT
T LIVIER - VICE PRESIDENT

(GREEN)

LP NADER PRESIDENT
NONA LaDUKE - VICE PRESIDENT

(SOCIALIST WORK

MES HARRIS - PRESIDENT
ARGARET TROWE - VICE PRESIDEN

(NATURAL LAW

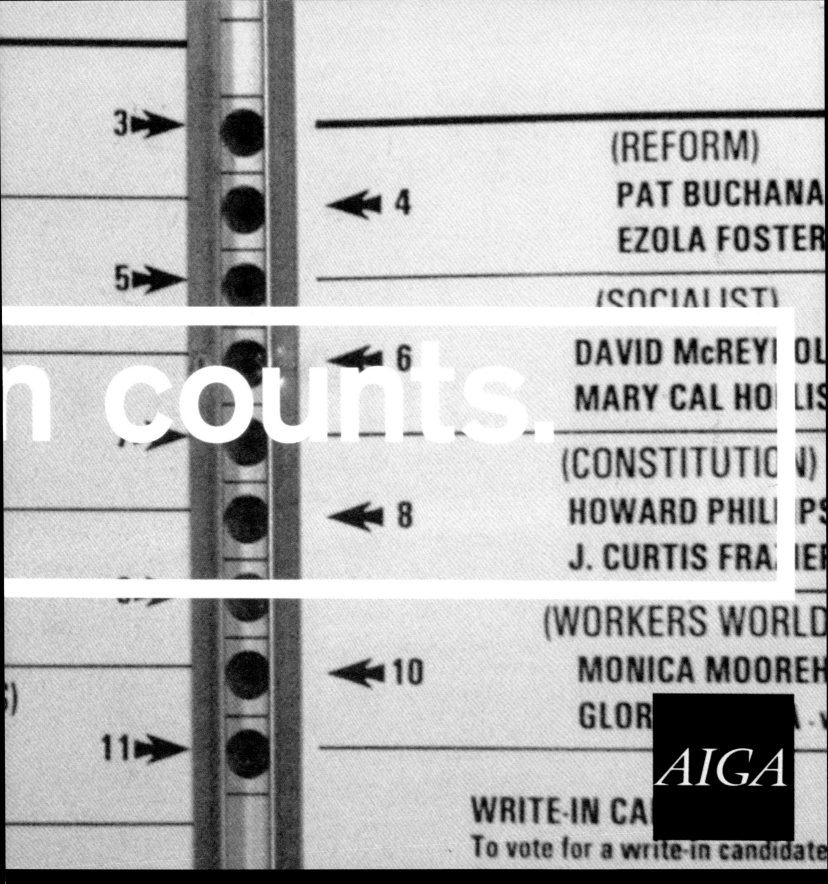

Progressive Architecture
International
Furniture Awards
May 14

NASA News for Now:
Space Planning
in Outer Space
June 4

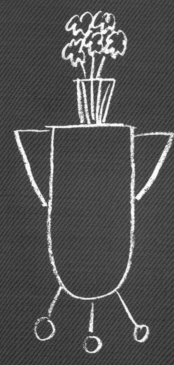

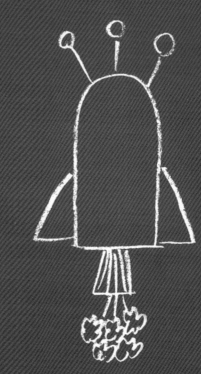

NASA News for Now:
Space Planning
in Outer Space
June 4

Progressive Architecture
International
Furniture Awards
May 14

如何產生想法

紐約國際設計中心
The International Design Center, New York

左圖
我對這個設計非常滿意，連忙拿回家給我的妻子桃樂西看。「這是誰畫的？」她問。我說是我。「好吧。」她說：「你覺得有人會用嗎？」但在沒有預算的情況下，我認為這幅可愛的塗鴉和其中的構思好到足以克服執行面上的不完美。直到今天，這仍是我職業生涯前十年中最喜歡的作品。

上圖
我掌握了馬西莫·維涅里最具代表性的手法，我覺得大家分不出我們的作品。上圖是他的海報，下圖是我的。

當時我已經為馬西莫·維涅里工作了四年，每天都努力學習我認知中的「維涅里風格」，也就是運用一些已經核准可用的字體、兩三種鮮豔的顏色以及線條和條紋等結構元素，再把這些全都排進一個模組化的網格裡。我很喜歡模仿，並且自欺欺人地認為，連馬西莫都分不出我和他的作品之間有何區別。某天他把一個大客戶指派給我，幫紐約國際設計中心的家具展間做平面設計。我們一開始就設定好基本規則，要使用「Bodoni」字體和暖紅色（PMS Warm Red）。只要確保好這兩項元素，其他可以自由發揮。

我的對口是年輕有才的行銷經理芬·馬里斯（Fern Mallis），她是個說話很快的紐約人，也是我最喜歡的客戶。她邀請我為接下來的兩場活動設計邀請函，一場是實驗家具展，另一場則是美國太空總署科學家的太空船內部設計講座。電話響起時，我興奮地畫完了兩份邀請函的草稿，當然使用了Bodoni字體和暖紅色。

來電者正是芬：「抱歉，我們剛剛預算被刪減了，只能做一張邀請函。你有辦法把這兩場活動放進同一份設計裡嗎？」「當然不行！」我氣急敗壞地說。這兩場主題完全不同，一場是家具，一場是外太空，沒有人會同時參加這兩場活動。除此之外，我很喜歡我已經設計好的草稿。

但芬絲毫沒有動搖，最後我沮喪地掛下電話。這些客戶！為什麼要把事情搞得那麼複雜？這樣要別人怎麼做事？而且現在這種情況，他們還期待看到多好的成品？接著我幾乎是不假思索地畫了一張圖，想證明這根本是不可行的。這張圖正著看，可以看到一張桌子和一個花瓶，但倒過來，就會看到一艘火箭。我夠聰明，赫然發現這張圖就是答案。

就像我為這名客戶做的其他設計一樣，還是使用了Bodoni字體和暖紅色，但其實大家不在意字體和顏色，它們只是某種元素的傳遞機制。什麼元素呢？想法。這幅畫的確很粗糙，卻是一種想法，能夠給人驚喜、十分吸引人，又有娛樂效果。就在塗鴉的那一刻，我意識到，原來內容比形式更為重要。

CALL FOR ENTRIES
THE FIFTEENTH ANNUAL AMERICAN CENTER FOR DESIGN
ONE HUNDRED SHOW

ALEXANDER ISLEY, JILLY SIMONS, ERIK SPIEKERMANN, JUDGES
MICHAEL BIERUT, CHAIR

ENTRY DEADLINE: MAY 1, 1992

DESIGN: MICHAEL BIERUT / PENTAGRAM
LETTERING: ELIZABETH ANN KRESZ BIERUT / TRANSFIGURATION SCHOOL

如何超越風格

美國設計中心
American Center for Design

左圖
設計時，有些人會想模仿小孩的筆跡，其實不用那麼麻煩。美國設計中心如今已經關門大吉，但我女兒伊莉莎白的作品永遠留存，她現在是一位在曼哈頓執業的律師，早就不記得自己曾經為這張海報寫過字。

設計界提到風格兩字時，通常帶有貶義。大多數設計師説自己「沒有風格」，就是想在案子上實驗新手法。模仿別人的原創設計時，就會説這叫做「純粹的風格」。而批評膚淺的作品時，人們則往往説這個東西「只有風格」。

然而，在任何藝術形式中，風格都是必然存在的，平面設計尤其如此。多數平面設計的案子裡，功能需求往往最簡單，比如名片上的文字必須清楚、尺寸必須可以裝進錢包。之後，所有包含字體、色彩、排版、材質和製作方式等，則都是取決於個人喜好，這也就形成了大家所説的「品味」。我們可以來問問設計師，最近有沒有哪一場會議專門在討論這些「品味」問題？他們可能會説，大概就是昨天開的會吧，而且回想起來不太愉快。

1990年代初，雖然我已經在維涅里設計工作十年了，但自認還是像個新鮮人。當時我非常渴望能找到自己的發揮空間，卻完全不知道如何著手。設計領域日新月異，從《Emigre》雜誌大膽的字體排印學，到克蘭布魯克藝術學院（Cranbrook）與加州藝術學院（CalArts）的實驗發明，我不禁覺得超越風格是一件不可能的事。出乎意料地，正當我沉浸在自我反省之中，美國設計中心（American Center for Design）邀請我去擔任百大秀（100 Show）評審主席，那是世上最前衛也最時尚的設計比賽，美國設計中心的100場秀，他們還請我幫忙設計海報，吸引我的同行來參加比賽。果不其然，接下來我拖稿了好幾個禮拜，設計中心的工作人員越來越緊張，深怕我無法勝任這項任務。最後，他們説我至少要交一段推薦語，可以印在競賽傳單的背面。於是我交了一段意識流文字，看起來更像是心理諮商過程中寫出來的東西。沒想到他們很喜歡，建議我乾脆就把文字放在海報正面。啊，這真是全方位的解決方案。

但要用什麼字體才對？這件小事現在成了整個案子最棘手的問題。我要用最新設計的Grunge字體來迎合潮流嗎？還是要和Helvetica字體一起堅持現代主義？又或者用Garamond No. 3字體最保險？到了不能再拖的最後一刻，我想到了解決辦法。我一個字一個字地，把這段文字念給我4歲的女兒伊莉莎白聽，讓她一筆一畫寫出來。純真的形式凌駕於疲軟又憤世嫉俗的內文，而我也終於解脫了。

Kronos Quartet
Chinoiserie
The Whispers of Angels
The Duchess of Malfi
Mark Morris Dance Group

如何不靠商標也有辨識度

布魯克林音樂學院
Brooklyn Academy of Music

左圖
BAM布魯克林音樂學
院成立於1861年，早
期的幾十年間有恩里
科‧卡盧索、莎拉‧
伯恩哈特與伊莎朵
拉‧鄧肯公開演出。
百年後，藝術統籌哈
維‧利希騰斯坦給了
勞勃‧威爾森、菲利
浦‧葛拉斯、碧娜‧
鮑許與彼得‧布魯克
等獨立藝術家初試啼
聲的機會。

下一跨頁
我們用特殊方式來處
理平淡無奇的無襯線
News Gothic字體，
打造出BAM風格，
即使畫面中完全沒有
出現學院商標，也
看得出學院的理念。
巧合的是，這個字體
是由莫里斯‧富勒‧
班頓（Morris Fuller
Benton）在1908年
設計的，也就是BAM
正式開始營運的那
一年。

1960年代，全美最古老的表演藝術中心「布魯克林音樂學院」陷入困境，一位名叫哈維‧利希騰斯坦（Harvey Lichtenstein）的年輕夢想家出手相救，將學院重新打造為全球最前衛的聖殿，至今仍持續運作。利希騰斯坦創辦的下一波藝術節（Next Wave Festival），偷師曼哈頓的當代表演藝術標竿，轉化為一場銳不可擋的布魯克林復興運動，並且一直延續至今。

1995年，我們已經為下一波藝術節做了許多年的平面設計，這一次，BAM希望我們能設計出一些歷久彌新的東西。「就像萬寶路牛仔的形象不會一直改變。」學院董事成員威廉‧坎貝爾（William Campbell）如此說道。當時，他是菲利普莫里斯國際菸草公司（Philip Morris）的行銷總監。他們希望從今以後，從海報到36頁的刊物，再到小幅廣告，全都要有BAM風格，但他們卻不想要有一個學院商標。

傳奇的當代廣告先驅赫爾穆特‧克朗（Helmut Krone）給了我靈感。「我一生都在跟商標設計奮戰，」他這麼說過：「但其實人們看到商標就會想，『這是一個廣告，跳過不用看』。」所以，他設計了許多與眾不同的方案，大膽地排列組合，為客戶創造出極具辨識度的形象，最知名的代表就是福斯汽車（Volkswagen）在1959年的「Think small」廣告，使用Futura字體並有大幅留白的排版手法沿用至今。

正因如此，我想到要運用單一種字體，也就是經典的News Gothic，但稍作一些改變。我們把字的兩側裁掉，象徵學院沒有框架。如同我向哈維‧利希騰斯坦和他同事凱倫‧布魯克斯‧霍普金斯（Karen Brooks Hopkins）以及喬瑟夫‧梅里洛（Joseph Melillo）所說明的。這個裁切表示BAM超越疆界，不會受限於單一舞台，而且這樣能讓4英吋高的文字塞進2英吋的文字空間裡，非常節省。「有點像從你的臥室窗戶看到金剛的大眼睛，」我說道。即便你看不見整隻金剛，也知道牠非常巨大。

同年，我們推出了下一波藝術節的新設計，這種獨特的標題處理方式一開始讓人摸不著頭緒，BAM建築顧問休伊‧哈迪（Hugh Hardy）還說這很像家電品牌美膳雅（Cuisinart）的字體。然而二十年之後，這個設計已經與BAM密不可分了。

BAMbill

**The Brooklyn Academy
of Music**

Brooklyn Academy of Music

Brooklyn
Academy
of
Music

30
Br
Tel
Fax

BAM

Brooklyn
Academy
of
Music

BAM's 1995
Next Wave Festival

Robert Wilson
Tom Waits
Vito Acconci
Kristin Jones & Andrew Ginzel
Ilya Kabakov
Don Byron
Bill Frisell
Vernon Reid
Steven Berkoff
Cloud Gate Dance Theatre
Carl Dreyer
Richard Einhorn
The Camerata Chorale
Brooklyn Philharmonic
Kronos Quartet
Ping Chong
David Roussève / REALITY
Cheek by Jowl
Mark Morris Dance Group

ee
tickets
to the **15th**
Anniversary of
he BAM Next
Wave Festival

Light

Wav

95

guid

Music

Brooklyn
Academy
of
Music

30 Lafayette Avenue
Brooklyn NY 11217
Telephone: 718.636.4122
Fax: 718.857.2021

Stephen P. Millikin
Audience Development Manager

BAM

Mark Morris
Dance Group

**Brooklyn Academy of Music
1995 Next Wave Festival
is sponsored by
Philip Morris Companies Inc.**

**For tickets call TicketMaster
212.307.4100
For information call BAM
718.636.4100
BAM Prefers VISA**

Brooklyn
Academy
of
Music

30 Lafayette Avenue
Brooklyn NY 11217
Telephone: 718.636.4100
Fax: 718.857.2021

hile the famous gas lamps are burning

Live Piano Music
Sat. 5–7pm, $19.96

18/875-5181

ccepted

BAM

Based on Alice's
Adventures in Wonderland
and Through the Looking Glass
by Charles Dodgson
(a.k.a. Lewis Carroll)

October 7 at
10–14 at
October 8 at

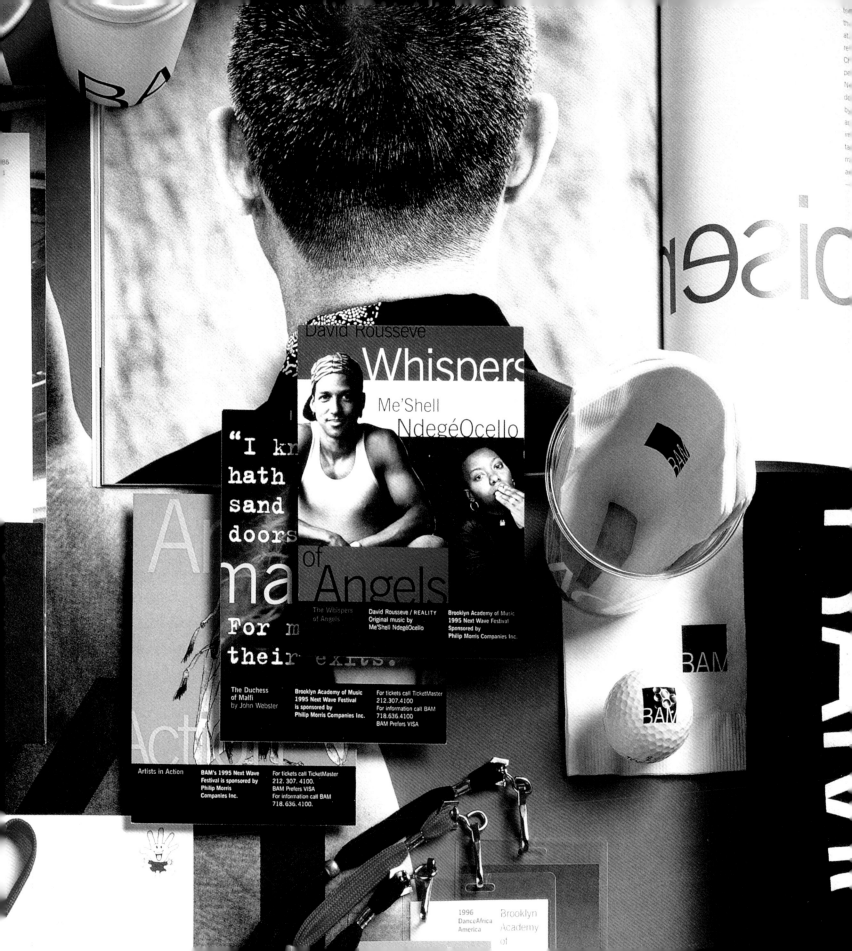

下方左圖
請印刷廠製作裁切文
字的杯子比想像中還
要難，因為他們一直
不肯相信我竟然想要
把文字「印錯」。

下方右圖
我們在節拍器馬達上
方放了一隻舉起的
手，讓「Wave」帶
有「招手」的雙關意
涵更加明顯。

已故的設計鬼才蒂博爾·卡爾曼（Tibor Kalman）
曾受博物館請託設計品牌識別。但他沒有設計商
標，而是遞給客戶一本字體手冊，說只要挑選一種
字體並反覆使用，只要時間夠長，最後就會變成他
們的品牌識別。他是對的。我相信一個偉大品牌最
重要的特徵就是一致性。但這不是指千篇一律。千
篇一律是靜止的，毫無生命，而一致性是具有互動
感與活力的。沒錯，BAM後來一直使用同一種字
體，成為了一致性的典範。

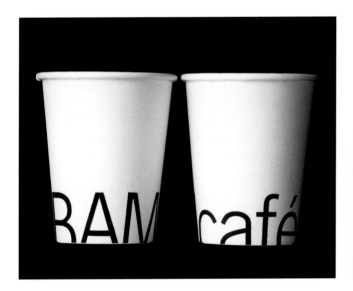

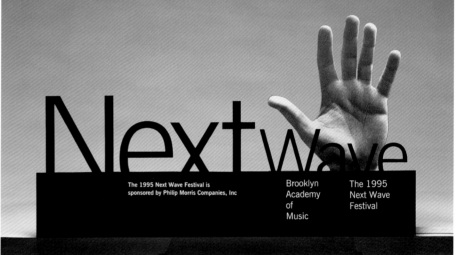

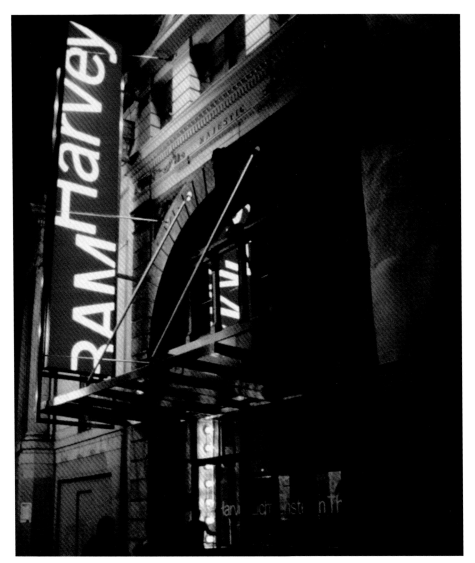

左上圖
1999年利希騰斯坦退休後，輝煌劇院（Majestic Theatre）更名為BAM哈維劇院（BAM Harvey Theater）。

左下圖
就連BAM的廁所商標都要使用裁切的圖案。

下圖
多年來學院都不想擁有正式商標，最後終於請我們用招牌字體來定調。設計師艾蜜莉·海斯·坎貝爾製作的商標使用指南只有六頁，至今仍受到嚴格遵守。

下一跨頁
當代字體與BAM歌劇院百年的布雜藝術（Beaux-Arts）碰撞出新火花。

Brooklyn
Academy
of
Music

30 Lafayette Avenue
Brooklyn NY 11217
Telephone: 718.636.4131
Fax: 718.636.4171

M. Lourdes Marquez
Associate Director of Sponsorship

BAM

Men's
Room

opera

如何建造一座永久留存的城鎮

佛羅里達祝賀城
Celebration, Florida

左圖
我們的設計在佛羅里達州祝賀城中無所不在，一般人不會注意到的地方也有這些設計的蹤影，比如水溝蓋。

上圖
華德·迪士尼原本夢想在佛羅里達州中部打造一座未來主義烏托邦，後來變成一座主題公園，也就是1982年開放的「未來社區的實驗原型」（Experimental Prototype Community of Tomorrow, EPCOT）。十多年後，祝賀城動工了，卻是運用截然不同理論基礎。

若開車沿著佛羅里達州中部4號州際公路行駛，走192號公路出口，看到一道長長的白色柵欄後右轉，就會進入另一個世界。路旁是一座座附帶庭院和前廊的傳統房屋，城鎮中心有經典的中央大街，人行道的兩側有著各式小商店。這座城市已有20年的歷史，只要走路就能抵達公園和學校，沒有美國人熟悉的大型停車場和量販店圍繞。這就是佛羅里達州的祝賀城。

1990年代初，華德迪士尼公司（Walt Disney Company）決定收回之前在主題公園周圍買下的5000英畝土地，並嘗試一些新策略，也就是住宅開發。當時的執行長麥可·艾斯納（Michael Eisner）對設計充滿熱情，他邀請了建築師勞勃·史騰（Robert A. M. Stern）及賈克林·羅伯森（Jaquelin Robertson）來規畫這個造鎮計畫。他們提出了大規模的新都市主義（New Urbanism）實驗，這是一種都市設計理念，要打造出小規模、混合型的社區，就像前一個世紀常見的都市形態。除了傳統住宅之外，也要融入一些知名建築師的公共建築，像是菲力普·強生（Philip Johnson）的市政廳、麥可·葛瑞夫（Michael Graves）的郵局，還有羅伯特·文丘里（Robert Venturi）與丹尼絲·史考特·布朗（Denise Scott Brown）的銀行。

我們則是受託設計這座城鎮所有的視覺形象，包含街道商標、商店招牌、公共高爾夫球場的球洞標記，甚至是水溝蓋。都市的純正性（authenticity）是一個棘手的概念，尤其是對平面設計師而言，我們要扮演的不僅是形式創造者，也是理念的溝通者。我們需要打造出一般人都能理解的共通語言，並自在地發揮各種尋常可見的元素，包含字體、顏色和圖像等。機場的商標和小鎮街角的路牌看起來不能一模一樣。要創造出7500位居民每天所見的所有視覺圖案，這真的是一項巨大的挑戰。而我們在祝賀城的目標，就是要成為日常風景中的一部分。

我過去合作過的許多客戶都是理想主義者，但祝賀城的造鎮團隊才是箇中翹楚。我們正在打造一個全新的世界，這令人激動。現在這個城鎮已不那麼新了，但越老舊，我越是喜歡。

下圖
城鎮不需要商標,但需要一個市徽。五角星設計合夥人翠西·卡麥隆設計的祝賀城市市徽就是要讓人憶起傳統的美國小鎮。這個市徽還被印在手錶上,指針上的狗狗每分鐘都會經過騎車的小女孩身邊一次(見右頁最右下圖)。

右圖及右頁
我們設計的圖案都要經過世上最厲害的幾位建築師核可,包含勞勃·史騰、羅伯特·文丘里、丹尼絲·史考特·布朗、西薩·佩里、麥可·葛瑞夫與和菲力普·強生。我們推薦給城鎮使用的官方字體「Cheltenham」是貝特倫·古德西(Bertram Good-

hue)於1896年設計的,幸運的是,他正好也是一位建築師。這種字體既經典而又不繁瑣,有各種不同的粗細與變化,從油漆商標到切割的金屬文字都能使用,就連社區入口處,那座長達40英尺的橡樹柵欄上也有它的蹤影。

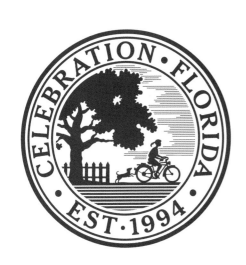

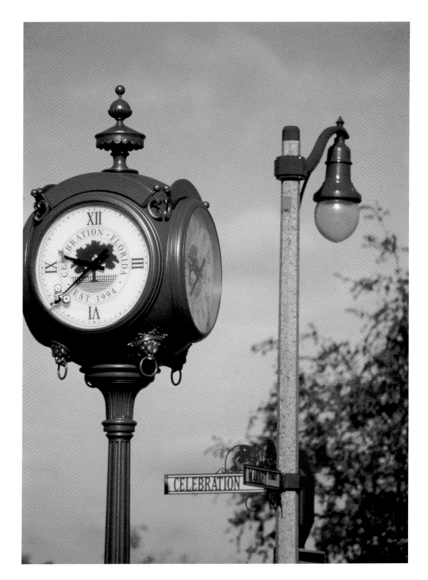

佛羅里達祝賀城

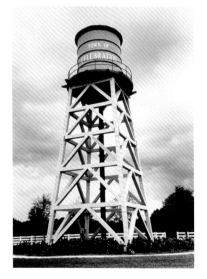

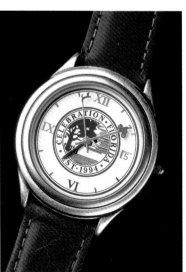

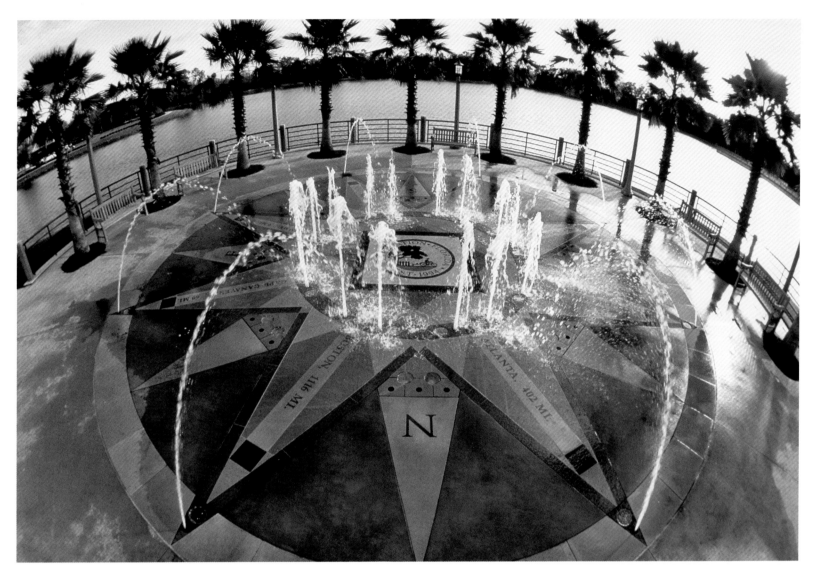

佛羅里達祝賀城

左上圖
祝賀城購物區中心的噴水池圖案也是我們的作品，這是一個指南針，指向社區以外的其他地點。

右上圖
鎮上的電影院由西薩·佩里設計，具有美國現代的時髦風格，是城鎮的一座地標，兩側旗桿上則有城鎮的名稱。

下一跨頁
諷刺的是，祝賀城的中心大街並不叫做「中心大街」，因為隔壁的奧西歐拉縣已經有一條同名的大街了。於是中心大街被改名為祝賀大道。

左下圖
鎮上所有小商店的招牌風格都是一致的。雖然街道指示和水溝蓋用的是相同的視覺語言，但商店招標則帶有美國本土歷史感，舉凡是霓虹燈、木雕和馬賽克瓷磚，都是這種風格。

右下圖
祝賀城公共高爾夫俱樂部的視覺設計比市徽困難許多。我花了一些時間才找出原因，因為我們的客戶都不是騎腳踏車、綁馬尾的年輕女孩，而是熱愛高爾夫球的行家。好幾位高階主管在會議上表演揮桿動作給我們看，高爾夫俱樂部商標上的剪影也被修改得越來越完美。

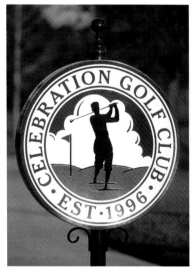

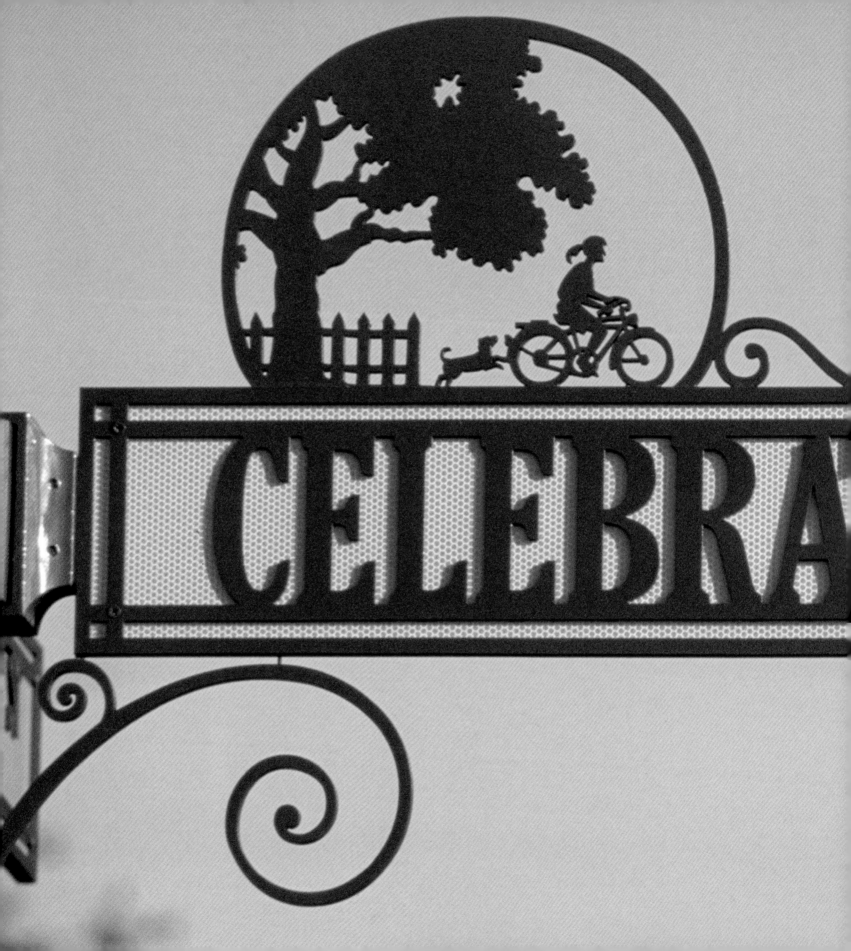

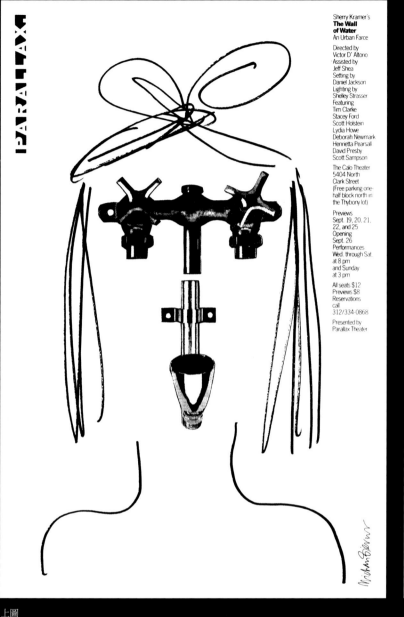

Sherry Kramer's
**The Wall
of Water**
An Urban Farce

Directed by
Victor D'Altorio
Assisted by
Jeff Shea
Setting by
Daniel Jackson
Lighting by
Shelley Strasser
Featuring
Tim Clarke
Stacey Ford
Scott Holsten
Lydia Howe
Deborah Newmark
Henrietta Pearsall
David Presby
Scott Sampson

The Calo Theater
5404 North
Clark Street
(Free parking one-
half block north in
the Thybony lot)

Previews
Sept. 19, 20, 21,
22, and 25
Opening
Sept. 26
Performances
Wed. through Sat
at 8 pm
and Sunday
at 3 pm

All seats $12
Previews $8
Reservations
call
312/334-0868

Presented by
Parallax Theater

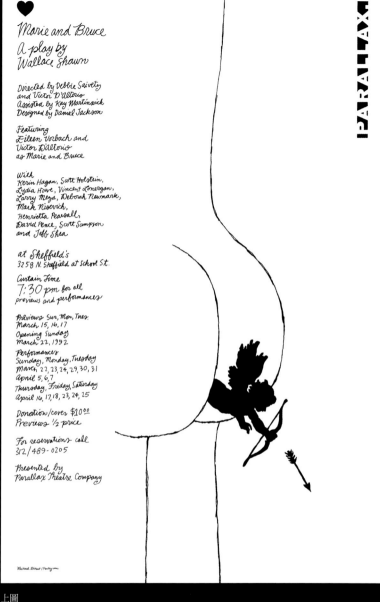

*Marie and Bruce
A play by
Wallace Shawn*

*Directed by Debbie Saivetz
and Victor D'Altorio
Assisted by Kay Martinovich
Designed by Daniel Jackson*

*Featuring
Eileen Vorbach and
Victor D'Altorio
as Marie and Bruce*

*With
Kerin Hagan, Scott Holstein,
Lydia Howe, Vincent Lonergan,
Larry Mega, Deborah Newmark,
Mark Niseovich,
Henrietta Pearsall,
David Pence, Scott Sampson
and Jeff Shea*

*at Sheffield's
3258 N. Sheffield at School St.*

*Curtain Time
7:30 pm for all
previews and performances*

*Previews Sun, Mon, Tues.
March 15, 16, 17
Opening Sunday
March 22, 1992
Performances
Sunday, Monday, Tuesday
March 22, 23, 24, 29, 30, 31
April 5, 6, 7
Thursday, Friday, Saturday
April 16, 17, 18, 23, 24, 25*

*Donation/cover $10.00
Previews ½ price*

*For reservations call
312/489-0205*

*Presented by
Parallax Theatre Company*

上圖
《水之牆》(*The
Wall of Water*)是一
齣瘋狂喜劇,關於四
名女孩合住一間公
寓,裡頭卻只有一間
廁所,最後她們把彼
此都逼瘋了。設計這
張海報的挑戰是,要
建立出瘋狂與室內管
線間的視覺聯繫。

上圖
在華萊士‧肖恩
(Wallace Shawn)
的舞台劇《分手快
樂》(*Marie and
Bruce*)裡講述了一
段最搞笑、最沉重又
最荒誕的婚姻關係。
多年來,這張海報都
掛在五角星設計的廁
所裡。

如何不收設計費

視差劇場
Parallax Theater

左圖
維克多‧達托里奧的
劇場工作室名為「視
差」（Parallax），
我從沒有問過他這個
名字的意涵，而他也
同樣沒有問我為什麼
要如此設計商標。

高中時期，維克多‧達托里奧（Victor D'Altorio）就是我們學校最厲害的演員，演出校內每一齣舞台劇，大部分都擔綱主角，或至少是全劇最吸睛的角色，比如《彼得潘》（*Peter Pan*）的虎克船長、《浮生若夢》（*You Can't Take It with You*）的波里斯、《第十二夜》（*Twelfth Night*）的管家馬伏里奧。而我總是負責製作海報。

大學畢業後，他也來到紐約尋覓演出機會，而我則剛開始擔任設計師。沒過多久，我就接到電話。「嘿，小麥？」他說，只有我的家人和老友才會這麼稱呼我。「我們正要製作一齣戲，你可以幫我們做海報嗎？」我說當然沒問題。他又告訴我，他們劇團沒什麼錢。我說，別擔心。

維克多的演員生涯從未大紅大紫，但他成了一名受人愛戴的表演老師，也當過導演，先是在紐約發展，後來到芝加哥，最後落腳在洛杉磯。而我免費幫他設計每一場的演出海報。網路上總有許多設計師指責不收費的行為，認為這會腐蝕設計產業。但我很喜歡友情相挺，尤其我和維克多是多年的好友，彼此間有著不言而喻的默契。

首先，他委託的案子都很有趣。他總會簡短地解釋這齣戲的內容，然後把海報上的文字傳給我。他的說明往往生動且充滿啟發性，文案也都很完整，沒有錯字。接著，收到我的設計稿後，維克多每一次都會問我一個問題：「我該如何感謝你？」最後，他從來不亂開支票，例如承諾我在首映之夜見到大明星，或以後發給我高價的案子。我認為，他身為一位演員，非常了解一個工作上的道理，那就是，對於有創造力的人來說，最好的回報就是讓他們好好完成工作，但許多其他客戶都不明白這一點。接到維克多以「嘿，小麥？」作為開場的來電，就表示我有機會能夠自由發揮。

遺憾的是，我再也接不到那樣的電話了。維克多在2009年過世，實在太年輕了。

PARALLAX

FOOL *for* LOVE.

A PLAY *by* SAM SHEPARD

Directed *by* Victor D'Altorio.
Setting *by* Daniel Jackson. Lighting *by* Lee Kennedy.
Costumes *by* Amy Carlson. Sound *by* Chris Olson.
With Neil Flynn, Henrietta Pearsall, Thom Vernon & Tom Webb.

Chicago Actors Ensemble (*in the* Preston Bradley Center).
941 West Lawrence, Fifth Floor. (Free parking in lot east of building.)
First preview, Thursday, June 4. Opening night, Sunday June 7, 1992.
Performances, Thursday, Friday, Saturday, Sunday at 8 pm through July 12.
Tickets $10.00. Previews $7.00. Senior and student discount $8.00.

Presented *by* PARALLAX THEATER COMPANY.
For reservations, *call* (312) 509-8172.

PARALLAX

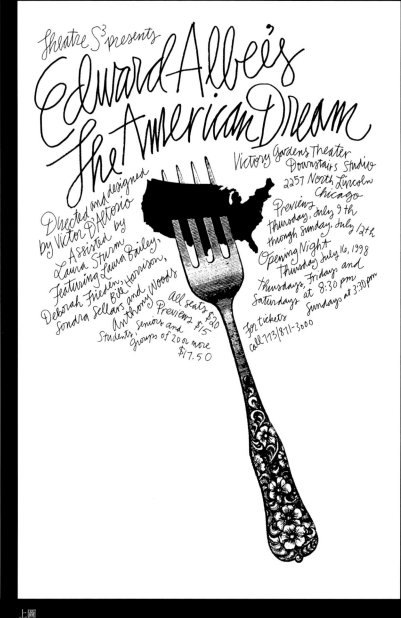

上圖
不知為何，維克多的
許多作品開頭似乎都
是關於一段破裂或
互相折磨的關係，比
如山姆·謝普（Sam
Shepard）的《愛
情傻子》（*Fool for
Love*）。就如同我為
視差劇場設計的其他
海報，這次我也用殘
酷的插圖來與劇名形

上圖
這是愛德華·阿爾比
（Edward Albee）
經典的諷刺劇作《美
國夢》（*The Ameri-
can Dream*），美國
的消費主義被微妙地
拆解開來。

Design by Pentagram

Parallax Theater presents

TheBabysitter

A short story by Robert Coover.
Designed and directed by Victor D'Altorio.
Adapted by Victor D'Altorio and Henrietta Pearsall. Lighting by Rand Ryan.
Performed by Keith Bogart, T. L. Brooke, Winifred Freedman, James C. Leary, John Eric Montana, Rhonda Patterson, Henrietta Pearsall & Darin Toonder.
McCadden Place Theater at 1157 North McCadden Place, one block east of Highland between Santa Monica and Fountain.
Thursdays, Fridays & Saturdays at 8pm. Previews Thursday, January 6,7,8,13. Opening night Friday, January 14, 2000.
All seats $20, previews $14. For tickets 323/960-7896.

PARALLAX

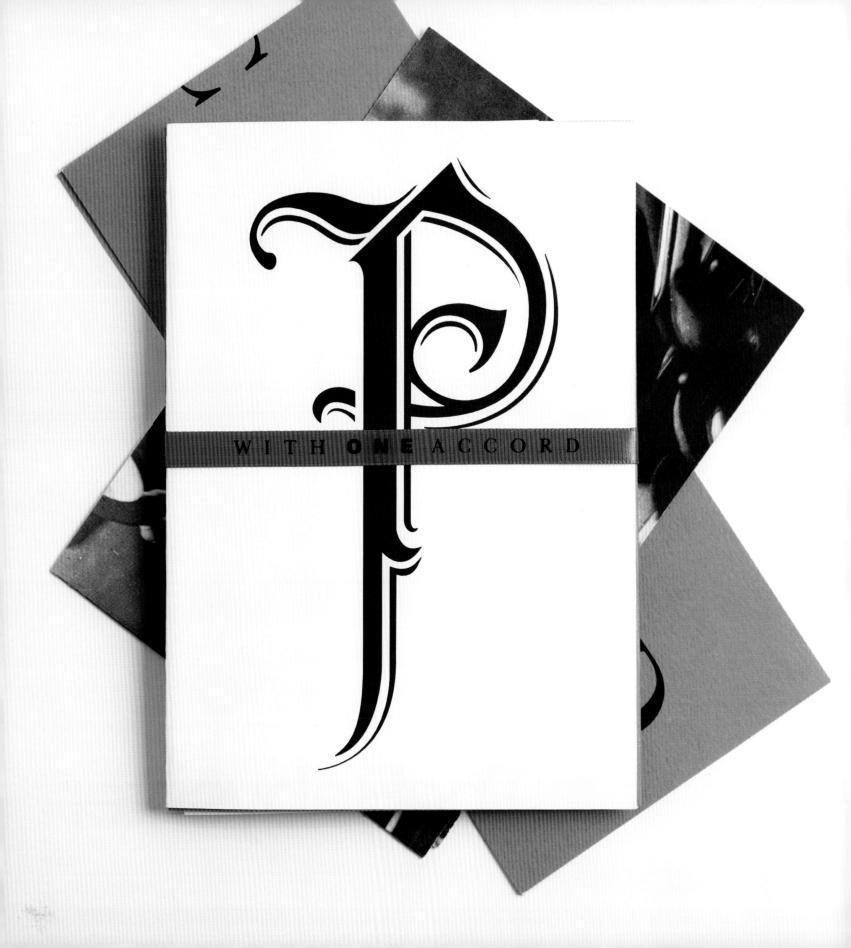

如何籌得十億美元

普林斯頓大學
Princeton University

在五角星設計待了幾年後的某天，我接到前客戶喬蒂（Jody Friedman）的來電。她錄取了母校普林斯頓大學的一份工作，要負責學校的「發展交流」。她說，他們要進行募款計畫，問我能否幫忙做平面設計。

我根本不知道發展交流的意思，也不清楚什麼是募款計畫，更沒踏進過普林斯頓大學校園。喬蒂耐心向我解釋，說這些活動基本上就是為了募款。我開始有點緊張。畢竟，我截至當時為止的職業生涯中，都像個小螺絲釘一樣地工作，客戶要我做一些事情，我就計算要收多少錢，如果客戶同意，那我就開始做事，完成後客戶就會付錢。但是，這個案子的核心，竟然是要透過跟別人要錢來賺錢。

我其實很害怕冒險進入未知領域，還暗暗認定自己一定會被那些異常聰明又受過頂尖教育的人嚇壞。所以我試圖回絕這個案子，但喬蒂十分堅持。最後我只好答應，而且還學到了一個很好的教訓：最好的成長機會就是去做一些你原本不知如何著手的事。這位普林斯頓的案主是位好嚮導，帶領我進入神祕的大學募款活動。我們設計了一個主題和平面呈現方式。我創造出一些新的交流方式，但並不是因為我很大膽或富有想像力，而是因為我本來根本不知道這些事情有什麼樣的潛規則。由於不熟悉討錢的常用手法，我只是以一種校友會認同的方式來描述這所大學，並尋求他們的支持，他們也回應了，而且還極度熱情，對學校大有助益。整個活動的募資目標原本是75萬美元，最後募得了12億。

在平面設計中，形式是如此仰賴內容，而這是一種最好理解世界的方式。我的案子讓我的見識更加廣闊，曾與微生物學家一起坐在實驗室的長椅上、和職業足球員一起站在更衣室裡。對主題感興趣時，我也往往能夠設計得更好。因此，我學會要盡可能對更多的事物抱持著好奇心。

左圖
普林斯頓要舉辦迄今為止規模最大的募款活動，希望能呼籲校友贊助，最後決定用「齊心協力」當作文案。

上圖
活動開辦時，他們將代表學校的巨大橙色和黑色布幕垂掛在拿索院（Nassau）兩側，這是校園中最古老的建築物，也是校歌的主軸。

上圖
五角星設計的麗莎‧
塞維尼設計的小手
冊，邀請校友在母校
從基石到街道商標
等細節中，找出所有
「1」的細節。

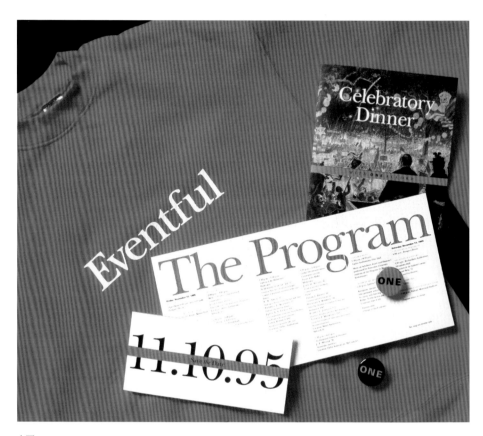

上圖
在普林斯頓畢業的設
計師威廉‧德倫特爾
和搭檔史蒂芬‧道爾
負責的設計方案中，
以Baskerville字體作
為代表學校的字體。

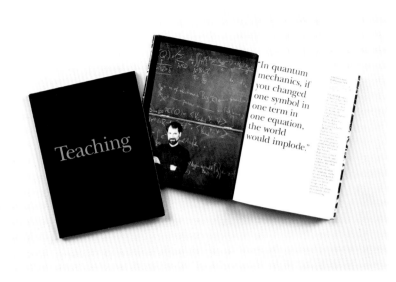

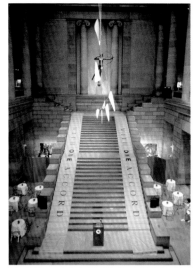

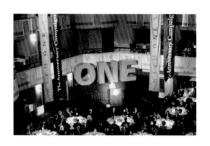

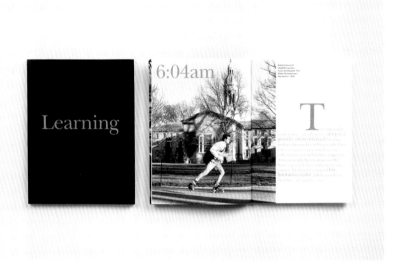

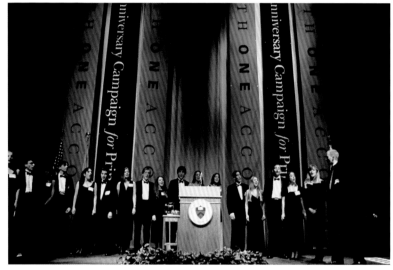

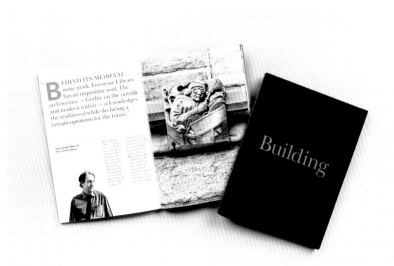

左上、左中、左下圖
三本平裝小冊子，採
用內斂的黑白印刷，
取代笨重的大部頭刊
物，大型手冊本來是
1990年代早期學校募
資的固定文宣形式。
第一本「教學」小冊
收錄了學校裡受人愛
戴的老師，呼籲校友
為特定學院籌資。第
二本「學習」則記錄
下五位學生在學校的
一天，藉此請大家
為學校獎學金捐款。
最後一本「建築」則
訪問了在學校工作的
傑出建築師，並邀請
大家協助打造校內新
設施。

上圖
學校在全美各地舉辦
開幕儀式，大型布幕
讓整個活動看起來
像一場慶祝盛典。三
條巨幅布幔與上面的
「ONE」跟著學校的
聲樂隊一起巡迴，讓
自豪的校友隨時都有
機會能拍照。

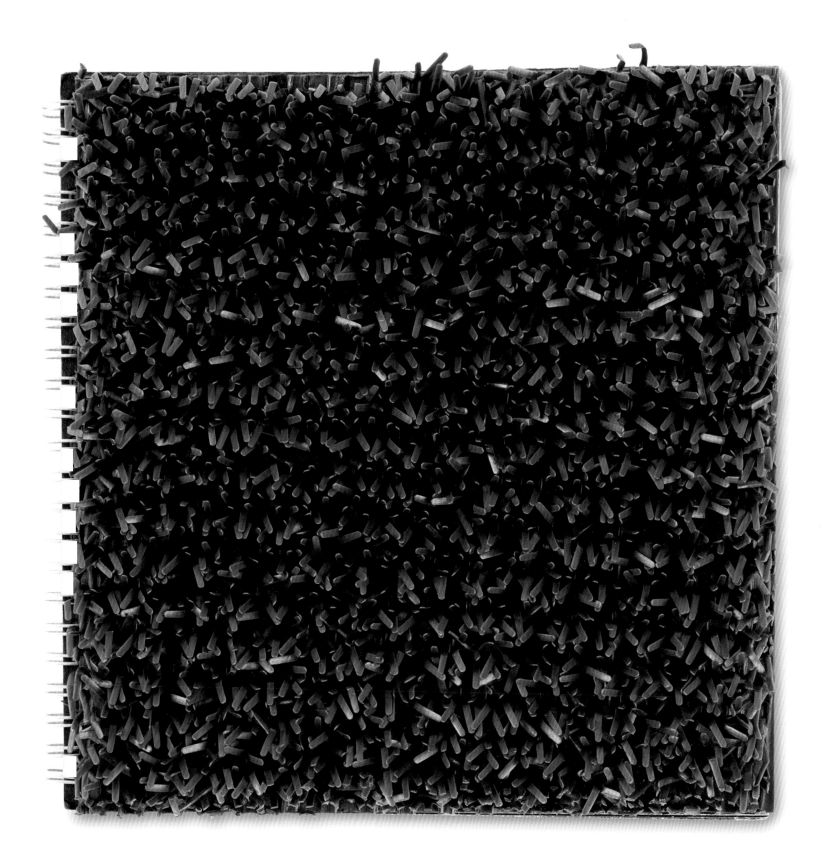

如何贏得一場勢均力敵的比賽

紐約噴射機隊
New York Jets

左圖
紐約噴射機隊是世界
上唯一用人工草皮當
作商標使用指南封面
的球隊。

上圖
最早的商標是1960年
代的作品，是個不太
精良的商業設計。如
果必須保持不變，它
有可能改變嗎？

2001年，我們接到了當時紐約噴射機隊總裁傑伊·克羅斯（Jay Cross）的來電。他可能是體育管理領域中，唯一同時擁有建築和核子工程學位的人。這次，他有一個任務，就是要重塑球隊的形象。問題是，我們不能更改商標。

紐約噴射機隊是20世紀中期媒體時代的產物，這支橄欖球隊成立於1959年，當時名為紐約泰坦隊（New York Titans），1963年更改了名稱及商標。六年後，炙手可熱的四分衛喬·拿馬斯（Joe Namath）帶領隊伍在第三屆超級盃中跌破眾人眼鏡拿下冠軍，成為他們不可抹滅的榮耀時刻。然而從那以後，這支球隊屢屢讓忠實球迷心碎，千奇百怪的球員、口無遮攔的教練，團隊陣容流動率極大，遲遲無法重新攀上1969年的巔峰。

運動隊伍的形象設計可能是平面設計中最充滿激情的題材。假設有家銀行更換了商標，或許根本沒有人會注意到。但假如球隊換了商標，就可能會收到球迷的恐嚇信。在球迷心目中，拿馬斯和隊友在超級盃上穿的球衣像圖騰一般神聖。形象設計雖然是商業策略之一，其中卻關乎各種神奇的思維模式。我們執行整個案子的期間，就必須嚴格依循這個四十多年的原創商標，當年是由一位匿名藝術家繪製的，現在變得神聖不可侵犯。這個原創商標的設計手法被形容為「貓咪的早餐」：球隊名稱使用了一種字體，底下的地名又是另外一種字體，下方有一顆小小的橄欖球，而整個綠底外框也是橄欖球的形狀。我們只能從這樣的商標著手。

事實證明，即便這個商標雜亂無章，卻成了我們無盡的靈感泉源。我們把球隊名稱的字體當成標準字，而小橄欖球上面的地名，則可以用來當成辨識度極高的替代商標。即使是那顆小小的足球，我們也能重新賦予它生命。更不用說最下方的綠底，就成了其他圖案的顏色素材。這個商標為噴射機隊帶來了全新的形象，即便經過數十年，球隊仍繼續使用這個形象。

以前各單位總會廣發商標使用指南手冊，現在已經被各種線上工具取代了。然而，實體文件所能傳達出的權威性，是網站做不到的，尤其如果這本手冊既簡單又令人印象深刻的話。以下的這本手冊介紹了噴射機隊的新形象商標，用讓人驚豔的人造草皮當成封面，提供了使用指引與修改靈感。

下圖
1978年，噴射機隊曾經更改過一次商標，在隊名頂部加上了噴射機的形象，不過這本手冊中沒有收錄。球迷們對此雖然沒有反感，但也是抱持著懷疑的態度。20年後，為了喚起拿馬斯當年的榮耀，教練比爾‧帕塞爾又把商標改回到最原始的版本，但整個品牌形象還是搖搖欲墜。

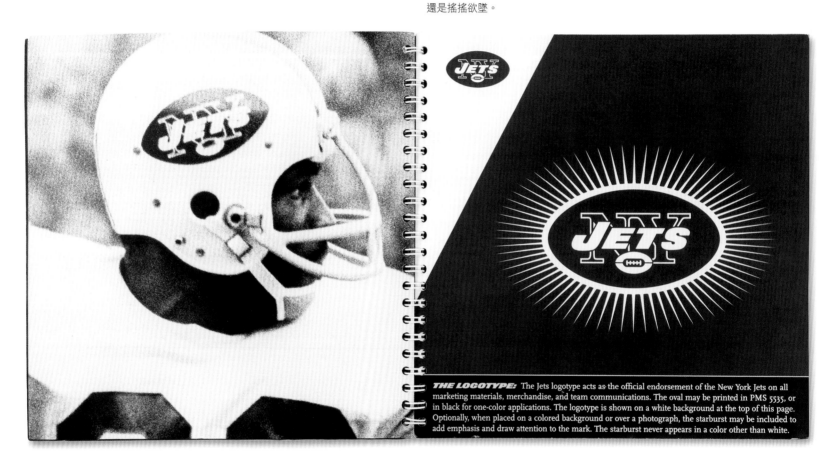

THE LOGOTYPE: The Jets logotype acts as the official endorsement of the New York Jets on all marketing materials, merchandise, and team communications. The oval may be printed in PMS 5535, or in black for one-color applications. The logotype is shown on a white background at the top of this page. Optionally, when placed on a colored background or over a photograph, the starburst may be included to add emphasis and draw attention to the mark. The starburst never appears in a color other than white.

紐約噴射機隊

下圖
字體設計師強納森．
霍夫勒與托比亞斯．
弗里爾瓊斯，用隊
名的四個字母創作出
完整的字體系統，所
有字母都是超粗的超
斜體。

JETS BOLD

ABCDEFGHI
JKLMNOP
QRSTUVWXYZ
1234567890

THE TYPEFACE: Pictured above is the character set for Jets Bold, the primary typeface of the New York Jets brand identity. It is a custom drawn font inspired by the original four letters, J-E-T-S, in the classic logotype. This typeface is available for both PC and Macintosh operating systems and is approved for use across all applications and mediums. As with everything, the way this typeface is used is critical. Sample stylistic treatments are displayed on the following spread to give an idea of it's intended usage.

右圖
全新字體「Jets
Bold」讓每個單字
看起來都很有魄力。
強納森和托比亞斯還
開玩笑說，麥可·貝
（Michael Bay）的
電影海報很適合選用
這個字體。

TYPOGRAPHIC STYLE: The vocabulary of football is rich with hard-hitting, descriptive terms such as those displayed above. Whether it be for a promotional flyer for a Jr. Jets event, or the design of stadium graphics, it's use instantly adds an unmistakable New York Jets flavor. It is intended primarily as a display typeface for headlines and titles, but works well at both small and large sizes. It is also extremely legible for a typeface of such angle and weight. Do not stretch, or otherwise manipulate the letterforms.

下一跨頁左上圖
球迷對標準色非常認
同，就像對球隊商標
一樣。我們非常小心
地在綠白兩色的噴射
機隊調色盤中，加入
了其他幾種互補色。

下一跨頁左下圖
與同一城市的對手
紐約巨人隊（New
York Giants）不同，
噴射機隊的商標沒有
特別凸顯球隊的故
鄉，但其實這座城市
本身就極具市場性。
因此我們另分割出另
外一個商標來彌補
這點，把「NY」兩
字放在橄欖球狀的
底色上，並採用Jets
Bold體。

下一跨頁右上圖
設計師布列特‧泰勒
發現商標中的小足球
暗藏了一位凶猛的
前鋒，於是全新吉祥
物「比賽臉」就此
誕生。

下一跨頁右下圖
由於整個品牌識別系
統都是源自於原始的
商標，整套設計不僅
包含多元的元素，也
依然忠於球隊精神。

Scala
Aa Bb Cc Dd Ee Ff Gg Hh Ii Jj Kk Ll Mm Nn Oo Pp
Qq Rr Ss Tt Uu Vv Ww Xx Yy Zz
1 2 3 4 5 6 7 8 9 0

News Gothic
Aa Bb Cc Dd Ee Ff Gg Hh Ii Jj Kk Ll Mm Nn Oo Pp
Qq Rr Ss Tt Uu Vv Ww Xx Yy Zz
1 2 3 4 5 6 7 8 9 0

SUPPORTING TYPEFACES: As a complement and support to the primary typeface, two additional fonts have been specified. These supporting typefaces increase functionality and are intended for use at smaller point sizes. Do not use them in large headlines or titles. Scala is a good choice for body copy and longer narratives, such as in Jetstream, or the Yearbook. News Gothic works well for charts, statistics, and other technical applications. Bold and italic weights are also available within these font families.

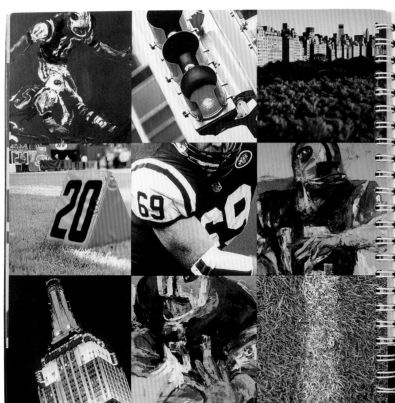

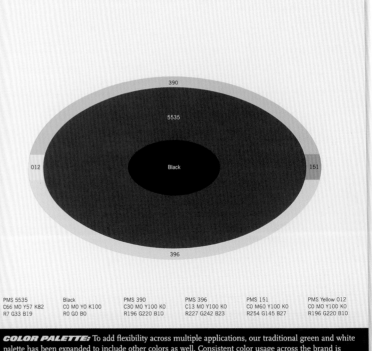

PMS 5535	Black	PMS 390	PMS 396	PMS 151	PMS Yellow 012
C66 M0 Y57 K82	C0 M0 Y0 K100	C30 M0 Y100 K0	C13 M0 Y100 K0	C0 M60 Y100 K0	C0 M0 Y100 K0
R7 G33 B19	R0 G0 B0	R196 G220 B10	R227 G242 B23	R254 G145 B27	R196 G220 B10

COLOR PALETTE: To add flexibility across multiple applications, our traditional green and white palette has been expanded to include other colors as well. Consistent color usage across the brand is maintained by following these rules: PMS 5535 should represent at least 50% of all applied color within any application. Up to 40% may feature PMS 390 or 396. Yellow 012 and PMS 151 should represent no more than 10%. Black, white, photography, and illustration are not calculated as part of applied color.

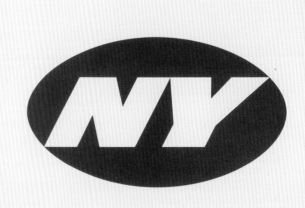

THE MONOGRAM: The monogram acknowledges and honors the great city and state for which we play. It features the distinctive Jets Bold typeface within the familiar oval shape of our logotype. The oval may appear as PMS 5535, 390, 396, black, or white. When the oval appears in PMS 5535 (shown here) or black, the NY letterforms within it are white. For dark backgrounds, the oval may appear in PMS 390, 396, or white, and the letterforms within may appear in PMS 5535 or black.

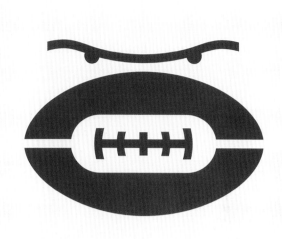

THE GAMEFACE: The closest thing to a Jets mascot, the "Gameface" mark represents the passion and fervor of our fans, players and coaches. It is derived from the little football shape that has long been anchored at the base of the New York Jets logotype. It may appear in PMS 5535, 390, 396, or black, but is most effective when the background is lighter in color than the mark itself. Showing the Gameface mark in white on dark backgrounds is not recommended.

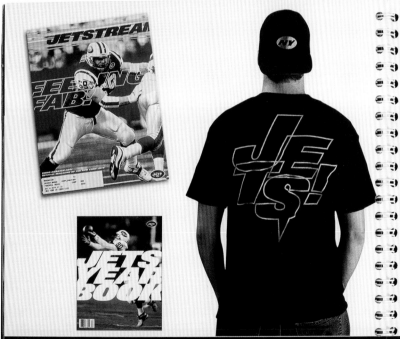

EXPRESSIONS OF THE BRAND: Sample applications of brand identity elements and the guidelines defined in this manual are shown on this spread. As important as it may be to continuously find new and fresh ways to implement and expand the Jets brand, it is just as important to retain an element of continuity across everything produced, even when these items are made by different people in different parts of the world. Consistency is ensured when we work within the specifications of type and color, and when our marks and symbols are used where, when, and how they are intended. It is important to consider the medium in which the item is being produced and to be sensitive to materials and production processes. Variety and surprise can be achieved through the use of scale, style of photography and illustration, as well as meaningful and cleverly written copy. Paying equal attention to all of these should result in a consistent, but unique application of brand identity. This is how we build the Jets brand.

右圖
噴射機隊的品牌形象
中，另一個極具代表
的是聽覺元素，他們
是這麼喊的：「噴！
射！機！隊！噴射機
隊！噴射機隊！噴射
機隊！」每場比賽
中，所有人都會呼喊
這個戰鬥口號。我們
把這個口號圖像化，
變成噴射機品牌識別
中的另一項元素。

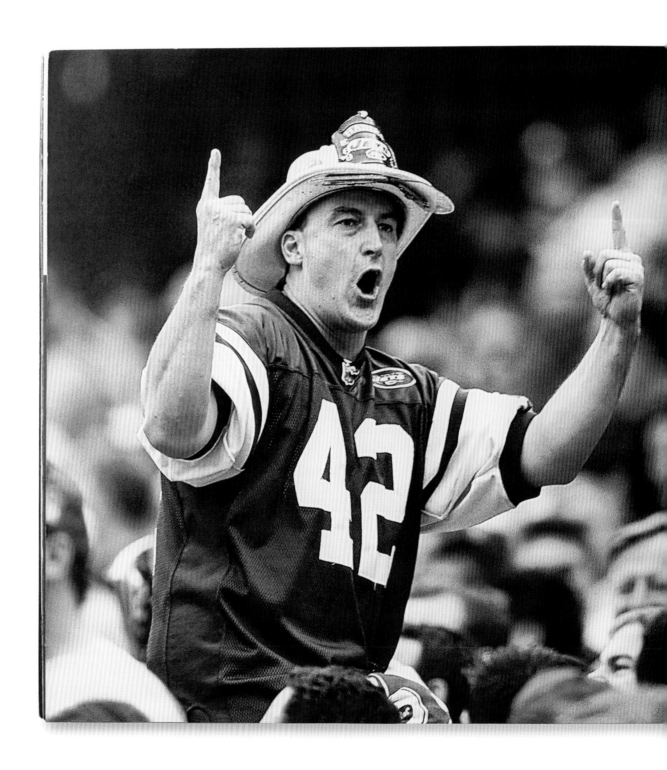

紐約噴射機隊

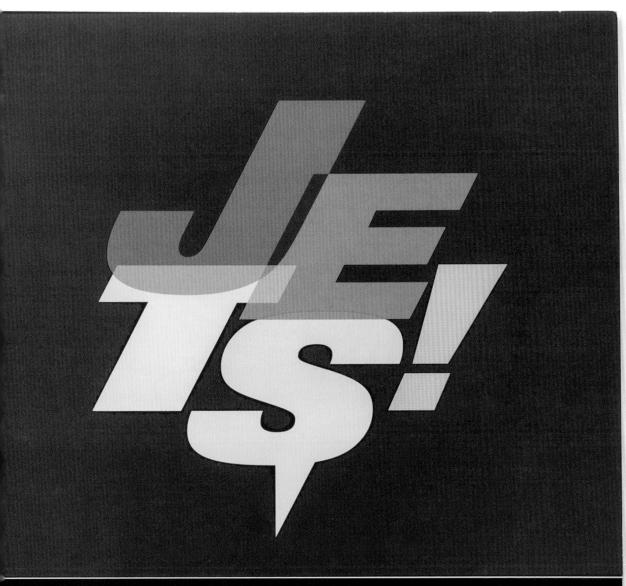

THE CHANT: Perhaps the most dynamic and inspiring element of the Jets personality is the Chant: J! E! T! S! JETS! JETS! JETS!... as shouted by thousands of Jets fans at our games throughout the country. So simple and authentic, the Chant unites entire stadiums in support for their team. A graphic treatment of the chant, in multiple colors and configurations, has been adopted as an official part of the Jets brand identity. Options and variations for Chant graphics are illustrated on the next spread.

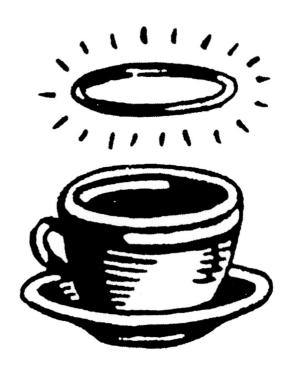

(BAD) (GOOD)

如何變好

好餐館
The Good Diner

左圖
「好餐館」的名稱與
商標彰顯出這家餐廳
是以咖啡作為整體的
核心價值。

上圖
由於室內裝潢很上鏡
頭,這間餐廳曾是世
上最常登上報章媒
體的小餐館。偶爾會
有人打電話來問説能
否參觀。建築師詹姆
斯・比伯總會這麼回
答:「這裡24小時
都有開,但不接受預
約,這是一間快餐
館。」

謝爾頓・威迪格(Sheldon Werdiger)和伊凡・卡齊斯
(Evan Carzis)都是聰明的建築師。1980年代末經濟衰退,
紐約的建築業也因此停滯不前,所以他們決定要開一間餐館。
他們向我解釋説,這間餐館不要太花俏,不走復古路線,不要
有50年代那種絢爛的風格,也不要裝潢得像個時髦的場合,
或刻意假裝樸素。他們就是要開一家普通餐館,只要花4.99美
元就吃到兩顆蛋、培根和吐司,地點就在第11大道和第42街
的交叉口。謝爾頓和伊凡希望能擴張據點:「無論是遊客去搭
環狀線的路上、UPS司機早上送包裹的途中、酒吧年輕人喝完
最後一輪回家的半路上。」這間餐廳要能吸引到所有人。

我們面臨的挑戰,就是要從店名開始發想,在沒設計費下,打
造出平民化設計、快餐式風格。我建議取名為「澤西簡餐店」
(Jersey Luncheonette),商標則是一個盤子,上面有紐約
州的輪廓剪影,看起來就像一塊小牛肉排。沒有人喜歡這個想
法,他們也不喜歡「狂野西部餐館」、「日落咖啡館」或「最
後一站」。這些都太拐彎抹角了。最後我説,不如叫做「好餐
館」。這個名字聽起來不怎麼樣,也不特別,但……稱得上
好。至於餐館商標,我們的合作夥伴伍迪・皮特爾畫了一個咖
啡杯,再加上一個光環。

接著,我們在油氈上手工雕刻出商標,並放在入口處地板上。
我的搭檔是詹姆斯・比伯(James Biber),他曾一手打造許
多曼哈頓的高檔餐廳,他解釋説,小餐館不會花太多心思做室
內設計,比較會用心在菜單上。所以他只用了一項最根本的素
材,那就是各種顏色的油漆妝點座位和吧台。由於沒有美術預
算,所以我們用影印的廚房設備照片來裝飾牆面,而整間餐廳
裡唯一訂做的品項,就是形狀像奶昔杯的吊燈以及一座訂製的
手扶欄杆。

就像大部分的情況一樣,我們的設計費用就是餐廳開業後免費
用餐。但一個禮拜吃了三頓4.99美元的培根雙蛋餐之後,詹姆
斯和我都覺得,還沒吃回本前,我們就會先死於膽固醇中毒。

右上圖
「好餐館」是一場在地設計過程的實驗。我們沒有繪製霓虹燈招牌的圖案，只透過電話把文字資訊告訴製作廠商，並說，第二行的字要最大，第一行和第三行次之，以此類推，再請他使用任何他覺得好看的顏色。廠商把成品交給我們時，我們很緊張，但最後的成果相當令人滿意。

右下圖
客戶一度對店名猶豫不決，擔心這種模稜兩可的形容詞對卡車司機等客群來說太沒有吸引力。「好吧，不然叫做『他媽的好餐館』如何？」我建議。最後，我們保留了原來的店名。

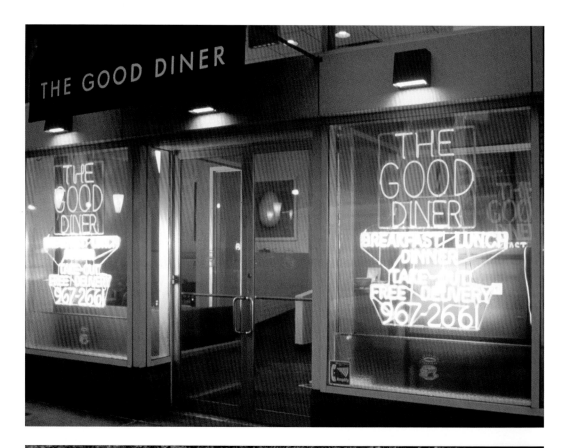

上圖
對簡餐館而言，小小的火柴盒就如同他們的年報、公司形象宣傳和60秒超級盃廣告。

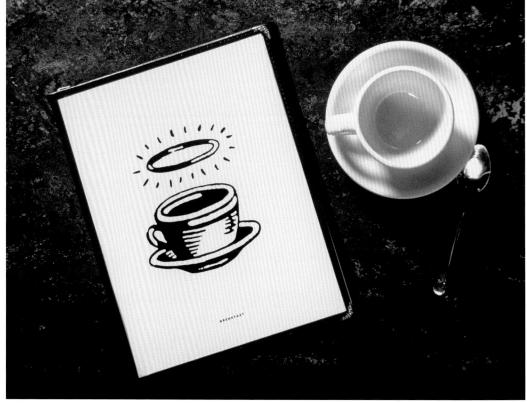

好餐館

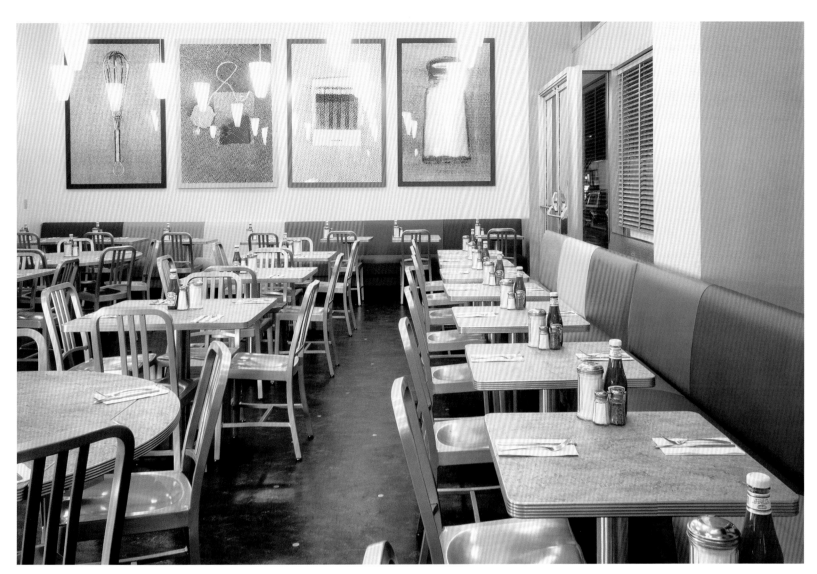

最左圖
伍迪·皮特爾精心繪製的商標以手工切割的方式，刻在入口處的油氈上。

左圖
連結櫃檯通往座位區的欄杆，要看作「GOOD」，或是「GOOP」，端看你對餐點的感受。

上圖
餐廳沒有美術預算，卻有很多空曠的牆面需要填補，於是我們把物品放在影印機上，放大印出來。這四張裱框的照片代表了四種原始元素：風、水、火、土，但我們不確定是否有人注意到。

下一跨頁
人造皮革五彩繽紛，何必選用單一色系？這些顏色順序是負責安裝的師傅自己決定的。

THE ARCHI
TECTURAL
LEAGUE NY

-ism

如何跑馬拉松

紐約建築聯盟
The Architectural League of New York

左圖
由建築聯盟舉辦的
「布雜藝術宴」
（Beaux Arts Ball）
是建築界的年度盛
事，每年都有一個新
的主題。2013年，
我們用純粹的字體
排印來呼應「主義」
（ism）這個有些深
奧的概念。

上圖
這是建築聯盟的原始
徽章，二十多年來我
一直避免更換。

我第一份工作到職後沒幾個星期，我老闆馬西莫・維涅里就把我叫進他的辦公室。當時我只是個來自俄亥俄州的天真年輕人，幾乎不知道自己在做什麼。馬西莫和他的妻子兼合夥人蕾拉要去義大利一個月，並請我跟進他目前手上的案子，也就是幫紐約建築聯盟進行設計。我喜歡建築，但我只知道大師級的法蘭克・洛伊・萊特（Frank Lloyd Wright），或是小說《源泉》（The Fountainhead）裡的建築師霍華德・洛克（Howard Roark），其他完全沒概念。沒想到，我馬上就和理查・麥爾（Richard Meier）、麥可・葛瑞夫和法蘭克・蓋瑞（Frank Gehry）這幾位建築大師通話，並著手尋找紐約建築聯盟百年紀念展的資料。我彷彿重讀了碩士學位，而研究對象就是建築聯盟。

建築聯盟成立於1881年，旨在將建築師和其他創意從業者匯聚在一起，組織的管理階層中也包含了各種專業領域的藝術家和設計師。馬西莫・維涅里是聯盟的董事會成員，所以無償擔任他們的平面設計顧問。身為馬西莫的助理，我接手了公司為他們做的免費工作。而十年之後，我自己也被任命為董事會成員，二十多年後，我仍在為他們服務，彷彿一場漫長的馬拉松慢跑，也是我職業生涯中最享受也最長久的關係。

設計師經常被要求為一些組織打造形象。我們不是這些組織內部的人，但會摸索定位，並給予他們最好的建議。我們這種受聘的外部顧問，會設計一套形象系統讓他們使用，並衷心祈求在案子完成之後，他們能成功樹立形象。年復一年地為建築聯盟做設計，我由衷體會到工作的樂趣。聯盟並沒有設定正式的平面設計標準，但組織形象不斷提升，素材永遠不會有用完的一天。多年來，我都不想設計一個死板的商標，反而將每一次新任務視為開放式的討論、一個擴大聯盟視覺形象的機會。隨著時間過去，某些模式也開始出現，比如說，我們後來還是設計了一個聯盟商標，但每次有新案子，我們依然會面臨最好（也最令人害怕）的挑戰：如果可以做任何你想做的設計，你會做些什麼？

右圖
早期為建築聯盟工作，我設計了幾份演講邀請函，也被當作小海報使用。這是馬西莫·維涅里第一次鼓勵我在自己的作品上署名。

右頁
為聯盟執行目前的專案是一種特別的享受。我們的「新興之聲」系列活動始於1981年，匯集世界各地的後起新秀建築師，舉辦各式講座，至今依然年年舉辦。這些海報顯然是我在向童年熱愛的專輯致敬，靈感來自於約翰·貝治（John Berg）與尼克·梵希亞諾（Nick Fasciano）為芝加哥樂隊（Chicago）設計的封面。

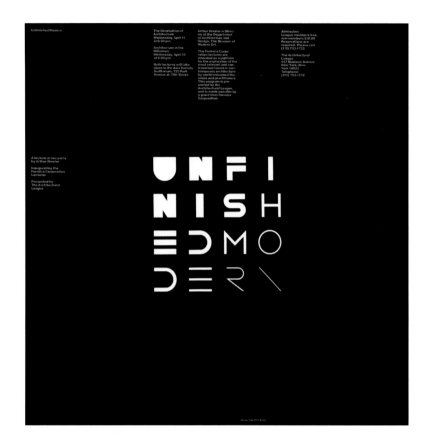

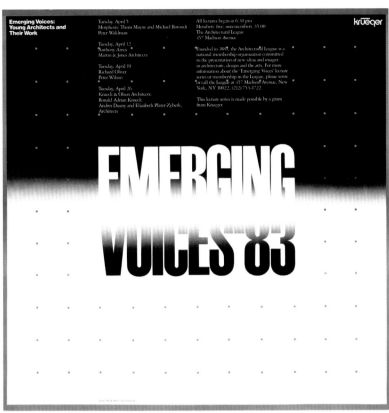

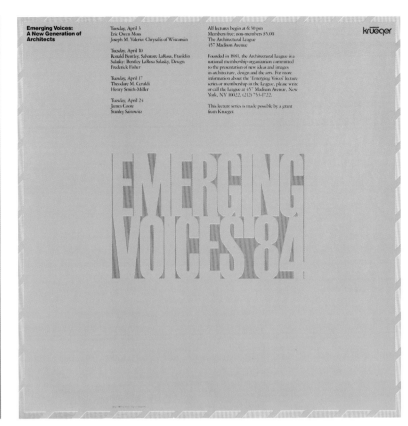

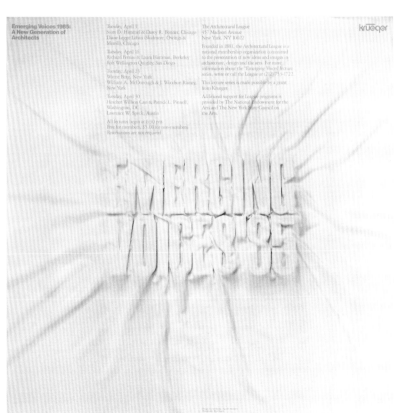

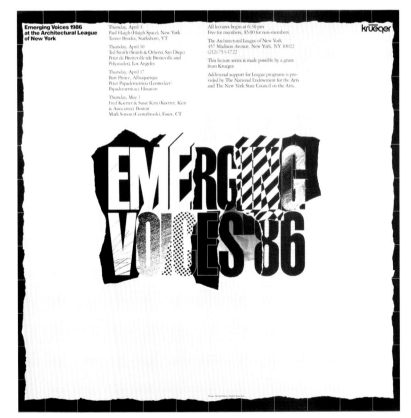

下圖
舉辦30周年的「新興之聲」系列，在我們的「理念、形式、共鳴」設計中達到最高峰，匯聚成一本300頁的書，記錄了建築聯盟是如何慧眼識英雄，提拔了無數中生代建築師，讓他們在全球發揮影響力。這些傑出的建築師包括了布拉德·克魯菲爾、詹姆斯·科納、瑪莉詠·韋斯與麥可·曼弗雷迪、泰迪·克魯茲、SHoP建築事務所，以及和珍妮·甘。

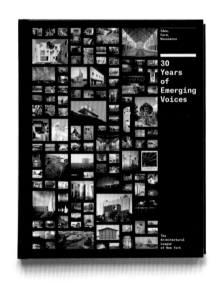

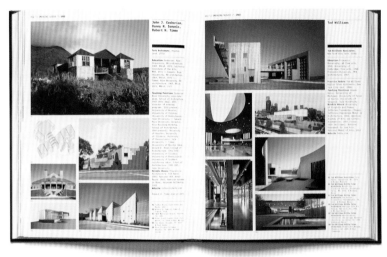

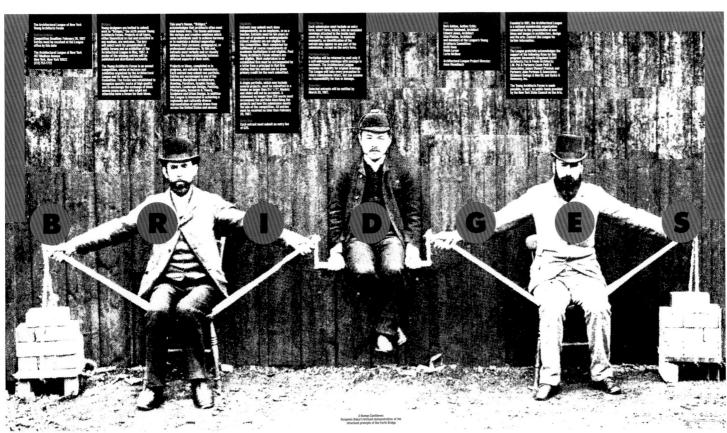

A Human Cantilever:
Benjamin Baker's brilliant demonstration of the
structural principle of the Forth Bridge

左圖
1980年代初
以來，我在建
築聯盟的對口
一直都是執
行總監羅莎
莉・吉納夫
羅（Rosalie
Genevro）
及專案總監
安妮・黎瑟
巴赫（Anne
Rieselbach）
，截至目前為
止，我們的交
流一直非常有
默契。但即便
如此，她們有
時也會拒絕我
的許多提議。
建築聯盟為年
輕設計師舉辦
的競賽每年都
有不同的主
題，我經常假
裝為此苦惱，
但其實心裡很
珍惜這些設計
機會。我記得
1987年的主
題「橋梁」
（Bridges）
就十分棘
手。

右圖
1999年的競賽海報
直接呼應「規模」
（Scale）這個主
題，設計出一張超巨
幅海報，在現今數位
與環保意識抬頭的時
代，已經不太可能再
看到這樣的設計了。

SCALE

The Architectural League of New York
Young Architects Forum

Call for Entries

Eligibility

Theme

Submission requirements

Entry fee

Entry forms

Portfolio return

Selection

Jury

Architectural League Program Director

Sponsors

Entry form

General Information

Eligibility Agreement

Portfolio Identification

The Architectural League of New York

Artemide

下圖
聯盟搬到蘇活區的新
辦公室時，我們製作
了這張海報向保羅·
索萊里（Paolo Sol-
eri）的《未來城市》
（*Visionary Cities*）
書封致敬。

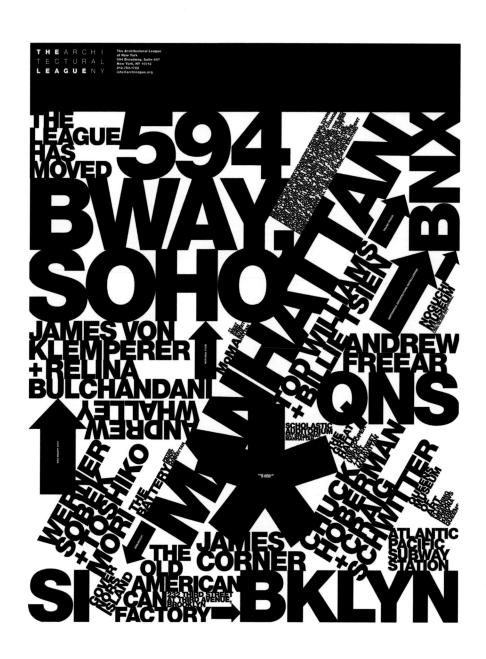

下圖
對於任何一位當代的
紐約建築師來説，「
布雜藝術宴」是一定
要參加的年度業內交
流盛事。2006年的主
題是「點、點、點」
（Dot Dot Dot），
我們使用了十分切題
的字體排印。

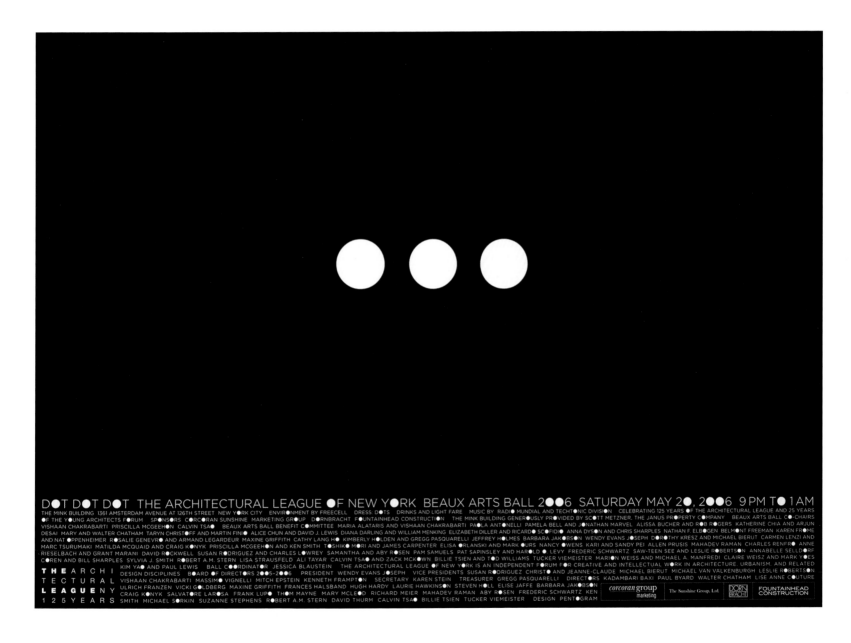

Light Years The Architectural League of New York's 1999 Beaux Arts Ball at th

ett-Lehigh Building, Saturday March 13, 1999. For tickets please call (212) 753 1722. Corporate Sponsor **Artemide**

紐約建築聯盟

左圖
2014年的布雜藝術宴於布魯克林華麗的威廉斯堡儲蓄銀行（Williamsburgh Savings Bank）舉辦。當年的主題是「工藝」（Craft），我們繪製了難解的巴洛克符號來呼應主題。

右圖
多年來，我一直覺得建築聯盟商標並不重要，因為比起符號，戲劇性的海報往往能夠做到更有力的溝通。然而隨著數位通訊和社群媒體興起，這種情況改變了，作為回應，我們設計了一個文字商標，將聯盟的縮寫嵌入正式名稱之中。

上圖及右圖
2011年，馬西莫·維涅里與蕾拉·維涅里獲得了聯盟著名的主席獎。我們設計的手冊中包含了五段不同的維涅里語錄，而且當然是使用Helvetica字體。未加剪裁裝訂的手冊也成了一張非正式的海報，這是我向這位恩師致敬的一種方式，他是一位慷慨的人，而且改變了我一生。

99

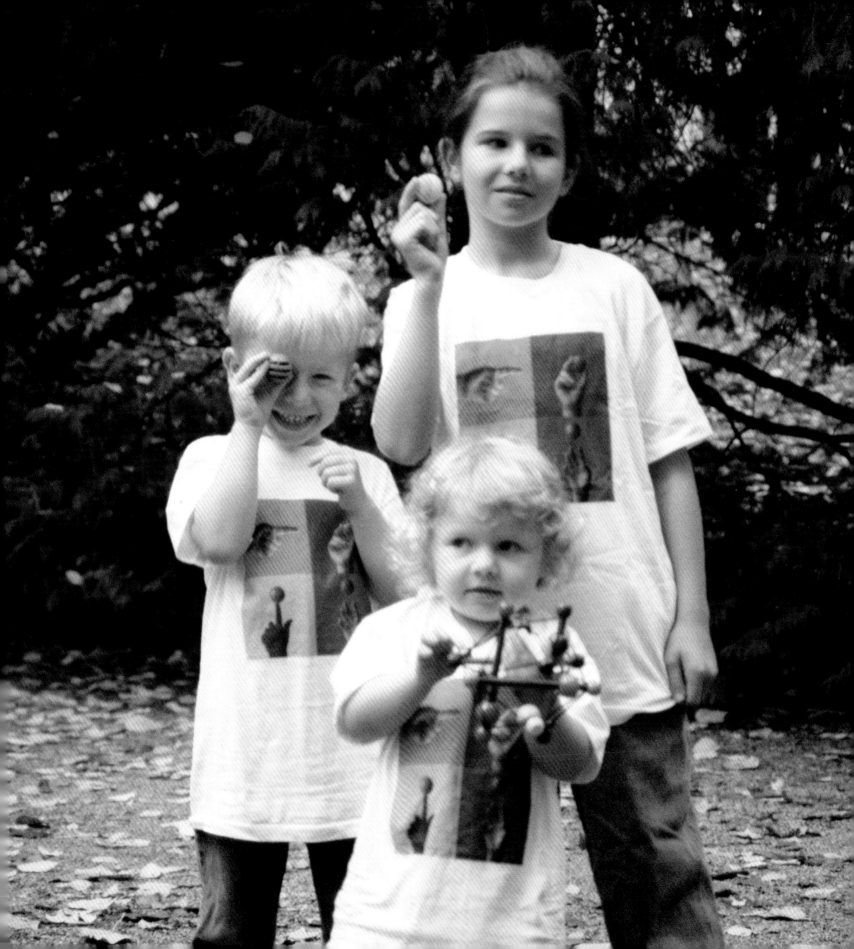

如何避免過度直白

明尼蘇達兒童博物館
Minnesota Children's Museum

左圖
德魯、莉茲、和瑪莎‧貝汝擔任明尼蘇達兒童博物館的視覺識別的模特兒。在自己三名孩子幫助之下，我更加了解如何為他們做設計。

上圖
這些名片提醒工作人員他們在一個需要「動手做」的地方上班。攝影師裘蒂‧奧勞森（Judy Olausen）讓當地的孩子們來擔任手模。

平面設計師對於陳腔濫調又愛又恨，「又愛又恨」本身也是一種陳腔濫調。在設計學校，我們被教導設計的目標是創造出新東西，但又不是全新的。好的外包裝要能讓義大利麵醬罐頭在競爭對手之間脫穎而出，但如果它看起來太過與眾不同，比如說，包裝得像一罐機油，那就會讓消費者感到困惑，甚至把他們嚇跑。因此，每一個平面設計的方案，都必須在撫慰人心與陳腔濫調之間遊走。五角星設計創辦人艾倫‧弗萊徹就很欣賞這種能力，比喻説輕撫這些陳腔濫調，就像是撫摸一隻貓咪，等待他們發出幸福的咕嚕聲。

1995年，明尼蘇達兒童博物館正準備搬家。原本它位於一座購物中心內，空間狹窄但舒適，接下來要搬往聖保羅市中心一座美麗的新大樓內。這座大樓由新鋭建築師茱莉‧史諾（Julie Snow）與文生‧詹姆斯（Vincent James）設計。我們受託製作博物館商標及平面設計，果不其然出現大量陳腔濫調元素，包含蠟筆記號、明亮的原色、積木、氣球和笑臉。

無論是在設計或生活中，真實經驗都是刻板印象的解藥。就讓我們忘掉「兒童博物館」的抽象概念吧，想想看，這座兒童博物館本身有什麼特別之處？博物館總監安‧比特（Ann Bitter）是個充滿活力的人，她描繪了未來的藍圖，也坦白了自己的恐懼。她説，新大樓很漂亮，但她擔心會失去客人在舊址中熟悉的親密感。明尼蘇達兒童博物館就像大多數的同類場館，也提供給孩子許多「動手做」的體驗機會，這當然又是另一種陳腔濫調的詞彙。孩子們會在這座又大又華麗的嶄新大樓中感到舒適嗎？

有時候，避開過度直白的元素，意味著必須接受它，然後拋棄它。孩子的手成為關鍵，他們受邀動手觸摸，並去感受每個物件的大小。我們沒有試圖用剪影或蠟筆塗鴉的手法畫出這些小小的手掌，反而是邀請當地的孩子擔任手模，拍下他們指指點點、數數和玩耍的照片。如今當年的孩子已經二十多歲，但他們的手繼續在明尼蘇達兒童博物館指引方向，讓其他小朋友在期待與驚喜之間，找到微妙的道路。

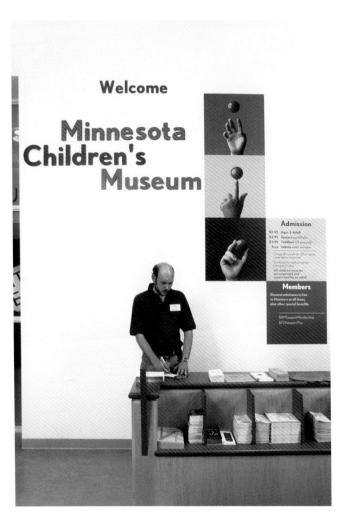

左圖
這座博物館是以各種方式組合了24張小手的照片取代商標。

右圖
博物館中央的集合空間裡，擺放著一隻頂著時鐘的大手，強化了我們平面設計的主題。

右圖
我們決定用手當作主軸，幸好博物館正好是五層樓，而不是六層樓。

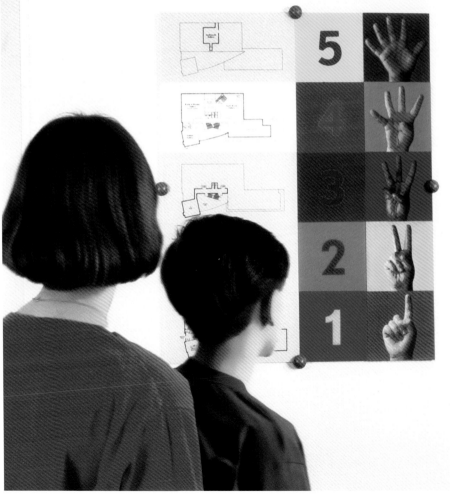

下圖
孩子的手在整座博物館裡指引方向，並感受比例大小，廁所指示頗具巧思。

上圖
禮堂的門上有一張巨幅門票，每次開門都會被撕成兩半。

下一跨頁
博物館盛大開幕，這些極富辨識度的手掌也融入建築物中，藉此歡迎觀眾。

It is five minutes to midnight.

如何避免世界末日

原子科學家公報
Bulletin of the Atomic Scientists

左圖
我們設計的《原子科
學家公報》年報在封
面上宣告了末日之鐘
目前的指針位置，內
容則總結了數十位專
家的評估。

上圖
最初的末日之鐘是藝
術家瑪蒂爾‧蘭斯多
夫的作品。1947年，
她受託為《原子科學
家公報》雜誌創刊號
封面繪製插圖，創造
出眾所矚目，罕見而
有力的意象。

20世紀最有力量的資訊設計，是出自一位風景畫家的手筆。1943年，原子核物理學家小亞歷山大‧朗斯多夫（Alexander Langsdorf Jr.）被徵召到芝加哥，與數百名科學家一同參與一項名為「曼哈頓計畫」（Manhattan Project）的祕密專案，要在短時間內研製出原子彈。最終的研發成果在日本廣島和長崎投下原子彈，也因此終結了第二次世界大戰。雖然和平隨之而來，但朗斯多夫與他的許多位同事仍深感不安。人類發明出能讓自身滅絕的武器，這意味著什麼呢？

為了讓更多人正視將這個問題，朗斯多夫和他的科學家同事開始籌措發行《原子科學家公報》的油印通訊。1947年6月，通訊轉型為雜誌。朗斯多夫的妻子瑪蒂爾（Martyl Langsdorf）是一名藝術家，她的風景畫在芝加哥各大畫廊都有展出。她自告奮用創作了第一期的封面，但她並沒有太多繪製插圖的空間，預算也只能讓他們做雙色印刷。但她找到了解決辦法——「末日之鐘」（Doomsday Clock）就此誕生。

關於核武擴散的爭論十分複雜，也相當有爭議，而末日之鐘將這個議題殘酷而簡單地視覺化，將午夜逼近與定時炸彈的戲劇化元素融合進圖像裡。他們沒有採用蘑菇雲這樣浮誇的圖案，轉而使用時鐘這種測量儀器，對於一個由科學家主導的組織而言，再適切不過。瑪蒂爾將創刊號封面上的分針設定在晚上11:53，原本只是因為「比較好看」。沒想到兩年後，蘇聯測試了他們自己的核武裝置，大國之間的軍備競賽也正式展開。為了強調這些情況的嚴重性，在下一期的刊物上，時鐘被調整至晚上11:57。從那之後，指針移動了20次。這是多麼偉大、清晰又簡潔的視覺溝通方式！

幾年之前，這個科學單位想要設計一個商標。我們告訴他們說，你們已經有商標了，自此，我們也展開了與《原子科學家公報》的合作關係，至今仍在繼續。每年，我們都會發表一份公布指針位置的報告。而每年，我們都希望時光倒流。

右圖及下一跨頁
設計師艾明・維特
和我建議他們直接
用末日之鐘作為商
標。《原子科學家公
報》的無特定立場的
中立特質，使他們
能將生物恐怖主義
（bioterrorism）和
氣候變遷資料納入年
度科學評估報告中，
而過去65年來，時鐘
的指針位置也因此調
整了20次。

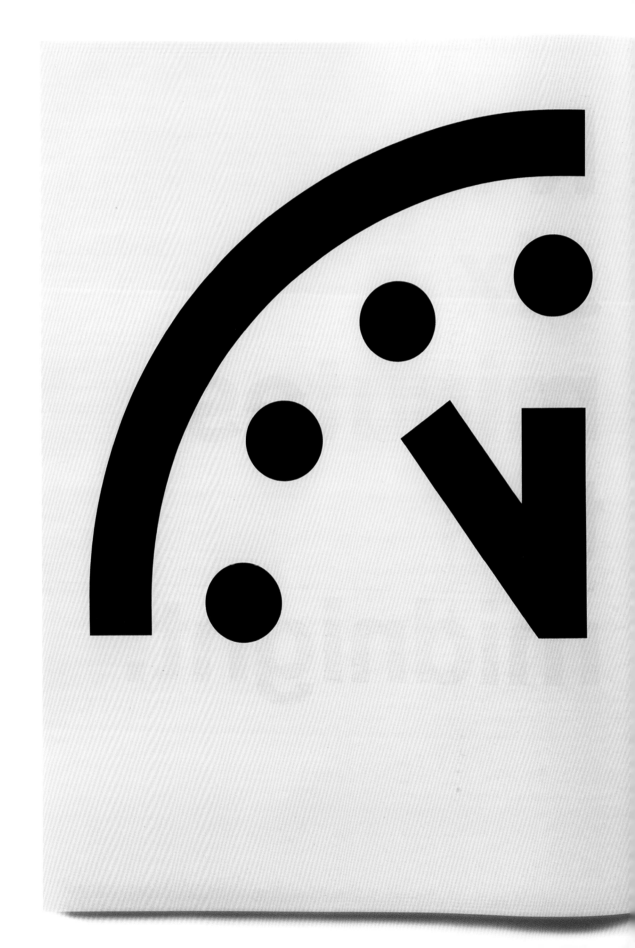

How close are we to catastrophic destruction? The Doomsday Clock monitors "minutes to midnight," calling on humanity to control the means by which it could obliterate itself. First and foremost, these include nuclear weapons, but they also encompass climate-changing technologies and new developments in the life sciences that could inflict irrevocable harm.

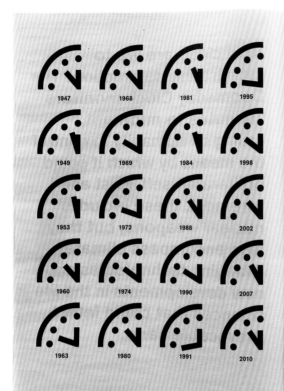

1947	1968	1981	1995
1949	1969	1984	1998
1953	1972	1988	2002
1960	1974	1990	2007
1963	1980	1991	2010

In 1947, the Bulletin first displayed the Doomsday Clock on the cover of the print magazine to convey, through a simple design, a sense of urgency and peril posed by nuclear weapons. The minute hand of the Clock has moved 19 times since, based on a global risk assessment by the Bulletin's Science and Security Board in consultation with other experts, and the Board of Sponsors, which currently includes 19 Nobel Laureates.

Turn back the Clock.

Join the Clock Coalition.

Engage with experts, policy makers, and citizens around the world through our web resources, blogs, online debates, discussions, and publications. Share information, express your opinion, hold leaders accountable, and help to build international momentum toward nuclear weapons disarmament and climate stabilization. Beginning January 13–14, 2010, start every year by participating online when the Bulletin gathers experts and scientists at a Doomsday Clock Symposium to sustain a worldwide forum about the perils we face and what we can do to meet them. Participate at: www.turnbacktheclock.org.

1 2 3

Nuclear Weapons

The nuclear age dawned in the 1940s when scientists learned how to release the energy stored within the atom. Immediately, they thought of two potential uses – an unparalleled weapon and a new energy source. The United States built the first atomic bombs during World War II, which they used on Hiroshima and Nagasaki, Japan in August 1945. Within two decades, Britain, the Soviet Union, China, and France had also established nuclear weapon programs. Since then, Israel, India, Pakistan, and North Korea have built nuclear weapons as well.

For most of the Cold War, overt hostility between the United States and Soviet Union, coupled with their enormous nuclear arsenals, defined the nuclear threat. The U.S. arsenal peaked at about 30,000 warheads in the mid 1960s and the Soviet arsenal at 40,000 warheads in the 1980s, dwarfing all other nuclear weapon states. The scenario for nuclear holocaust was simple: Heightened tensions between the two jittery superpowers would lead to an all-out nuclear exchange. Today, the potential for an accidental or inadvertent nuclear exchange between the United States and Russia remains, with both countries anachronistically maintaining more than 1,000 warheads on high alert, ready to launch within tens of minutes, even though a deliberate attack by Russia or the United States on the other seems improbable.

Unfortunately, however, in a globalized world with porous national borders, rapid communications, and expanded commerce in dual-use technologies, nuclear know-how and materials travel more widely and easily than before—raising the possibility that terrorists could obtain such materials and construct a nuclear device of their own. The materials necessary to construct a bomb pervade the world.

As a result, according to the International Panel on Fissile Materials, substantial quantities of highly enriched uranium, one of the materials necessary for a bomb, remain in more than 40 non-weapon states. Save for Antarctica, every continent contains at least one country with civilian highly enriched uranium. Even with the improvement of nuclear reactor design and international controls provided by the International Atomic Energy Agency (IAEA), proliferation concerns persist, as the components and infrastructure for a civilian nuclear power program can also be used to construct nuclear weapons.

Climate Change

Fossil-fuel technologies such as coal-burning plants powered the industrial revolution, bringing unparalleled economic prosperity to many parts of the world. But in the 1950s, scientists began measuring year-to-year changes in the carbon dioxide concentration in the atmosphere that they could relate to fossil-fuel combustion, and they began to see the implications for Earth's temperature and for climate change.

Today, the concentration of carbon dioxide is higher than at any time during the last 650,000 years. These gases warm Earth's continents and oceans by acting like a giant blanket that keeps the sun's heat from leaving the atmosphere, melting ice and triggering a number of ecological changes that cause an increase in global temperature. Even if carbon-dioxide emissions were to cease immediately, the extra gases already added to the atmosphere, which linger for centuries, would continue to raise sea level and change other characteristics of the Earth for hundreds of years.

The most authoritative scientific group on the issue, the Intergovernmental Panel on Climate Change (IPCC), suggests that warming on the order of 3-10 degrees Fahrenheit over the next 100 years is a distinct possibility if the industrialized world doesn't curb its carbon-dioxide emissions habit. Effects could include wide-ranging, dramatic changes. One drastic result: a 3- to 24-inch rise in sea level, leading to more coastal erosion, increased flooding during storms, and, in some regions such as the Indus River Delta in Bangladesh and the Mississippi River Delta in the United States, permanent inundation. This sea-level rise will affect coastal cities (New York, Miami, Shanghai, London) the most, compelling major shifts in human settlement patterns.

Inland, the IPCC predicts that another century of temperature increases could place severe stress on forests, alpine regions, and other ecosystems, threaten human health as mosquitoes and other disease-carrying insects and rodents spread lethal viruses and bacteria over larger geographical regions, and harm agriculture by reducing rainfall in many food-producing areas while at the same time increasing flooding in others – any of which could contribute to mass migrations and wars over arable land, water, and other natural resources.

Biosecurity

Advances in genetics and biology over the last five decades have inspired a host of new possibilities – both positive and troubling.

With greater understanding of genetic material and of how physiological systems interact, biologists can fight disease better and improve overall human health. Scientists already have begun to develop bioengineered vaccines for common diseases such as dengue fever and certain forms of hepatitis. They are using these tools to develop other innovative medical solutions, including cells that have been bioengineered to serve as physiological "pacemakers." The mapping of the complete human genome in 2001 allows for even greater understanding of human functioning. As a consequence of the Human Genome Project, scientists have already identified more than 1,800 genes associated with particular diseases.

But along with their potential benefits, these technological advances raise the possibility that individuals or non-state actors could create dangerous known or novel pathogens. Additionally, researchers with the best intentions could inadvertently create new pathogens that could harm humans or other species. For example, in 2001, researchers in Australia reported that they had accidentally created a new, virulent strain of the mousepox virus while attempting to genetically engineer a more effective rodent control method.

Unlike the biological weapons of the last century, these new tools could create a limitless variety of threats from new types of "controlled" agents, to viruses that similes their hosts, to others that incapacitate whole systems within an organism. The wide availability of bioengineering knowledge and tools, along with the ease with which individuals can obtain specific fragments of genetic material (some can be ordered through the mail or over the internet), could allow these capabilities to find their way into unexpected hands or even those of backyard hobbyists. Such potential dangers are forcing scientists, institutions, and industry to develop self-governing mechanisms to prevent misuse. But developing a system to ensure the safe use of bioengineering, without impeding beneficial research and development, could pose the greatest international science and security challenge during the next 50 years.

You
can
help.

From a small publication founded and distributed by scientists who worked on the Manhattan Project, the Bulletin has become a 501 (c) (3) nonprofit communications organization that is a vital information network for people all over the world. More than 80 percent of the Bulletin's revenues are directed into program areas to organize, produce, and disseminate information needed by policy makers and citizens. Every gift to the Bulletin is tax deductible to the fullest extent allowable by law.

To learn more about supporting the Bulletin and the Clock Coalition, contact the Development office at 312.364.9710, ext 17, or write kgladish@thebulletin.org. Secure online donations can be made at www.turnbacktheclock.org or www.thebulletin.org.

"With a growing digital publishing program, expert forums, fellowships, and awards, the Bulletin has more ways to bring substance and clarity to public debates. We need it."
Stephen Hawking, Author and Scientist

"The Bulletin remains relevant today because of its persuasive insight into the range of causes for our eroding global security. Its iconic atomic clock now ticks more urgently than ever."
Cynthia Levine, President, American Society of Magazine Editors

"That the Bulletin is expanding its digital publishing can only mean good things for the level of our national debates and the clarity of our decisions."
William Perry, former U.S. Secretary of Defense

"Rigorously sober."
Chicago Tribune

"Scientists can be counted upon to continue searching for solutions and to keep deep channels of communication open among nations, great and small, in the hope that no government will misjudge the gravity of the world situation."
John A. Simpson, Bulletin co-founder

Join the Clock Coalition

Turn Back the Clock with facts, reason, and civic engagement.

Get regular updates about nuclear disarmament, climate change, and biotechnology around the world—and take action to advance efforts to improve global security.

Sign up now at www.turnbacktheclock.org.

Support the Clock Coalition

Cash or authorized credit: Make an online contribution through our secure portals at "www.turnbacktheclock.org" or "www.thebulletin.org", or send a check or credit authorization WITH YOUR EMAIL ADDRESS to the Bulletin of the Atomic Scientists, 77 W. Washington St., Suite 2120, Chicago, IL 60602.

Turn back the Clock

Thank you.

It is six minutes to midnight.

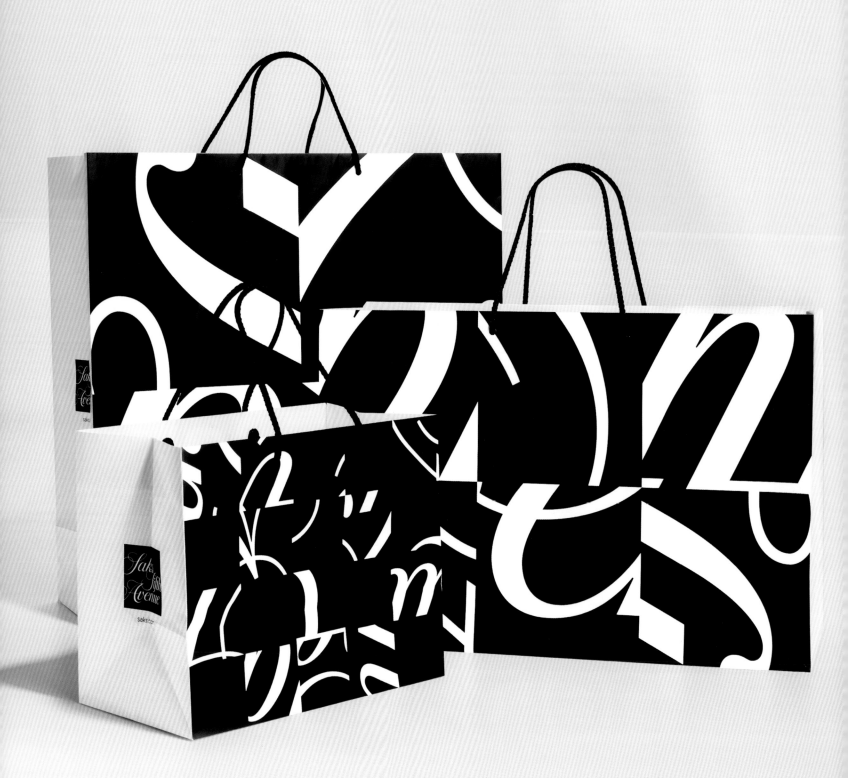

如何打造永恆時尚

薩克斯第五大道精品百貨
Saks Fifth Avenue

左圖
薩克斯百貨有將近六十款不同的提袋和紙盒，這歸功於設計出模組化的商標系統，讓每一款提袋和紙盒的圖案都能有所不同。

上圖
多年來，這間百貨已經換了四十幾個商標，最令人難忘的一個就是草寫的商標，最早出現於1940年代，並於1970年代修改得更加完善。

泰倫‧沙費爾（Terron Schaefer）對我說，我可以做任何我想做的事。薩克斯第五大道精品百貨成立於1924年，是紐約最大的零售百貨之一。沙費爾當年是這間百貨的行銷總監，他認為是時候讓這家店擁有全新的形象了。他給了我一張白紙。

我最不喜歡的就是從零開始。其他設計師總希望接到沒有任何限制的案子，但面對棘手的問題、歷史的包袱和難以妥協的底線時，我卻反而能做得很好。幸好，泰倫交給我的任務是一項誘人的挑戰。這間百貨十分自豪自身傳統和長年樹立的權威，同時，他們也銷售最新時尚。除了要融合永恆與潮流這兩項對立元素，他們也希望擁有辨識度極高的品牌形象，就像Tiffany的藍色盒子或是Burberry的格紋那樣。

我們試過各種方案。為百貨名稱換了幾十種不同的字體，看起來卻總是不太可靠。我們還嘗試使用旗艦店建築外觀的照片，但感覺十分老派。接著，我們又畫了一些新的圖形，結果依然令人沮喪，顯得太隨性。最後，泰倫發現我們已經精疲力盡，於是提出了一項建議。他說，很多人都還是很喜歡字體藝術家湯姆‧卡納塞（Tom Carnase）在1970年代創作的草寫商標。那是風格化的史賓賽體（Spencerian Script），十分華麗，在我看來已經過時，但我問團隊裡的設計師凱麗‧鮑威爾（Kerrie Powell）能不能稍微改造一下。當天下午，我在辦公室另一頭瞥了一眼凱麗的電腦螢幕，畫面中是那70年代商標的一小角，放大之後，看起來既新穎又充滿戲劇性，就像Nike的經典勾勾一樣。我意識到，這就是答案了。

解決設計問題和許多其他事情相同，都是先慢慢推進，最後一次收尾。我們把草寫商標分割成64個方塊。每個方塊都是戲劇化的抽象構圖，進而創造出幾乎是無限多的排列組合，非常適合包裝盒和紙袋。新的圖形語言立刻喚起了這間百貨的歷史，和他們對於新潮的永久承諾。對於薩克斯第五大道精品百貨而言，答案一直都在那裡。

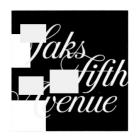

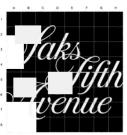

尋找「新」東西的時候，我們可以先問：是與什麼東西相比？比起為薩克斯百貨創作一個全新的商標，解構舊的商標更有效，也更能凸顯出變化。我們在紙袋及包裝盒底部印上完整的商標，這樣大家就能看懂袋側與外盒上的抽象印刷了。

上圖及右圖

藝術家喬·菲諾奇亞羅（Joe Finocchiaro）重新繪製了商標，看起來更輕盈、更優雅。薩克斯百貨希望新形象更加靈活，因此我們將商標拆解成64個方塊。團隊設計師珍娜·謝爾（Jena Sher）的未婚夫是耶魯大學物理學博士，他幫我們計算出這些正方形可以排列組合的形狀，已經快比已知宇宙中的粒子還要多。商標圖案被拆分成一格一格印製在紙盒上，看起來就像千鳥格紋。

左上圖
新圖樣與旗艦店的經典建築線條相得益彰。

左下圖
新圖樣在2007年推出，薩克斯百貨的櫥窗也跟著換上新外觀。就算沒有更換，消費者也很快就會將新圖樣和薩克斯百貨聯想在一起。

下圖
有些人看見新圖樣運用細節和黑白雙色碰撞出戲劇化的火花，就想起紐約派藝術家的作品，比如弗朗茨・克萊恩（Franz Kline）、巴尼特・紐曼（Barnett Newman）和艾爾斯沃茲・凱利（Ellsworth Kelly）。但我真正的靈感來源，是耶魯藝術學院教授諾曼・艾夫仕（Norman Ives）的字體排印拼貼。

下一跨頁
商標圖樣也呼應了百貨的地理特色，旗艦店在曼哈頓市中心占據了一整個街區。

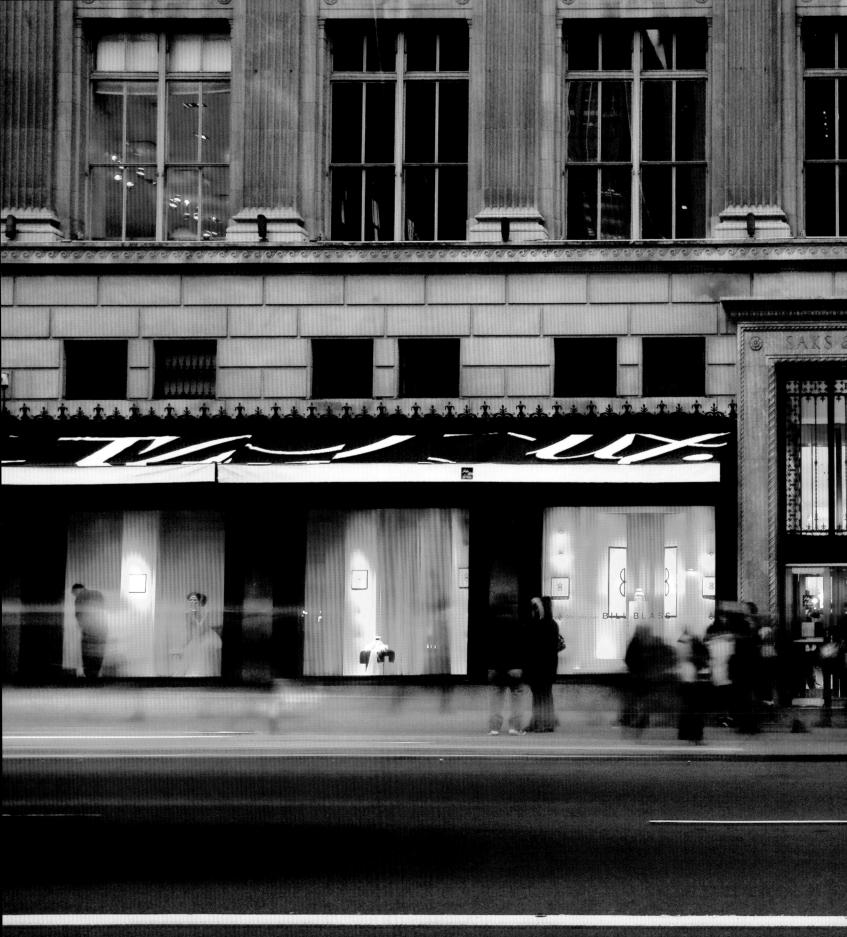

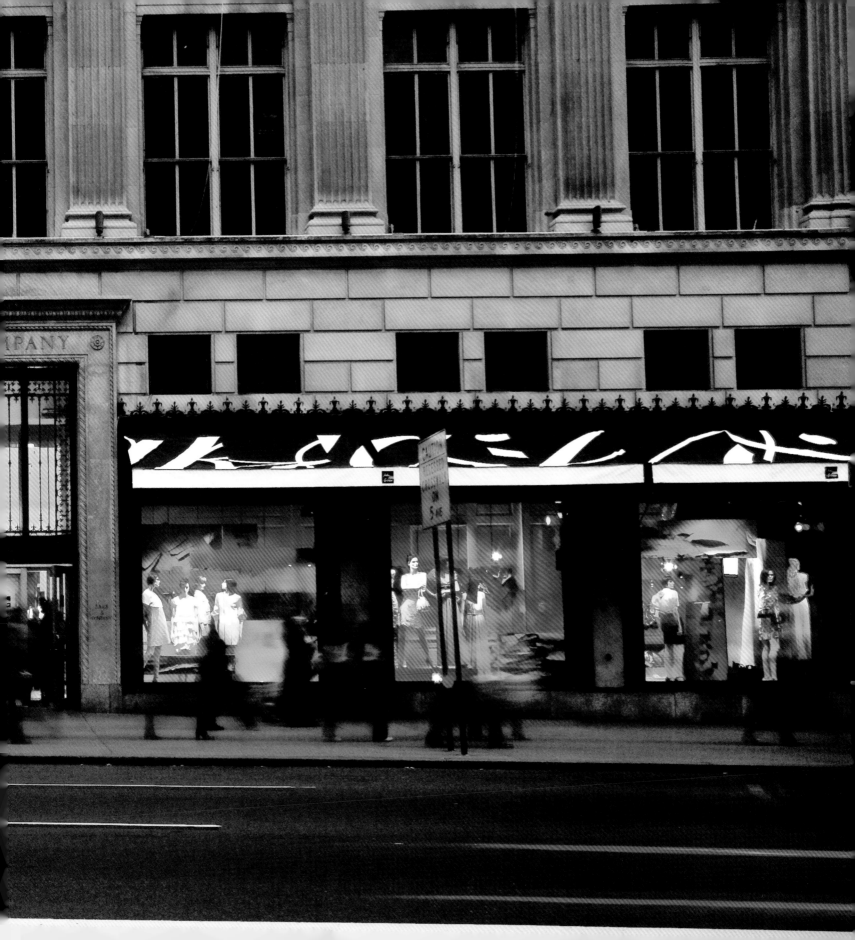

新的品牌形象明確建立之後，泰倫·沙費爾便展開了一系列季節活動，每個活動都有不同的主題。我們利用這個機會來延伸品牌的基本元素，其中某些元素固定不變，比如黑白配色及方形的格狀排列，但其他元素則能加以變化。這種手法既能翻新也能強化品牌的基本形象。

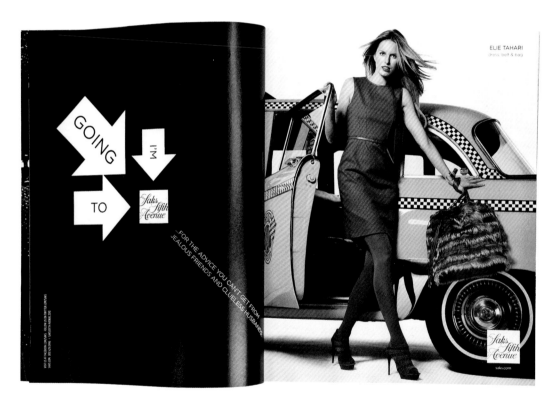

左圖
知名時尚攝影師安德斯·奧弗加德（Anders Overgaard）為2010年秋季「我要去薩克斯」活動掌鏡，讓模特兒用計程車、滑板等各種交通工具前往百貨。

右圖
這場活動的最終目的地就是薩克斯百貨，因此箭頭也在引導消費者前往店面。設計師珍妮佛·基農製作出錯綜複雜的圖案。

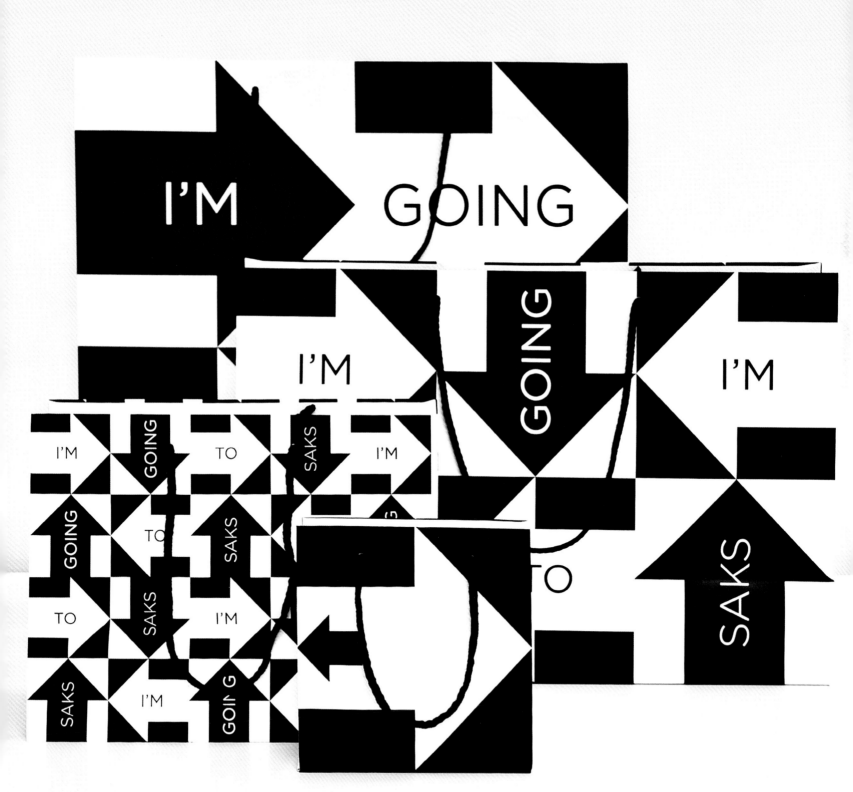

下圖
2010年春季活動「想想……」，靈感源自傳奇時尚編輯戴安娜·佛里蘭（Diana Vreeland）在《哈潑時尚》（*Harper's Bazaar*）的長期專欄〈何不……〉（Why don't you...）。主題中的十個字母，與薩克斯每年出版的十本型錄之一相互呼應。

右圖
五角星設計的珍妮佛·基農和傑西·里德（Jesse Reed）運用細小的剪影來渲染主題的排版，並將每本型錄與主題連結起來，包含動物圖案、鞋子、珠寶、男士配件等。

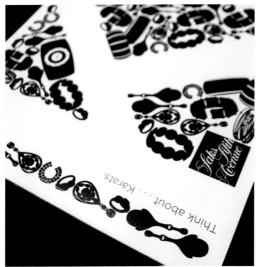

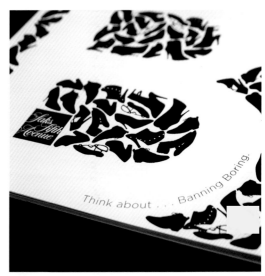

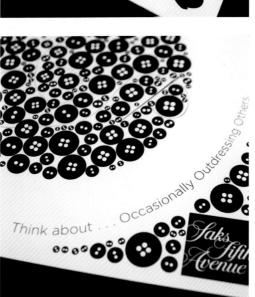

下圖及右圖
2011年百貨秋季活動「在薩克斯」反思了社群媒體的興起。喬・菲諾奇亞羅運用薩克斯的草寫字，打造了客製化的「@」符號。五角星設計的凱蒂・巴瑟隆納則將符號排列成各種催眠圖紋中使用。

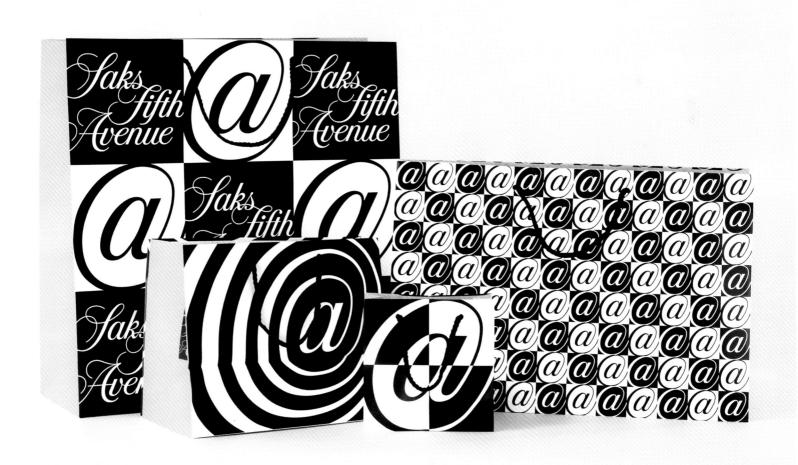

上圖、右圖及右頁
我們為薩克斯百貨做
的最後一個案子是
2013年的「LOOK」
活動，運用幾何字母
形式，可以堆疊、重
複或當成窗格。設計
師傑西・里德創造出
一連串的圖樣，就像
我們為薩克斯做的每
一次設計一樣，既能
拓展基本形象，又能
創造出多變的驚喜。

　　　　　　薩克斯第五大道精品百貨

如何跨文化

紐約大學阿布達比分校
New York University Abu Dhabi

左圖及上圖
這是一個前所未有的
挑戰，紐約大學在中
東的全新國際校區
需要前所未有的號召
力。我們徹底解構紐
約大學的火炬商標，
並融入都會與阿拉伯
風格。

2007年，充滿活力又直言不諱的紐約大學校長約翰·薩克斯頓（John Sexton）宣布了他的下一步願景——在世上第一個真正的全球之都設立他所謂的「世上第一所全球大學」。紐約大學阿布達比分校並不僅僅是一個典型的海外留學方案。它是一座完整的校園，學術設施和宿舍共占地40英畝，座落於阿布達比薩迪亞特島的文化區，預計要為兩千名師生提供服務，將西式博雅教育帶入這座新興的世界大都。

紐約大學是一所典型的都市大學，校區共有近一百棟建築，散落在紐約格林威治村和其他更遠的地帶。呼應著這座城市紛亂的活力，並沒有那種莊嚴的新喬治時代建築，周邊環繞的綠樹成蔭的廣場。正因如此，平面設計成為學校凝聚力，即使不是唯一，但一定是最重要的方式。我們與紐約大學合作多年，為他們法學院、史登商學院及瓦格納公共服務學院進行設計，也越來越欣賞他們校徽的凝聚力量，也就是那知名的火炬符號與紫色背景。現在，校徽的力量即將在阿布達比分校遭逢全新的考驗。紐約大學該如何運用設計，同時擁抱當地環境又能彰顯出他們的全球影響力呢？

一所教育機構的圖像資產通常是不可侵犯的。在這樣的情況下，如果既要彰顯學校原本的凝聚力，又要有所變化，最有效方式就是看看紐約大學的火炬能做些什麼運用。伊斯蘭藝術中典型的鮮豔色彩和催眠般的重複圖樣帶給我們啟發，於是我們擴展了大學的主題顏色，讓火炬旋轉並重複排列，創造出帶有阿拉伯風格的新圖樣。這個全新的圖樣能應用於印刷、網路和校區內，顯示出新校園既是紐約大學的一部分，也是阿布達比和整個世界的一部分。

左上圖
新色彩與紐約大學的紫色相得益彰，也希望能呼應而非複製伊斯蘭藝術中豐富的裝飾傳統。

右上圖
紐約大學阿布達比分校的新圖樣在校園書店中隨處可見。學校收到大量申請，幾乎已經跟哈佛一樣難錄取。

右圖
介紹新校園的招生手冊將兩種文化的圖樣相互搭配在一起。

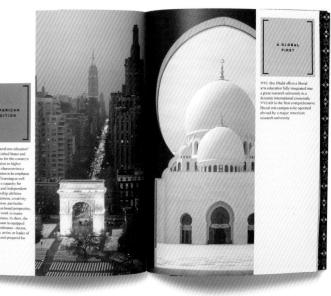

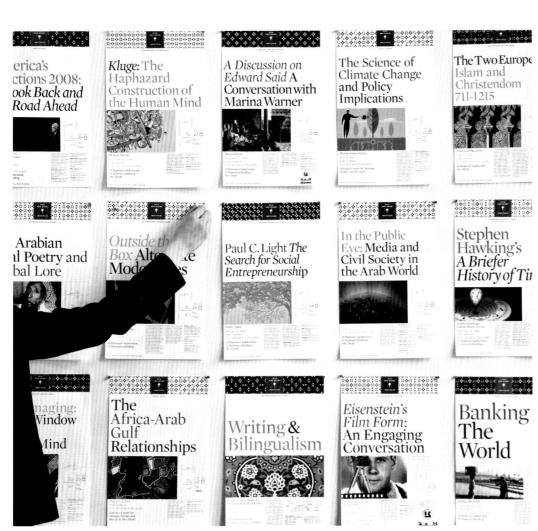

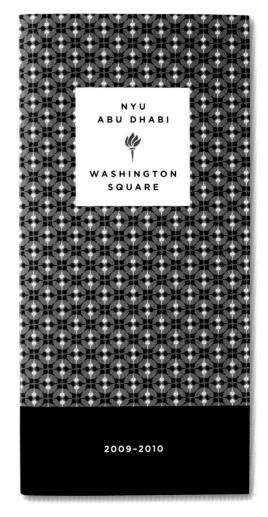

NYU
ABU DHABI

WASHINGTON
SQUARE

2009-2010

左上圖
紐約大學阿布達比分校尚未正式招募到學生，就已經啟動了一連串的穩健計畫，其中包含了座談、演講和研討會。

右上圖
紐約大學阿布達比分校支持約翰‧薩克斯頓的全球網絡願景，紐約校區中心華盛頓廣場也經常能看見他們的符號。

左圖
校園建築中裝飾著各種阿拉伯式浮凸花紋。

下一跨頁
五角星設計的圖樣設計師凱蒂‧巴瑟隆納為紐約大學阿布達比分校的一系列素材設計了一套複雜的格式，運用色彩、圖案和排版，打造出複雜又連貫的圖樣。

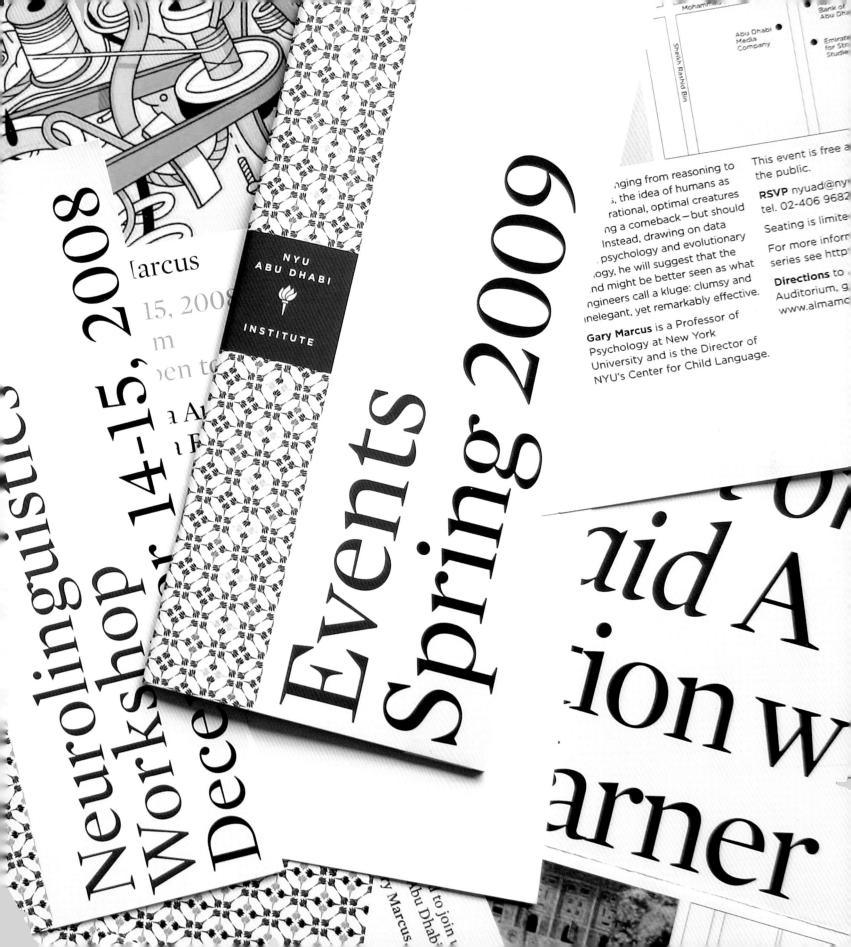

Neurolinguistics
Workshop 14-15, 2008

[arcus
15, 2008
m
pen to

a Al
F

NYU ABU DHABI INSTITUTE

Dece

Events
Spring 2009

...nging from reasoning to
..., the idea of humans as
...rational, optimal creatures
...ng a comeback—but should
... Instead, drawing on data
... psychology and evolutionary
...ogy, he will suggest that the
...nd might be better seen as what
...ngineers call a kluge: clumsy and
...inelegant, yet remarkably effective.

Gary Marcus is a Professor of
Psychology at New York
University and is the Director of
NYU's Center for Child Language.

This event is free a
the public.

RSVP nyuad@ny
tel. 02-406 9682

Seating is limite

For more inform
series see http:

Directions to
Auditorium, g
www.almamc

nid A
ion w
arner

如何在教堂舉止合宜

聖約翰座堂
The Cathedral Church of St. John the Divine

左圖
為了整合聖約翰座堂
的風格，打造出難出
其右的獨特性，我
們請字體設計師喬·
菲諾奇亞羅重新將
1928年的Black letter
字體繪製為他們的專
屬字體，並命名為「
神聖」。

上圖
位於曼哈頓上西區的
座堂已陸續建造了一
百多年，至今仍未完
工，是紐約最受歡迎
的地標之一。

每個組織想要建立形象時，通常會認為他們需要一個商標。但這其實就像你以為戴頂帽子就會很有個性一樣。你的外在確實有可能是一種身分指標，但這並非唯一的指標。更重要的應該是你說的話以及你如何表達，當然，最重要的是你的作為。

聖約翰座堂的作為就十足非凡。這是世上第四大基督教堂建築，於1891年動工，從未正式完工。中殿高達124英尺，是紐約遊客的必訪之地。但聖約翰座堂也不是只有美麗的哥德式建築，他們還舉辦音樂會、藝術展覽和各項活動。他們的廚房每年供應25000份餐點。來自不同信仰的人們，在每週30場禮拜中一起敬拜。有什麼方式，可以表現這座超過120年的石建築，既是21世紀最充滿活力，也是許多人生活中不可或缺的一部分呢？

我們十分著迷於古老石材和當代生活的結合，希望能找到方法，來重現遊客穿越宏大的西側大門時所經歷的那種驚喜之感。剛開始，我們嘗試十足現代的手法，甚至想加入幽默的風格。但後來，我們改變整體風格，把舊字體修改為新的版本，命名為「神聖」（Divine）。舊字體是佛雷德利·古迪（Frederic Goudy）1928年創作的Blackletter字體，參考古騰堡四十二行聖經中的字體，而我們將之重新數位化。我們藉由歷史形式與當代內容之間的對比，呼應了建築與內在意涵間的相對與共生關係。

我的老闆馬西莫·維涅里曾引用過一句義大利諺語：「我在此言說，亦在此否認。」人很複雜，組織也是如此。平面設計能綜合多種元素，有時甚至能將矛盾的事物融合在一起，這樣的能力始終令我感到驚奇。

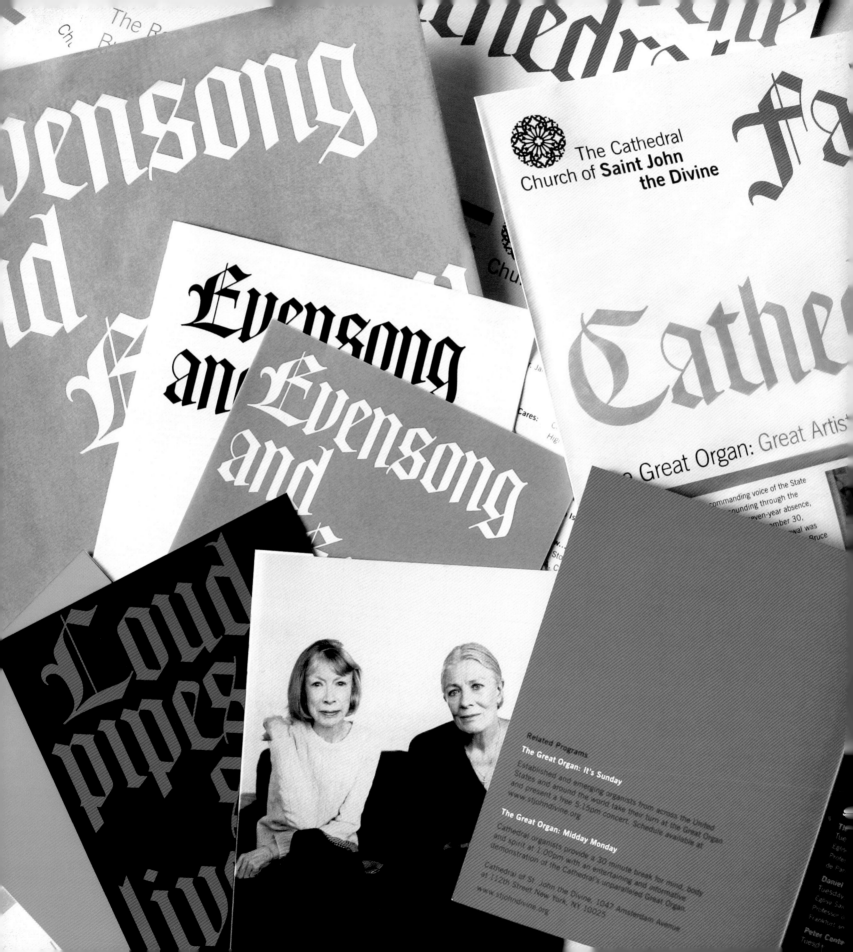

左圖
聖約翰座堂的文宣結
合了當代的語言、生
動的排版、明亮的配
色,以及百年歷史的
字體。

下圖
座堂的商標源自於他
們令人驚豔的玫瑰花
窗,是全美國最大的
一面。相較之下,座
堂的名稱則採用簡單
的無襯線字體書寫,
並巧妙地強調了他們
的簡稱。

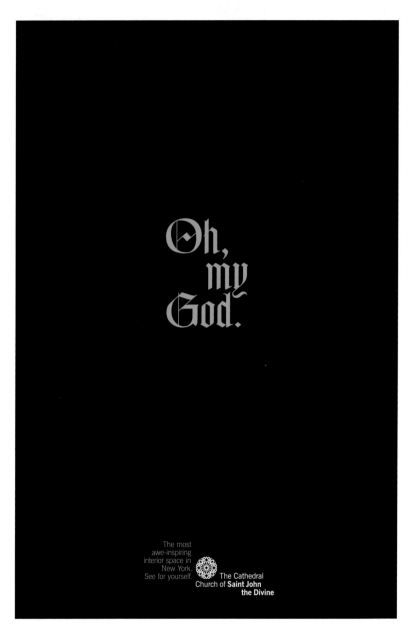

The most
awe-inspiring
interior space in
New York.
See for yourself.

The Cathedral
Church of **Saint John**
the Divine

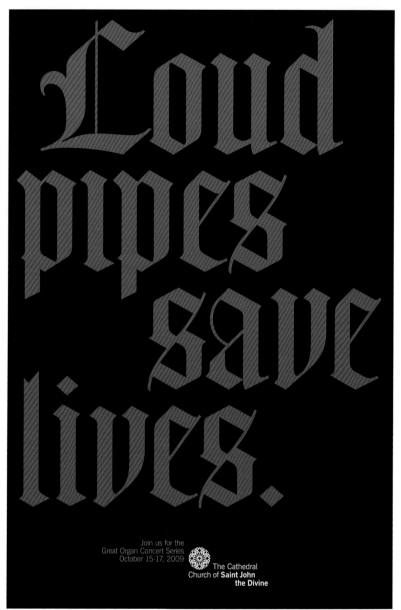

Join us for the
Great Organ Concert Series
October 15-17, 2009

The Cathedral
Church of **Saint John**
the Divine

上圖
2001年末，一場大
火蔓延至座堂內部大
部分的區域，他們因
此進行了百年來首次
翻修。重新開放時，
座堂已經恢復了往日
的宏偉，遊客也總是
發出讚歎。

上圖
「管風琴」系列活動
是這個場域舉辦的眾
多音樂展演之一。
海報上的這句標語「
大聲的管子，拯救生
命」（Loud pipes
save lives），本來
是哈雷重機騎士常用
的口號。

聖約翰座堂

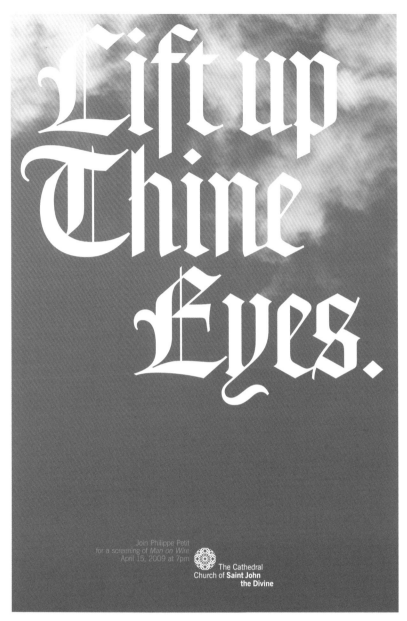

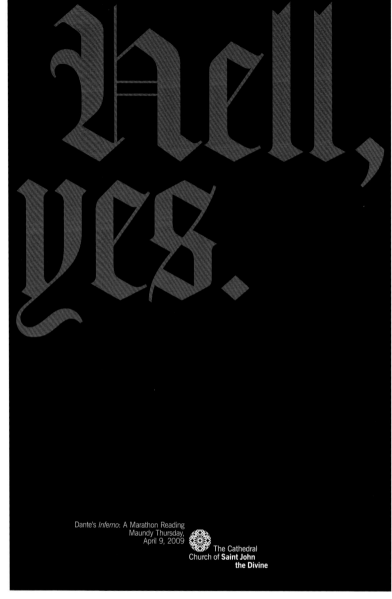

上圖
1982年以來，鋼索大師菲利普‧珀蒂（Philippe Petit）一直是座堂的常駐藝術家，他的傳記電影《偷天鋼索人》（*Man on Wire*）在座堂公益放映，圖為映演宣傳海報。

上圖
復活節前的濯足節，座堂都會舉辦一年一度的但丁（Dante）《神曲地獄篇》（*Inferno*）的馬拉松讀書會。圖為宣傳海報。

右圖
座堂於2012年舉辦「水的價值」展覽，我們用液體形式渲染了古迪的哥德體。

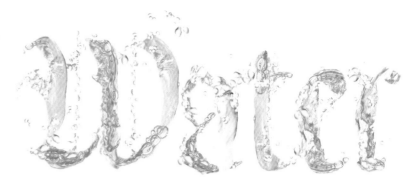

左圖
座堂的平面設計也被運用在數位介面上，包含電腦網頁與手機版網頁。

右圖
聖約翰座堂的公關總監麗莎・舒伯特（Lisa Schubert）總是尋找各種機會帶給來訪者驚喜。每年的聖方濟瞻禮，座堂都會舉行傳統的動物祈福。而我們為活動製作了紀念T恤。

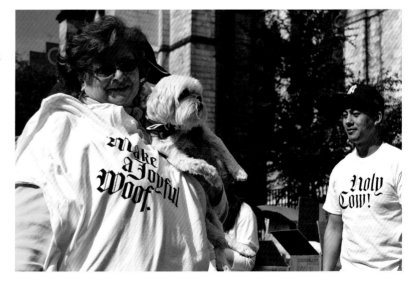

聖約翰座堂

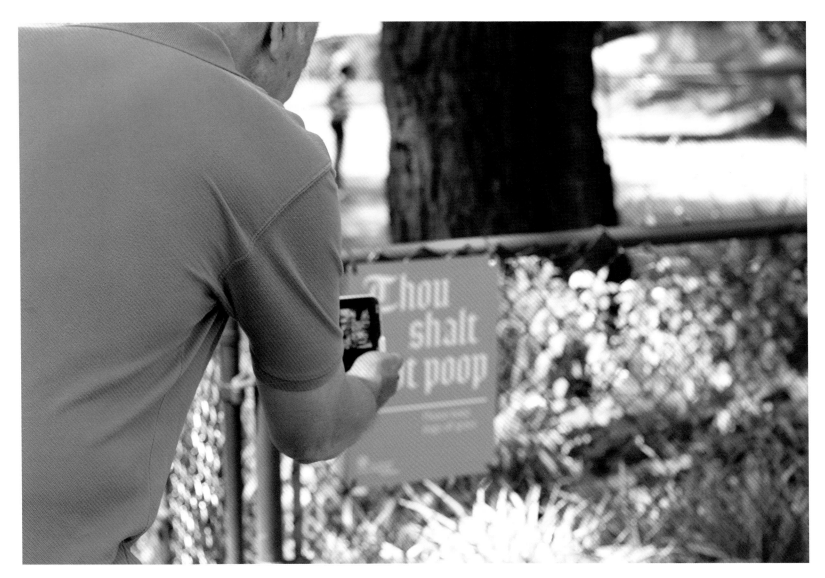

上圖及左圖
給狗狗看的十誡？我
和五角星設計的傑
西‧里德一起設計了
這個告示，提醒遊客
要愛護座堂的草地，
而告示本身也變成了
座堂內的拍照景點
之一。

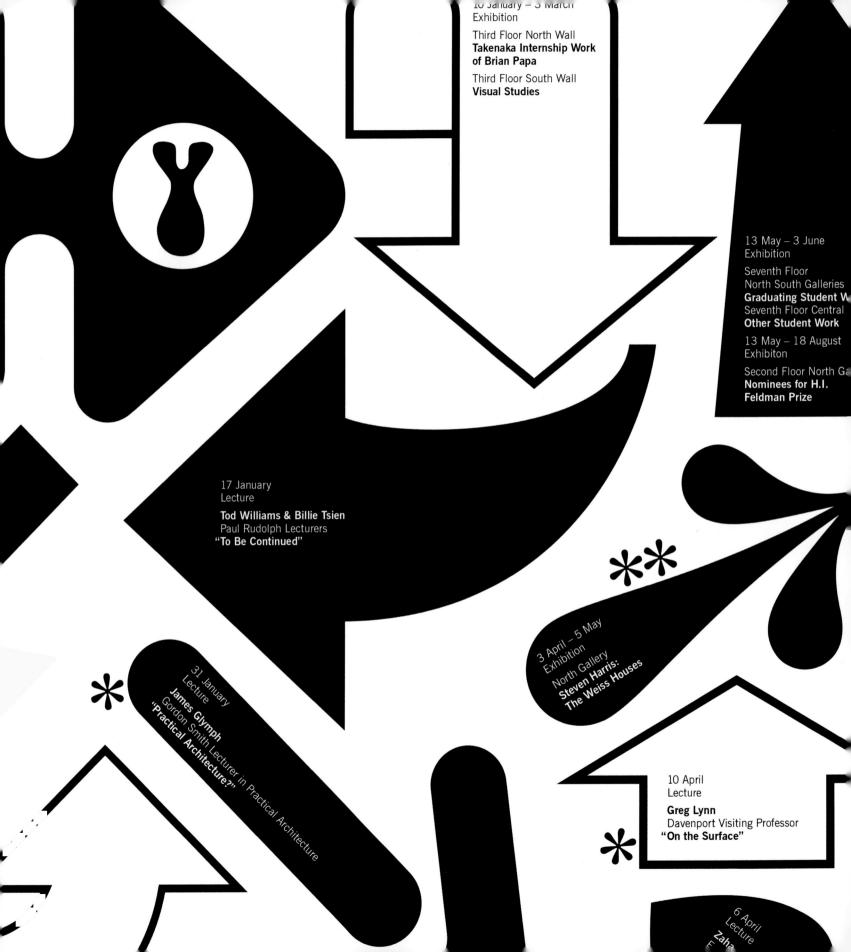

10 January – 3 March
Exhibition

Third Floor North Wall
**Takenaka Internship Work
of Brian Papa**

Third Floor South Wall
Visual Studies

13 May – 3 June
Exhibition

Seventh Floor
North South Galleries
Graduating Student W
Seventh Floor Central
Other Student Work

13 May – 18 August
Exhibiton

Second Floor North Ga
**Nominees for H.I.
Feldman Prize**

17 January
Lecture

Tod Williams & Billie Tsien
Paul Rudolph Lecturers
"To Be Continued"

31 January
Lecture
James Glymph
Gordon Smith Lecturer in Practical Architecture
"Practical Architecture?"

3 April – 5 May
Exhibition

North Gallery
**Steven Harris:
The Weiss Houses**

10 April
Lecture

Greg Lynn
Davenport Visiting Professor
"On the Surface"

6 April
Lecture

Zaha

如何讓建築師迷失方向

耶魯大學建築學院
Yale University School of Architecture

左圖
耶魯的海報使用了數百種字體，但只有一種顏色：黑色。

上圖
在我們最初交給勞勃‧史騰的提案中，對照了他們希望的古典主義，與我們想採用的折衷風格。

「我想要出人意表。」

大家都拿放大鏡檢視勞勃‧史騰，他也知道。當時他是耶魯大學建築學院新上任的院長，他本身也是這所學院1965年的畢業生。大家對他的期望很高，當然也有諸多懷疑。他曾是耶魯學生雜誌《透視》（*Perspecta*）的編輯，與羅伯特‧文丘里、丹尼絲‧史考特‧布朗等人同為早期激進的後現代主義理論提倡者。畢業後，他持續以理想主義的年輕設計師身分，在紐約實踐自己的理念。

過了35年，他成為世上最成功的建築師之一，無論是替富豪設計木瓦式（Shingle Style）的度假屋，又或者為大學校園打造細膩的喬治時代復興風格（Georgian Revival）宿舍，他都游刃有餘。但史騰如此擅長掌握建築歷史語言，在某些擁抱現代主義的同業看來卻是個危險的訊號，已經有人將他斥為「從新興郊區冒出來的嬉皮土豪」。他能將耶魯大學打造為21世紀的布雜藝術上流學校嗎？

史騰樂於顛覆一般人預期的前景。1999年時，他告訴我，這所學校已經沉寂太久，墨守成規，沒有什麼記憶點。他大刀闊斧地規畫了許多場演講、展覽和研討會，內容既複雜又充滿各式衝突的觀點，接著他請我做平面設計，藉此向全球宣傳這些新計畫。這是一項令人生畏的挑戰。史騰前一個類似的案子是他在哥倫比亞大學（Columbia University）時做的，瑞士設計師威利‧昆茲（Willi Kunz）為他設計的一系列海報非常有名，整個專案只使用了一種字體，也就是「Univers」。這種字體辨識度極高，而且難以匹敵。那麼，究竟還有什麼字體能概括史騰靈活的折衷主義？

回想起來，答案似乎顯而易見。我說，我們不僅不該使用單一字體，在整個案子中，我們也不要重複使用相同字體。我們設計的這套平面系統，透過多樣性來達到一致性。15年過去了，我們為耶魯建築學院設計的海報至今仍讓我感到驚豔，而且過程中，我還採用了許多我可能再也不會使用的字體，比如1942年勞勃‧史密斯（Robert E. Smith）創造的「Brush Script」。

右圖及右頁
史騰藉由每年舉辦成
千上百種活動，強調
互相碰撞的多元觀
點，把耶魯建築學院
變成一座交流互動的
溫室。

下一跨頁
學校每年都會用海報
公布秋季與春季的活
動計畫。我們能找到
多少種不同的方式來
呈現相同的資訊呢？

Yale School of Architecture

Lectures and Exhibitions
Fall 2000

A&A Building
180 York Street
New Haven, CT
Phone: 203.432.2889
Email: architecture.pr@yale.edu

Lectures begin at 6:30 PM in
Hastings Hall — located on
the basement floor. Doors Open
to the General Public at 6:15 PM

Exhibition hours are
Monday through Saturday,
10:00 AM to 5:00 PM.
Main, North, and South Galleries
are located on the second floor.

Cesar Pelli: Building Designs 1965-2000
Exhibition: Main, North and
South Galleries
September 5 - November 3

Bernard Cache [2]
September 7
"Current Work"

Marion Weiss and Michael Manfredi
Paul Rudolph Lecture
September 11
"Site Specific"

Steven Holl [2]
September 14
"Parallax"

Dietrich Neumann
September 18
"Architecture of the Night"

Douglas Garofalo
Bishop Visiting Professor
September 25
"Materials, Technologies, Projects"

Elizabeth Diller [2]
September 28
"Blur — Babble"

Herman D. J. Spiegel
Myriam Bellazoug Lecture
October 2
"Gaudi's Structural Expression and
Its Implications for Architectural
Education"

William McDonough [1,2]
October 5
"Future Work"

Hon. Anthony Williams [3]
Mayor, Washington, D.C.
Eero Saarinen Lecture
October 6
"Recasting the Shadows: The District
in the Twenty-First Century"

Richard Sennett [3]
Roth-Symonds Lecture
October 7
"Urbanism and the New Capitalism"

Aaron Betsky
October 9
"Architecture Must Burn"

Julie Bargmann [1]
October 12
"Toxic Beauty: Regenerating
the Industrial Landscape"

Beatriz Colomina [2]
October 23
"Secrets of Modern Architecture"

Ken Yeang [1]
October 26
"The Ecological Design of
Large Buildings and Sites:
Theory and Experiments"

Charles Jencks
Brendan Gill Lecture
October 30
"The New Paradigm in Architecture"

Craig Hodgetts and Ming Fung [2]
Saarinen Visiting Professors
November 2
"By-products: Form Follows Means"

Kathryn Gustafson
Timothy Lenahan Memorial Lecture
November 6
"European and American
Landscape Projects 1984-2000"

Jacques Herzog [2]
November 9
"Architecture by Herzog & de Meuron"

Ignacio Dahl Rocha
November 13
"Learning From Practice:
the Architecture of
Richter and Dahl Rocha"

The British Library
Colin St. John Wilson & M. J. Long
Exhibition: Main Gallery
November 13 - December 15

(a)way station
a project by KW:a
Paul Kariouk & Mabel Wilson
Exhibition: North Gallery
November 13 - December 15

in.formant.system
Douglas Garofalo
Exhibition: South Gallery
November 13 - December 15

Max Fordham and Patrick Bellew [1]
November 16
"Labyrinths and Things"

Barry Bergdoll
November 20
"Siting Mies: Nature and Consciousness
in the Modern House"

Richard Foreman [1]
November 30
"Landscape, Ecology and
Road System Ecology: Foundation
for Meshing Nature and People
So They Both Thrive"

1 These lectures are part of "Issues in Environment and Design"
seminar given in collaboration with Yale School of Forestry and
Environmental Studies.

2 These lectures are part of "The Millennium House" seminar.

3 These lectures are part of "Next Cities" symposium.

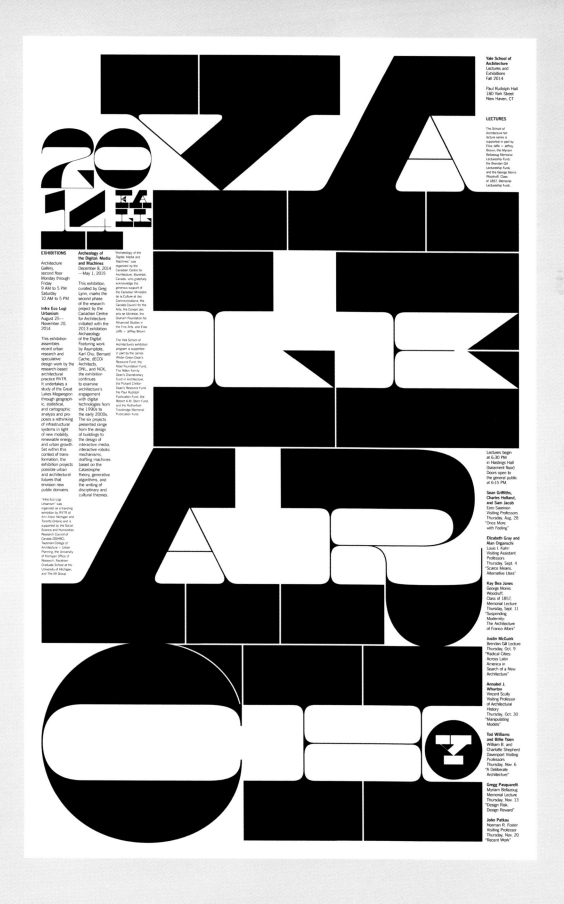

Yale School of
Architecture
Lectures and
Exhibitions
Fall 2014

Paul Rudolph Hall
180 York Street
New Haven, CT

LECTURES

The School of
Architecture fall
lecture series is
supported in part by
Elise Jaffe + Jeffrey
Brown, the Myriam
Bellazoug Memorial
Lectureship Fund;
the Brendan Gill
Lectureship Fund;
and the George Morris
Woodruff, Class
of 1857, Memorial
Lectureship Fund.

EXHIBITIONS

Architecture
Gallery,
second floor
Monday through
Friday
9 AM to 5 PM
Saturday
10 AM to 5 PM

**Infra Eco Logi
Urbanism**
August 25—
November 20,
2014

This exhibition
assembles
recent urban
research and
speculative
design work by the
research-based
architectural
practice RVTR.
It undertakes a
study of the Great
Lakes Megaregion
through geograph-
ic, statistical,
and cartographic
analysis and pro-
poses a rethinking
of infrastructural
systems in light
of new mobility,
renewable energy,
and urban growth.
Set within this
context of trans-
formation, the
exhibition projects
possible urban
and architectural
futures that
envision new
public domains.

"Infra Eco Logi
Urbanism" was
organized as a traveling
exhibition by RVTR of
Ann Arbor Michigan and
Toronto Ontario and is
supported by the Social
Science and Humanities
Research Council of
Canada (SSHRC),
Taubman College of
Architecture + Urban
Planning, the University
of Michigan Office of
Research, Rackham
Graduate School at the
University of Michigan,
and The MI Group.

**Archeology of
the Digital: Media
and Machines**
December 8, 2014
—May 1, 2015

This exhibition,
curated by Greg
Lynn, marks the
second phase
of the research
project by the
Canadian Centre
for Architecture
initiated with the
2013 exhibition
Archaeology
of the Digital.
Featuring work
by Asymptote,
Karl Chu, Bernard
Cache, dECOi
Architects,
ONL, and NOX,
the exhibition
continues
to examine
architecture's
engagement
with digital
technologies from
the 1990s to
the early 2000s.
The six projects
presented range
from the design
of buildings to
the design of
interactive media,
interactive robotic
mechanisms,
drafting machines
based on the
Catastrophe
theory, generative
algorithms, and
the writing of
disciplinary and
cultural theories.

"Archeology of the
Digital: Media and
Machines" was
organized by the
Canadian Centre for
Architecture, Montréal,
Canada, who gratefully
acknowledges the
generous support of
the Canadian Ministère
de la Culture et des
Communications, the
Canada Council for the
Arts, the Conseil des
arts de Montréal, the
Graham Foundation for
Advanced Studies in
the Fine Arts, and Elise
Jaffe + Jeffrey Brown.

The Yale School of
Architecture's exhibition
program is supported
in part by the James
Wilder Green Dean's
Resource Fund, the
Kibel Foundation Fund,
The Nitkin Family
Dean's Discretionary
Fund in Architecture,
the Pickard Chilton
Dean's Resource Fund,
the Paul Rudolph
Publication Fund, the
Robert A.M. Stern Fund,
and the Rutherford
Trowbridge Memorial
Publication Fund.

Lectures begin
at 6:30 PM
in Hastings Hall
(basement floor)
Doors open to
the general public
at 6:15 PM.

**Sean Griffiths,
Charles Holland,
and Sam Jacob**
Eero Saarinen
Visiting Professors
Thursday, Aug. 28
"Once More
with Feeling"

**Elizabeth Gray and
Alan Organschi**
Louis I. Kahn
Visiting Assistant
Professors
Thursday, Sept. 4
"Scarce Means,
Alternative Uses"

Kay Bea Jones
George Morris
Woodruff,
Class of 1857,
Memorial Lecture
Thursday, Sept. 11
"Suspending
Modernity:
The Architecture
of Franco Albini"

Justin McGuirk
Brendan Gill Lecture
Thursday, Oct. 9
"Radical Cities:
Across Latin
America in
Search of a New
Architecture"

**Annabel J.
Wharton**
Vincent Scully
Visiting Professor
of Architectural
History
Thursday, Oct. 30
"Manipulating
Models"

**Tod Williams
and Billie Tsien**
William B. and
Charlotte Shepherd
Davenport Visiting
Professors
Thursday, Nov. 6
"A Deliberate
Architecture"

Gregg Pasquarelli
Myriam Bellazoug
Memorial Lecture
Thursday, Nov. 13
"Design Risk,
Design Reward"

John Patkau
Norman R. Foster
Visiting Professor
Thursday, Nov. 20
"Recent Work"

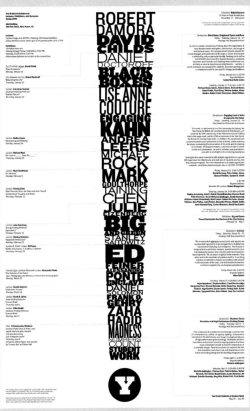

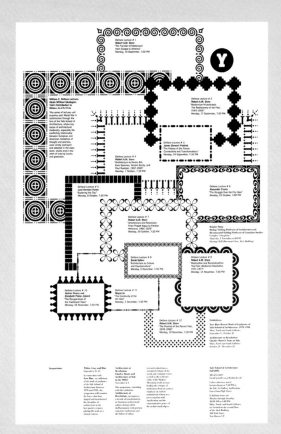

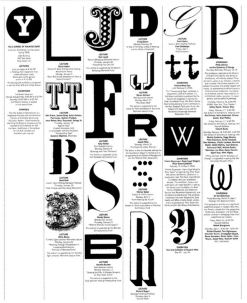

Yale School of Architecture
Lectures, Exhibitions, Symposia
Spring 2006

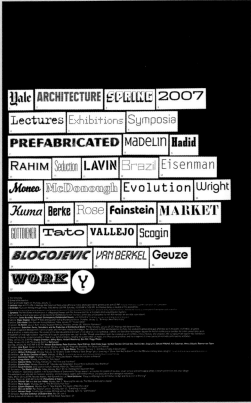

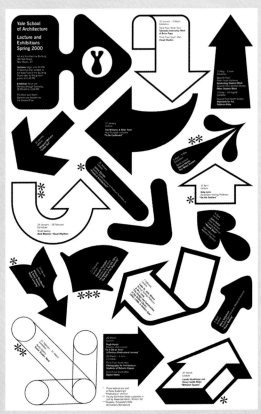

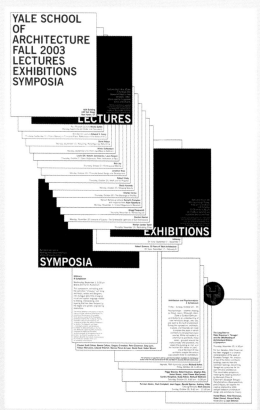

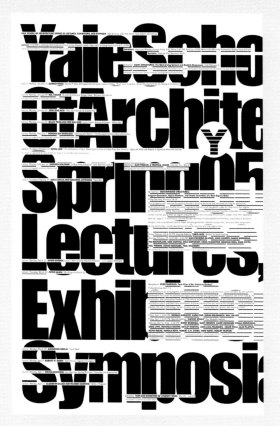

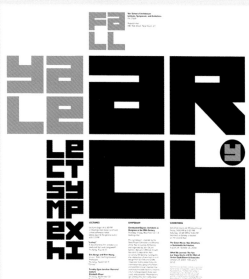

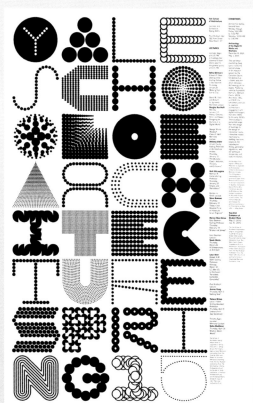

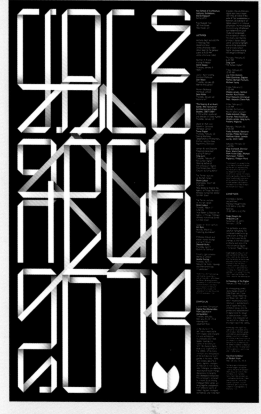

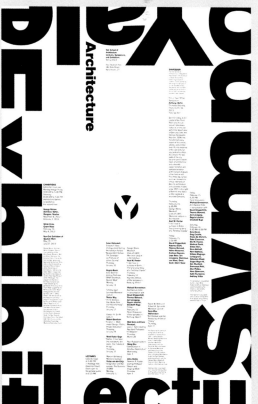

右圖及右頁
設計研討會海報時，是個直接參考特定主題的機會，比如城市生活密度、查爾斯‧摩爾的建築作品、拉斯維加斯街道商標、失落的繪畫藝術，或是喬治‧尼爾森（George Nelson）的影響等。

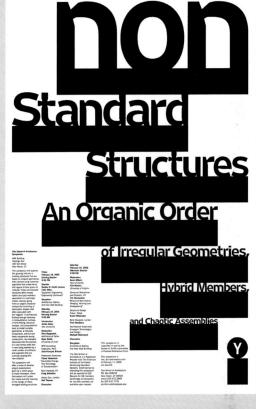

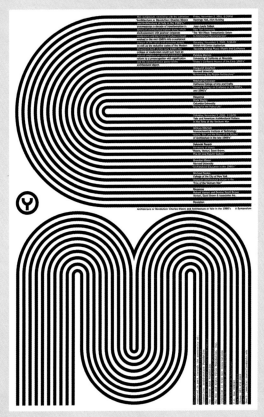

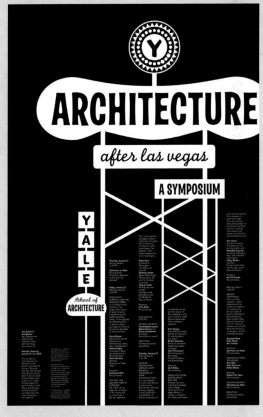

耶魯大學建築學院

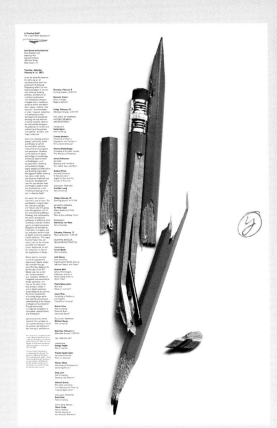

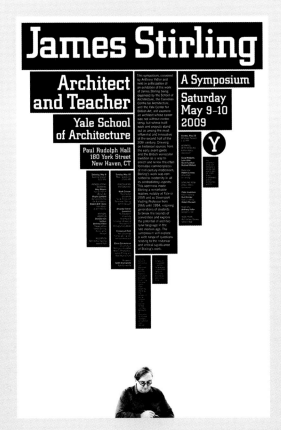

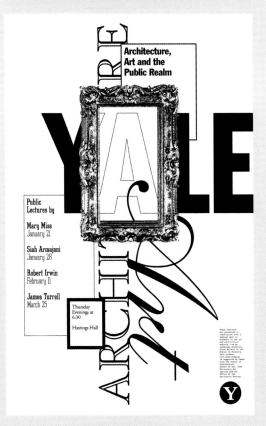

右圖及右頁
耶魯每年都會為有意
就讀建築系的學生舉
辦一場開放參觀活
動。這些活動海報
翻玩字母「Y」的幾
何形狀,或以字母
「O」傳達開放邀請
之意。

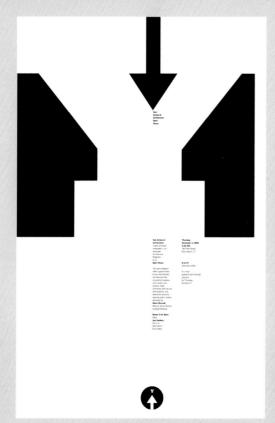

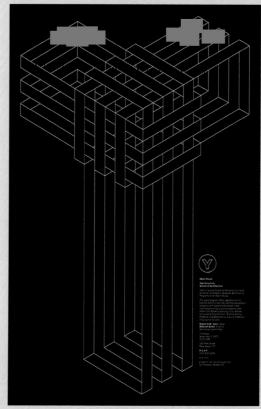

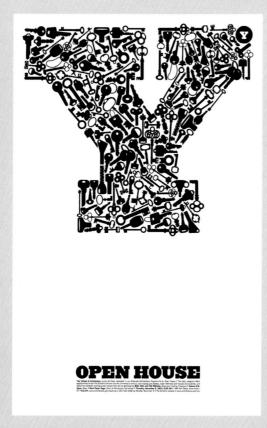

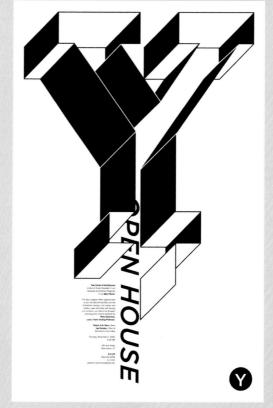

耶魯大學建築學院

右圖
我們的耶魯客戶非常寬容。我們其中一張提案海報從頭到尾只使用了最小尺寸的文字，再用粗體和底線等來強調重點資訊，他們默許這樣的手法，只有禮貌地要求我們以後不要再這樣做。

Y A L E S C H O O L O F A R C H I T E C T U R E
Lectures, Symposia, Special Events, and Exhibitions • Fall 2012
Paul Rudolph Hall, 180 York Street, New Haven, CT
L E C T U R E S
Lectures begin at 6:30 PM in Hastings Hall (basement floor). Doors open to the general public at 6:15 PM.
Thursday, August 30 • Peter Eisenman • "Palladio Virtuel: Inventing the Palladian Project"
Thursday, September 6 • Amale Andraos and Dan Wood • "Nature-City"
Thursday, September 13 • Tom Wiscombe, Louis I. Kahn Visiting Assistant Professor • "Composite Thinking"
Thursday, September 20 • Diana Balmori, William Henry Bishop Visiting Professor, and Joel Sanders • "Between Landscape and Architecture"
Thursday, October 4 • Paul Rudolph Lecture • Brigitte Shim • "Ways of Seeing Sound: The Integral House" • Opening lecture of the symposium "The Sound of Architecture"
Friday, October 5 • Elizabeth Diller • "B+/A−" • Keynote to the symposium "The Sound of Architecture"
Thursday, October 11 • Keller Easterling • "The Action is Form"
Thursday, November 1 • Brendan Gill Lecture • Panel Discussion • Mary Ann Caws, Jean-Louis Cohen, Beatriz Colomina, Peter Eisenman, Mark Jarzombek, Kevin Repp • "The Eisenman Collection: An Analysis"
Thursday, November 8 • Billie Tsien and Tod Williams, William B. and Charlotte Shepherd Davenport Visiting Professors • "The Still Place"
Friday, November 9 • Marc Newson with Edward S. Cooke, Jr. • "A Conversation" • Keynote to the symposium • "George Nelson: Design for Living, American Mid-Century Design and Its Legacy Today"
Thursday, November 15 • Eero Saarinen Lecture • Dr. Richard Jackson • "We Shape Our Buildings; They Shape Our Bodies"
The School of Architecture fall lecture series is supported in part by Elise Jaffe + Jeffrey Brown, the Brendan Gill Lectureship Fund, the Paul Rudolph Lectureship Fund, and the Eero Saarinen Visiting Professorship Fund.
S Y M P O S I A
Thursday–Saturday, October 4–6, 2012 • The J. Irwin Miller Symposium • THE SOUND OF ARCHITECTURE • Hastings Hall (basement floor) unless otherwise noted
Architecture is not tone deaf: It can create silent places and eddies of noise, deeply affecting our experience and facilitating or frustrating communication. Buildings have long been thought of in visual and practical terms, leaving their aural dimension largely unconsidered. Today, the ways we listen in built spaces have been transformed by developments in media, music, and art. New design tools are helping architects shape the soundscapes of their buildings, while new audio technologies afford access to previously undetected sonic environments. This symposium will draw on a variety of disciplinary expertise in its quest for an understanding of architecture as an auditory environment. Leading scholars from fields as diverse as archeology, media studies, musicology, philosophy, and the history of technology will converge to discuss critical questions alongside major architects, acoustical engineers, composers, and artists. This symposium aims to stake out a new set of questions for ongoing scholarly inquiry and to reaffirm architecture as a place of convergence among old and emerging disciplines.
Thursday, October 4, 6:30 PM • Brigitte Shim • "Ways of Seeing Sound: The Integral House"
Friday, October 5, 9:00 AM–6:00 PM • Dorothea Baumann, Barry Blesser, Mario Carpo, Carlotta Darò, Ariane Lourie Harrison, Craig Hodgetts, Mark Jarzombek, Randolph Jordan, Brian Kane, Graeme Lawson, Ingram Marshall, Raj Patel, John Durham Peters, Linda-Ruth Salter, Joel Sanders, Jonathan Sterne, Peter Szendy, Jack Vees, Beat Wyss
Friday, October 5, 6:30 PM • Keynote Address • Elizabeth Diller • "B+/A−"
Saturday, October 6, 9:30 AM–3:30 PM • Whitney Humanities Center • 53 Wall Street • Michelle Addington, Niall Atkinson, Timothy Barringer, Joseph Clarke, J.D. Connor, Veit Erlmann, Brandon LaBelle, Alexander Nemerov, John Picker, William Rankin, Karen Van Lengen, Sabine von Fischer
Friday–Saturday, November 9–10, 2012 • GEORGE NELSON: DESIGN FOR LIVING, AMERICAN MID-CENTURY DESIGN AND ITS LEGACY TODAY • Hastings Hall (basement floor)
Coinciding with the exhibition "George Nelson: Architect, Writer, Designer, Teacher" at the School, this symposium will examine the work of the designer George Nelson in the context of his time and the legacy of mid-century modern design today. Nelson and his contemporaries (among them Edward Wormley, Eero Saarinen, Harry Bertoia, Charles and Ray Eames, Jens Risom, and Florence Knoll) helped to evolve the Bauhaus aesthetic into a more colorful, playful, technically savvy, and versatile idiom evocative of the American lifestyle in the mid-century. From the Marshmallow Sofa for Herman Miller to the multimedia extravaganza "Visions of the U.S.A.," designed for the 1959 Sokolniki Park exhibition in Moscow, Nelson's highly collaborative approach to design has had a lasting influence. The challenges and opportunities that framed and inspired Nelson's work are matched by the paradigm shifts contemporary designers face today.
Friday, November 9, 2:00 PM–6:00 PM • Kurt W. Forster, John Stuart Gordon, John Harwood, Juliet Kinchin, Murray Moss, Dietrich Neumann, Margaret Maile Petty, Kristina Wilson
Friday, November 9, 6:30 PM • Keynote Address • Marc Newson with Edward S. Cooke, Jr • "A Conversation"
Saturday, November 10, 9:30 AM–4:00 PM • Donald Albrecht, Ralph Caplan, Beatriz Colomina, Jochen Eisenbrand, Rob Forbes, Paul Makovsky, Christopher Pullman, Alice Rawsthorne, Jane Thompson
"The Sound of Architecture" is supported by the J. Irwin Miller Endowment Fund. "George Nelson: Design for Living, American Mid-Century Design and Its Legacy Today" is supported in part by the generosity of the Edward and Dorothy Clarke Kempf Fund. The Yale School of Architecture is a Registered Provider with The American Institute of Architects Continuing Education Systems. Credit earned by attending these symposia will be reported to CES Records for AIA members. Certificates of Completion for non-AIA members are available upon request.
S P E C I A L E V E N T
Friday–Saturday, November 30–December 1, 2012 • YALE WOMEN IN ARCHITECTURE: A REUNION AND CELEBRATION OF THE 30TH ANNIVERSARY OF THE SONIA SCHIMBERG AWARD
This first-ever gathering of the alumnae of the Yale School of Architecture will celebrate the accomplishments of women architects across the years and mark the 30th anniversary of the Sonia Albert Schimberg Award. Sonia Albert (M.Arch. 1950) was one of two women architecture graduates that year and her daughters created the award in her memory to recognize the most promising woman graduate each year. The gathering will present and discuss the legacy of women graduates of Yale and take stock of the current conditions in architecture and related fields. Topics include the roles of client and architect, social change, shifting and enlarging the definition of practicing and teaching architecture. Alumnae spanning over 30 years of graduating classes as well as current students and experts from other disciplines, will participate in the program. Come and take part in helping to shape the future for Yale women in architecture.
E X H I B I T I O N S
Architecture Gallery, second floor • Monday through Friday, 9:00 AM to 5:00 PM • Saturday, 10:00 AM to 5:00 PM
August 20 – October 27, 2012 • PALLADIO VIRTUEL
November 8, 2012–February 2, 2013 • GEORGE NELSON: ARCHITECT, WRITER, DESIGNER, TEACHER
"Palladio Virtuel" is supported in part by the Graham Foundation for Advanced Studies in the Fine Arts and by Elise Jaffe + Jeffrey Brown. "George Nelson: Architect, Writer, Designer, Teacher" is an exhibition of the Vitra Design Museum, Weil am Rhein, Germany. The American tour of the exhibition has been generously sponsored by Herman Miller, who is also the presenting sponsor of the exhibition at the Yale School of Architecture. The Yale School of Architecture's exhibition program is supported in part by the James Wilder Green Dean's Resource Fund, the Kibel Foundation Fund, The Nitkin Family Dean's Discretionary Fund in Architecture, the Pickard Chilton Dean's Resource Fund, the Paul Rudolph Publication Fund, the Robert A.M. Stern Fund, and the Rutherford Trowbridge Memorial Publication Fund.

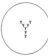

耶魯大學建築學院

右圖
我邀請設計師瑪麗安·班傑斯（Marian Bantjes）手寫了海報上的「建築誘惑」標題，希望字體能充滿「情欲感」，而她也交出了作品。後來意想不到的是，這個設計被饒舌歌手吹牛老爹（P. Diddy）的時尚品牌偷走了，經過一些巧妙的改動，他們把「誘惑」（Seduction）改成了品牌名稱「Sean John」。生活在一個邊界如此漏洞百出的世界裡，是多麼奇怪和美妙的事

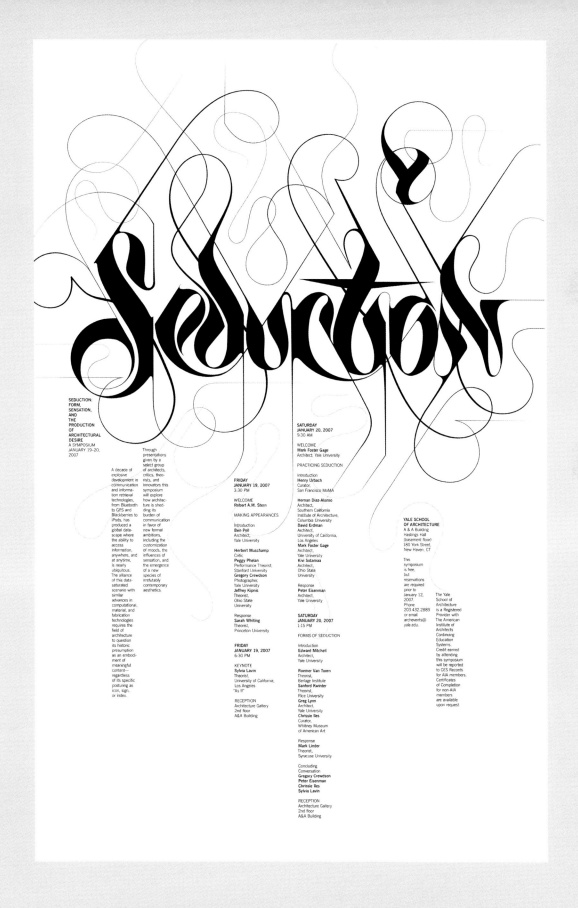

SEDUCTION:
FORM,
SENSATION,
AND
THE
PRODUCTION
OF
ARCHITECTURAL
DESIRE
A SYMPOSIUM
JANUARY 19-20,
2007

A decade of
explosive
development in
communication
and informa-
tion retrieval
technologies,
from Bluetooth
to GPS and
Blackberries to
iPods, has
produced a
global data-
scape where
the ability to
access
information,
anywhere, and
at anytime,
is nearly
ubiquitous.
The alliance
of this data-
saturated
scenario with
similar
advances in
computational,
material, and
fabrication
technologies
requires the
field of
architecture
to question
its historic
presumption
as an embodi-
ment of
meaningful
content—
regardless
of its specific
posturing as
icon, sign,
or index.

Through
presentations
given by a
select group
of architects,
critics, theo-
rists, and
innovators this
symposium
will explore
how architec-
ture is shed-
ding its
burden of
communication
in favor of
new formal
ambitions,
including the
customization
of moods, the
influences of
sensation, and
the emergence
of a new
species of
irrefutably
contemporary
aesthetics.

FRIDAY
JANUARY 19, 2007
3:30 PM

WELCOME
Robert A.M. Stern

MAKING APPEARANCES

Introduction
Ben Pell
Architect,
Yale University

Herbert Muschamp
Critic
Peggy Phelan
Performance Theorist,
Stanford University
Gregory Crewdson
Photographer,
Yale University
Jeffrey Kipnis
Theorist,
Ohio State
University

Response
Sarah Whiting
Theorist,
Princeton University

FRIDAY
JANUARY 19, 2007
6:30 PM

KEYNOTE
Sylvia Lavin
Theorist,
University of California,
Los Angeles
"As If"

RECEPTION
Architecture Gallery
2nd floor
A&A Building

SATURDAY
JANUARY 20, 2007
9:30 AM

WELCOME
Mark Foster Gage
Architect, Yale University

PRACTICING SEDUCTION

Introduction
Henry Urbach
Curator,
San Francisco MoMA

Hernan Diaz-Alonso
Architect,
Southern California
Institute of Architecture,
Columbia University
David Erdman
Architect,
University of California,
Los Angeles
Mark Foster Gage
Architect,
Yale University
Kivi Sotamaa
Architect,
Ohio State
University

Response
Peter Eisenman
Architect,
Yale University

SATURDAY
JANUARY 20, 2007
1:15 PM

FORMS OF SEDUCTION

Introduction
Edward Mitchell
Architect,
Yale University

Roemer Van Toorn
Theorist,
Berlage Institute
Sanford Kwinter
Theorist,
Rice University
Greg Lynn
Architect,
Yale University
Chrissie Iles
Curator,
Whitney Museum
of American Art

Response
Mark Linder
Theorist,
Syracuse University

Concluding
Conversation
Gregory Crewdson
Peter Eisenman
Chrissie Iles
Sylvia Lavin

RECEPTION
Architecture Gallery
2nd floor
A&A Building

YALE SCHOOL
OF ARCHITECTURE
A & A Building
Hastings Hall
(basement floor)
180 York Street,
New Haven, CT

This
symposium
is free,
but
reservations
are required
prior to
January 12,
2007
Phone
203.432.2889
or email
archevents@
yale.edu.

The Yale
School of
Architecture
is a Registered
Provider with
The American
Institute of
Architects
Continuing
Education
Systems.
Credit earned
by attending
this symposium
will be reported
to CES Records
for AIA members.
Certificates
of Completion
for non-AIA
members
are available
upon request.

Yale School of Architecture **Symposium**

A&A Building, Hastings Hall
180 York Street, New Haven, CT

This symposium is partially funded by a grant from the Graham Foundation for the Advanced Studies in the Fine Arts and the David W. Roth and Robert H. Symonds Memorial Lecture Fund.

This symposium is free but reservations prior to Oct 10, 2003 are required.
Yale School of Architecture
P.O.Box 208242
New Haven, CT 06520
Phone 203.432.2889
Fax: 203.432.7175
email: jennifer.castellon@yale.edu

Architecture and Psychoanalysis

Friday
October 24, 2003
Evening Session
6:30 pm

KEYNOTE
Roth-Symonds Lecture
Richard Kuhns, Professor of Philosophy, Columbia University
"Constructive and Destructive Passion: Architecture and Psychoanalytic Thought"

RECEPTION
Architecture Gallery, 2nd floor A&A Building

Saturday
October 25, 2003
Morning Session
9:30 am

THE CREATIVE SUBJECT: ARCHITECTS / ARCHITECTURE

IDENTITY
Juliet Flower MacCannell, Professor Emeritus, English and Comparative Literature, U.C. Berkeley
"Breaking Out"
Suely Rolnik, Professor, Dept. of Social Psychology, Catholic University of Sao Paulo
"Beyond the Pumping of Creation"

ORGANIZATION
Robert Gutman, Lecturer in Architecture, Princeton University
James Krantz, Organizational Consultant
"The Psychodynamics of Architectural Practice"

Saturday
October 25, 2003
Afternoon Session
1:15 pm

THE OBJECT: BUILDING / CITY

THE BUILDING
Stephen Kite, Architect and Professor, University of Newcastle
"Adrian Stokes and the 'Aesthetic Position': Psycho-analysis and the Spaces In-Between"
Peggy Deamer, Associate Professor, Yale University
"Form and (Dis)Content"

THE CITY
Sandro Marpillero, Adjunct Associate Professor of Architecture, Columbia University
"Urban Operations: Unconscious Effects"
Richard Wollheim, Professor in Residence, Dept. of Philosophy, U.C. Berkeley; faculty, San Francisco Psychoanalytic Institute
"Why We Hate the Modern City"

Sunday
October 26, 2003
Morning Session

Photo: Knoll / Barcelona 1929 / Mies van der Rohe

Joan Copjec, Professor of English, Comparative Literature, and Media Studies and Director, Center for the Study of Psychoanalysis and Culture, SUNY Buffalo
"Disorientation"

Parveen Adams, Convenor M.A. and Ph.D. program, Psychoanalytic Studies, Brunel University
"Sexual Accidents"

REPRESENTING / WRITING THE SPATIAL EXPERIENCE
Donald Spence, Clinical Professor of Psychiatry, UMDNJ
"Boundary Violations and Other Un-Heimlich Maneuvers"
Mark Campbell, Managing Editor, *Grey Room*
"Geoffrey Scott and the Dream-Life of Architecture"

CLOSING REMARKS
Mark Cousins, Director of History and Theory Program, Architectural Association
"Two Principles of Architectural Functioning"

RECEPTION
Architecture Gallery, 2nd floor A&A Building

左圖
學校的商標是在圓圈放一個字母「Y」，但為了強化不斷變化的主題，每次的「Y」都會長得不太一樣，圖中的是「Rorschach」粗體。

下一跨頁
耶魯大學的海報是我們工作室最喜歡的案子之一，在過去15年間，我團隊中無數位設計師與實習生都為這個案子投注了心力，尤其是凱莉‧鮑威爾、蜜雪兒‧梁、葉芙‧路西維德、萊茨‧侯和潔西卡‧史文森這幾位同仁。耶魯大學的約翰‧雅各布森從一開始就指導這個案子，當然，我最要感謝的就是勞勃‧史騰，在我整個職涯中，他一路上都十分鼓勵我。

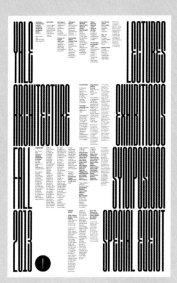
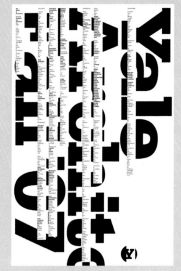
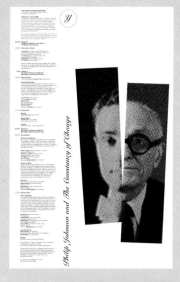

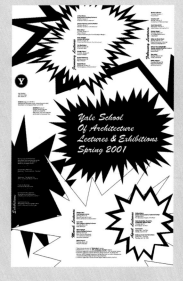
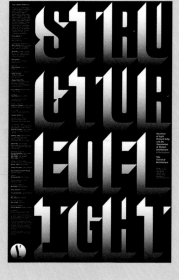
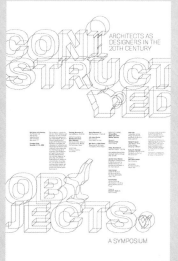
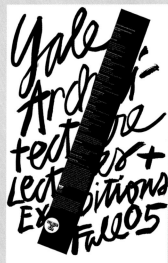
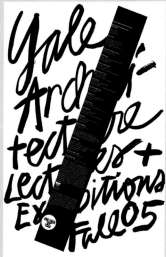
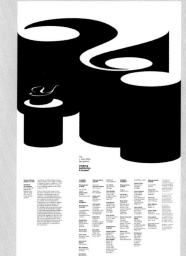
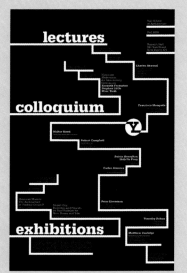

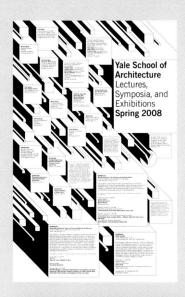

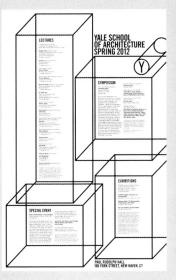

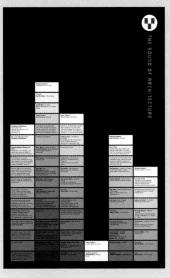

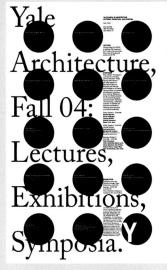

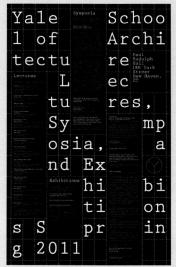

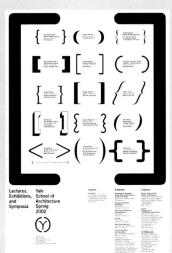

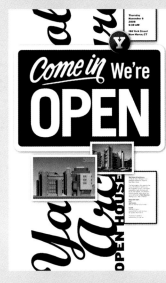

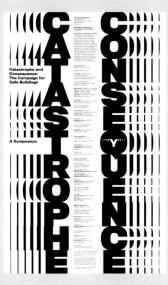

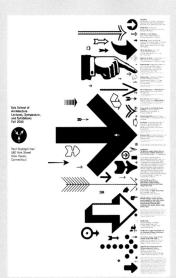

153

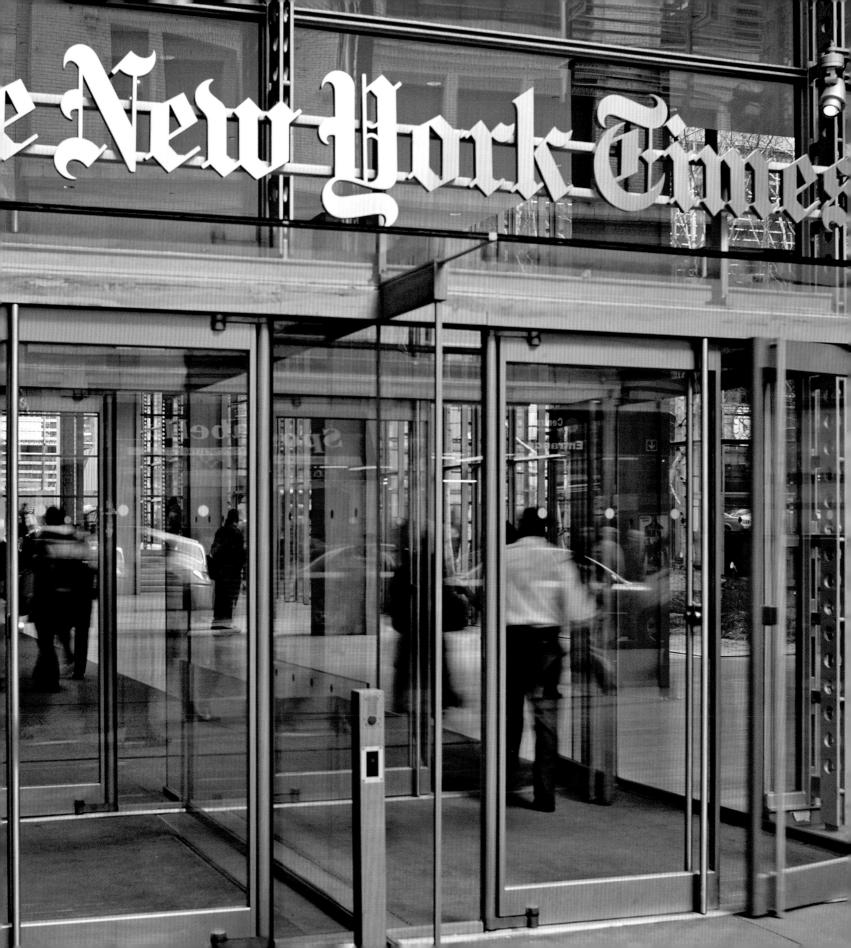

如何在玻璃建築外牆裝上招牌又不遮擋視線

紐約時報大樓
The New York Times Building

左圖
造訪《紐約時報》的
人們從Fraktur字體
組成的華麗招牌下路
過，招牌與極簡主義
的大樓形成對比。

上方上圖
「時報廣場」
（Times Square）就
是以《紐約時報》總
部命名的，這份報紙
具有劃時代的意義，
而總部大樓位於四十
二街與百老匯大道的
交會處。

上方下圖
《紐約時報》位於四
十三街的倉庫外面，
用黃色玻璃球來標示
貨車的停車格。

2001年，《紐約時報》聘請普立茲克建築獎（Pritzker Prize）得主倫佐・皮亞諾（Renzo Piano）設計新的總部大樓。近90年來，《紐約時報》一直在西43街一棟單調的磚頭建築中運作著。它的外觀看起來像一座工廠，裡頭也確實是一座工廠。報紙在地下室印刷完成之後，就被裝上卡車，每日黎明之前啟程，把新聞送到讀者手裡。

皮亞諾操刀的大樓座落於往南三個街區之處，與舊廠房截然不同。整棟建築被玻璃外牆包覆，外面再罩上一整片陶瓷圓棒橫向排列而成的遮陽板，與報刊名稱的字體線條相呼應，並展現出這間媒體的數位非物質性（digital immateriality）與新聞的透明性。

但問題來了，這座新建築的所在區域有招牌限制政策，與全國其他地區大不相同。其他地方往往希望街道上的招牌尺寸更小、數量更少，紐約政府為了保留時報廣場的多元特色，反而要求周邊商家要設置更多、更大、更耀眼的招牌，並且根據法律，這些招牌必須直接附著在建築物上，不能放在大樓的正門口。然而，在一棟外牆全部都是玻璃的建築物上，究竟要怎麼放上招牌，又不會遮擋視線呢？身為這個案子的商標設計師，我們必須解決個難題。

我們的解決方案就是在大樓面朝第八大道的外牆上，安裝上「New York Times」幾個大字，長達110英尺。整個商標由959個水滴型裝置組成，每一塊都精確地包覆在遮陽板的陶瓷圓棒上。水滴尾部的尖端凸出2英吋，行人由下往上看時，就會看到這些尖端組合出來的招牌黑色大字，如果是從大樓內往外看，則什麼也不會看到。

新大樓雖然很美，但有些人擔心員工可能會懷念舊辦公室數十年的傳統。針對這一點，我們為大樓內共800個標誌——從會議室到廁所——打造了獨一無二的指示牌。每個招牌，都從紐約時報龐大的影像資料庫中，挑選出不同的照片來搭配，並以誇張的點狀雜訊質感印製，向那些每晚在記者辦公室下方隆隆作響的印刷機致敬。

就如同許多其他設計師，我最早在《紐約時報》接到的案子，是為他們的言論版製作簡潔、明瞭的插圖，吸引讀者去了解其中複雜甚至密集的觀點。這種案子壓力很大，但總讓人躍躍欲試。我們往往會在出刊之前才接到工作，然後要在24小時之內交稿並核准，隔天就會刊在報紙上了。相較於大多數設計案長達數個月甚至數年之久，這種即時的滿足感讓人耳目一新。

右圖
喬治．凱南
（George Kennan）反對北大西洋公約組織（NATO），而往外擴展的字母「N」和「O」，也強調了「否定」的意涵。

下圖
最後一個字母模仿里程表轉動到一半的狀態，象徵入侵石油盛產地區。

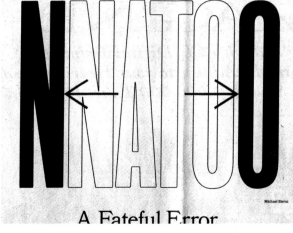

THE NEW YORK TIMES OP-ED WEDNESDAY, FEBRUARY 5, 1997

Foreig

THOMAS L

The Neut

DAVOS, Switzerland
In virtually every article about the dispute between Swiss bankers and Jewish groups over the bank accounts of Holocaust victims, there is a historical reference that is blandly repeated over and over: "Switzerland was neutral during World War II." Every time I read that reference I can't help thinking: What does it mean to be neutral between the perpetrators of the worst crimes against humanity in modern history and their victims? What does it mean to say that the same rules should apply to the money of both? What does it mean to put yourself outside history?

The reason this Nazi banking issue continues to fester is because too many Swiss still insist on being morally neutral, on trying to live off the international system without being fully part of it. As one senior Swiss official remarked to me: "The Swiss people are shocked by this banking affair, because they are not used to seeing themselves on CNN." In their view, they are the victims of a plot to take their quiet little country away, to drag them back into history.

Michael Bierut

A Fateful Error

THE NEW YORK TIMES OP-ED WEDNESDAY, APRIL 23, 2003

THOMAS L.

Regime Ch

While the war in Iraq has rightly grabbed all the attention in the Middle East, another effort at regime change has also been going on in the neighborhood, and it's been quite a drama. It's the silent coup that Palestinian moderates, led by Mahmoud Abbas, have been trying to undertake against Yasir Arafat.

Mr. Arafat was forced by the Palestinian legislature to designate Mr. Abbas (a k a Abu Mazen) as his first prime minister. The move was openly designed to diminish Mr. Arafat's power and to ease him upstairs, if not out the door. Mr. Abbas has been trying to assemble a cabinet, and Mr. Arafat has been fighting him at every turn — trying to stuff the cabinet with his cronies and deny Mr. Abbas the key security portfolios. Mr. Arafat "fears he will not be the strongman in the coming phase," a Palestinian legislator, Hassan Khraisheh, told The Associated Press in Jerusalem.

He's right, but Mr. Arafat is no pushover, and if Mr. Abbas and his allies in the Palestinian legislature are to prevail, they will need help. America, Europe, Israel and the Arab states should all pitch in.

The Bush team has a huge strategic stake in the outcome of this Palestinian struggle, because it will affect America's room for maneuvering in Iraq. Let me explain. What does America want in Iraq? It wants the emergence of an Iraqi political center, of both parties and politicians, who are authentically Iraqi, authentically nationalist and respectful of Islam — but with a progressive, modernizing agenda and a willingness to

Michael Bierut

Why the Mullahs Love a Revolution

By Dilip Hiro

LONDON
The Bush team's vision for a postwar Iraq was founded on the dreams of exiles and defectors, who promised that Iraqis would shower American troops with flowers. Now, with the crowds shouting, "No to America; no to Saddam," and most Iraqis already referring to the American "occupation," the Bush administration seems puzzled.

ity south and the Shiite neighborhoods of Baghdad. Over the centuries, as members of a community that was discriminated against and repressed, the Shiites learned to find comfort in religion and piety to a much greater extent than the ruling Sunnis. In recent decades, Shiite clerics devised clandestine networks of communication that even Saddam Hussein's spies failed to infiltrate. Eschewing written messages or telephones, they used personal envoys who spoke in code. In the wake of Iraq's collapse, this messenger system has proved remarkably efficient.

solid: although he is a Shiite, he lacks any constituency inside Iraq. Nor is he likely to inspire new followers. Had he joined the hundreds of thousands of Shiites who made the pilgrimage to Karbala this week he might have enhanced his standing. But apparently he couldn't be bothered.

Compare this luxury-loving, highly Westernized banker (who was convicted by Jordan in absentia of embezzlement and fraud) with Ayatollah Khomeini, the ascetic Iranian Shiite cleric who shunned worldly goods and and led a popular revolution that over-

nial government had to call in troops from the Indian Army to quell it. By the time they restored order, 6,500 people were dead, all but 500 Iraqi civilians. The 1920 revolt is the crucible in which Iraqi nationalism was formed. That unity showed its durability during Iraq's armed conflict with the predominantly Shiite Iran in the 1980's. To the complete surprise of the Iranians, Saddam Hussein managed to retain the loyalty of the Iraqi Army, where Shiite conscripts formed a majority.

Thus the only viable solution for

The Art Of Being No One

By Joyce Carol Oates

PRINCETON, N.J.

In an ideal world uncontaminated by ego and individual "identity," all works of art, if not entertainment, might well be attributed to "Anonymous." These works would be judged solely on their intrinsic merit; the attachment of specific authors, whether for the enhancement of the works or their detriment, would be irrelevant. What freedom creators and consumers alike would have no expectations, thus no disappointments; we would retain a childlike attitude to art, willing always to be surprised.

In past centuries, it was not uncommon for a work of fiction, for instance, to be by "Anonymous," or his shadowier kin "Anon." "A Lady," perhaps, or "A Gentleman." The special intrigue of the roman à clef (and isn't all works by such authors roman à clef?) is further enhanced by mystery, which begs public discussion, about the author's identity.

A novel by "Anonymous" is very different from a novel by X, a mere individual to whom a specific, inevitably delimiting and diminishing

Joe Klein has literary history

—

There is something about the welfare debate. The politicians have... er and decided it's... throw a million or... poverty. But they ca... proponents of this so... effort have gone out...

Welfare b... let kids s...

avoid being seen for... men and women of e... who are taking food... of infants and child... stricken elderly, the...

They seek camou... misms. So here is Cl... ida Republican, as qu... page of Friday's Wa...

"This is a most his... hope the President... our efforts to res... Americans out of a... system."

Ah, it's a rescue... picture it? Clay Shav... Floridian protecting... from all those break... they might otherwis...

The welfare legi... before Congress is in...

posal" (the proposal being that the children of poor folk be purchased for food by their betters), he used the enigmatic author-name "Dr. Swift," though the voice of his proposal is that...

The author of "Primary Colors" would not have wished to limit the authority of his roman à clef by affixing his own name. For a Newsweek columnist, an individual in the...

左上圖
作家喬伊思・卡羅爾・歐茨（Joyce Carol Oates）在文章中隱晦批評匿名行為。

左下圖
過去的和平主義左派如今支持以武力干預科索沃。

下方上圖
最高法院的裁決分歧。我很幸運，他們的建築物剛好有8根柱子。

下方下圖
讀者對《黑道家族》突兀的大結局說「不」。

THE NEW YORK TIMES **OP-ED** *FRIDAY, APRIL 2, 1999*

Michael Bierut

...KS

...en it is ...ses — ...or the ...(of all ...s when ...e "last

...after ...ltraso-...ware, ...t they ...ith an ...he in-...against

...n't ...S. ...y.

...not re-

...t Mr. ...e Unit-...ilitary ...een as

...ement ...nce of ...paci-...ed out ...o pro-...an nu-...s, they ...e fear ...ome a ...erpow-

not believe that Russia will rush to the aid of its Serb-Orthodox brethren. Unlike the czar's divisions in 1914, the Russian Army today is not capable of...

it was... traditio... peace-r... that th... wanted... superio... "cowbo...

Thes... no suc... Europe... Yugosl... the mo... is that... barking...

To be... — in V... nia, in... Even in... strator... But the... — Gre... Americ... in Buc... veighin...

So w... ent fro... with, th... can res... interes... aimed... moral...

This... postmo...

"will not allow itself to be drawn into military conflict." It is always easier to heed the call of obligation when the risks are low...

The Supreme Court

MICHAEL BIERUT

...Chiefs

...airman is the principal military ...ident and the secretary of de-...ility is to ensure that civilian de-... the best professional advice ...ers in the Pentagon and around ... chairmen like Adm. William ...lin Powell in the late 1980s and ...out these responsibilities well. ...nt chairman, Gen. Peter Pace, ..., Gen. Richard Myers, failed in ...onsibility. When Mr. Rumsfeld ...ht the war in Iraq with too few ...anning — ignoring the advice of ... professionals and outside ex-...saluted and mouthed the same

...miral Mullen, Mr. Gates seems ... wants to hear the truth about ...ow be done to extract American ...he disaster. We hope that the ad-...he truth and that together they ...dent Bush to listen.

...Move

MICHAEL SCLAFANI
Spring Lake, N.J., June 11, 2007

To the Editor:

Authenticity, as defined by politics today, is nothing more than an illusion; men who were raised with everything acting as if they had nothing.

were looking for in a president.

Until the seriousness of the highest job in the land is covered as such, we will have flawed candidates running for the office of the presidency in this country and mediocrity determining who is qualified to run.

HENDRIK E. SADI
Yonkers, June 8, 2007

The Night We Watched as Tony Went . . .

Michael Bierut

To the Editor:

Re "One Last Family Gathering: You Eat, You Talk, It's Over," by Alessandra Stanley (The TV Watch, front page, June 11):

I'm not mad at David Chase, creator of "The Sopranos," for leaving Tony in a diner at the end, alive, and eating onion rings with Carmela and the kids (let's believe that Meadow makes it to her seat).

Where else could the story have closed more compassionately than at a small Formica table?

To the Editor:

Re "TV Writers Were Also Watching 'Sopranos' " (Arts pages, June 12):

To the Editor:

The last episode of "The Sopranos" is neither a prank nor a joke.

I believe that David Chase's brilliant ending is in the mind of Tony Soprano, whose world goes dark at that moment.

ELIZABETH SEYDEL MORGAN
Richmond, Va., June 11, 2007

Fort Lee, N.J., June 12, 2007

Cut the Nuclear Arsenal

To the Editor:

Re "Nasty, Unfinished Cold War Business" (editorial, June 9): Ever since August 1945, mankind has known how to destroy itself with atomic bombs. How to avoid doing so must be at the top of every country's agenda, and our children and grandchildren must be kept aware of the danger.

When the Soviet Union had 100 bombs and seemed close to using them, I was scared. Now, 15,000 bombs do not scare me anymore. But the sooner we reduce the number to 100, the better.

Better still, but more difficult, will be a comprehensive treaty that keeps these weapons out of international disagreements. What is holding us back? RICHARD WILSON
Cambridge, Mass., June 10, 2007
The writer is emeritus professor of physics at Harvard University.

Orthopedic Surgery

To the Editor:

Re "Health Care as if Costs Didn't Matter," by David Leonhardt (Economix column, June 6):

Mr. Leonhardt's inclusion of knee replacements in his examples of "medically questionable care" runs contrary to many published reports...

157

為了在《紐約時報》大樓外面加上商標，我們把每個字母切割成窄長的橫條，有的字母被切成26條，像是小寫字母「i」，有的則高達161條，比如大寫字母「Y」。五角星設計的設計師翠西·卡麥隆（Tracey Cameron）與皮亞諾建築團隊的設計師，以及他們的建築盟友FXFowle工作室一起工作了好幾個月，努力製作出更精確的商標圖案。雖然我們進行了許多次測試，但始終不確定是否可行。我搭上一輛行經上城第八大道的公車，看到終於成功安裝的第一個字母時，忍不住大聲鼓掌，把車上的乘客都嚇了一跳。

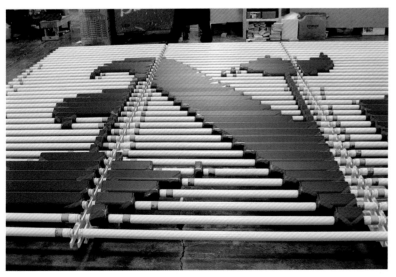

左上圖
每個精確放置的長條都有一端突出的「喙」。

左下圖
當從下方往上看時，凸出物會重疊在一起，就能看到黑色的文字。

上圖
支撐商標的水平橫桿是用來調節玻璃帷幕大樓的熱量增減。

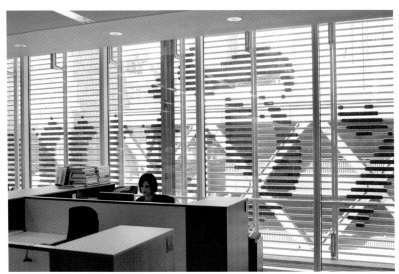

左圖
從大樓內部往外看，商標幾乎不會擋住視線，可以看到港務局公車總站。

下圖
《紐約時報》商標使用的Fraktur字體是字型設計大師馬修・卡特（Matthew Carter）客製化版本，我們放大到10,116級字輸出。

下一跨頁
我一度建議可以考慮把招牌做成白底白字，某些角度就會看不到。而《紐約時報》當時的執行長小亞瑟・奧克斯・蘇茲伯格（Arthur Sulzberger Jr.）瞪著我，好像我瘋了一樣，說：「嗯，但我們報紙頭版上印的商標是黑色的，不是嗎？」

第二張跨頁
《紐約時報》的大衛・瑟姆（David Thurm）是這個案子的負責人，他很強勢，想盡辦法要將這份報紙的歷史帶到新大樓來。而我們採取的作法，就將八百多張老照片做成不同的房間指示和門牌。

Men

03E3-246

Page One

04P6-352

Video Edit
Room

Women

04C2-002

Equipment
Room

Men

02E2-243

Team Room

21C1-007

Stat Room

02E2-242

Team Room

10E2-241

Team Room

03E3-246

Conference Room

Conference Center

Women

16N1-205

Copy Room

10W2-215

Team Room

13N2-207

Privacy

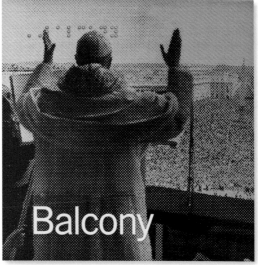

Balcony

Riser Closet

如何讓博物館瘋狂

藝術與設計博物館
Museum of Arts and Design

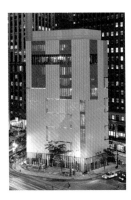

左圖
我們用新的平面語言為藝術與設計博物館的新家打造新形象。

左上圖
愛德華‧達雷爾‧史東這棟位於哥倫布圓環2號的作品，是紐約評價最兩極化的建築之一。

右上圖
布拉德‧克魯菲爾的重新設計也十分具有爭議，他將一整片黑暗的房間改造成彼此相通且充滿光線的空間。

藝術與設計博物館多年來都有形象危機。1956年成立時，名稱是當代工藝博物館（Museum of Contemporary Crafts），1986年又改名為美國工藝博物館（American Craft Museum）。2001年再次更名為目前使用的藝術與設計博物館，簡稱「MAD」（瘋狂）。雖然擁有一個俏皮的暱稱，但過了5年，大多數人還是不知道有這個地方。

但這種情況即將改變。博物館位於哥倫布圓環，是百老匯大道、第59街和中央公園西側交會之處，不僅位置尷尬、結構也十分特殊。它建於1964年，設計師是愛德華‧達雷爾‧史東（Edward Durell Stone），原本是超市大亨後代亨廷頓‧哈特福德（Huntington Hartford）的收藏博物館。建築評論家艾達‧路易絲‧赫斯塔布（Ada Louise Huxtable）將這棟樓形容為「在棒棒糖上刀模裁切（die-cutting）出的威尼斯宮殿」。哈特福德收藏博物館只營運了5年，這棟無人居住的大樓便被市政府徵收，直到2002年提供給藝術和設計博物館使用。

大樓需要一點變化。建築師布拉德‧克魯菲爾（Brad Cloepfil）提出了巧妙的改造方案，在地面、天花板和牆壁上切割出蜿蜒而綿延的縫隙。我們則受託要打造全新平面形象來象徵大樓的重生。受到克魯菲爾設計的啟發，我提議也用一條連貫的線來組成新的商標。這是我最好的點子之一。

但問題是：它行不通，至少用「MAD」三個字沒辦法做。所幸我聽說有些人認為這個簡稱有點不太得體，於是我抓住這點，提議把簡稱改為「A+D」，可以強調這座博物館的聚焦領域，又可以藉由這個新的縮寫來實踐我的點子。我在一連串會議上提出這樣的想法，搭配越來越複雜的商標原型，但最後我沒能成功說服他們。如果你有個很棒的構思，但卻無法付諸實行，那這就不能算是一個好點子。

那天晚上，我盯著工地。翻新的MAD大樓面朝曼哈頓唯一一座完整的圓環。大樓是方形，圓環是圓形。我又看了看博物館簡稱的三個字母，也能找到方形和圓形嗎？答案是有。於是，最簡單的幾何圖案解決了所有問題。終於不再需要緊張的計畫和狂熱的推銷，一個能自我推銷的解決方案就這樣出現了，這並不常見。下一次會議中，大家一致通過了我的新提案。

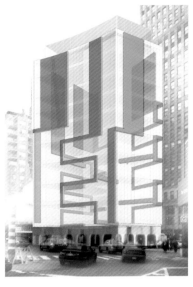

左上圖
我對克魯菲爾的圖形感到著迷，圖中，一條連貫的縫隙穿透整棟建築，於是我便將這個概念運用在我的初步設計概念中。

左中圖
我決心設計一個與建築物相呼應的商標，卻發現無法用於MAD三個字母上，於是我提議要將簡稱改為「A+D」，這不太可能，客戶果然也不同意。

左下圖
雖然開了很多次會，手工畫了好幾十個草稿，還是無法說服客戶。事實上，我內心深處也無法說服自己。

下圖
這是我的第二次提案，摒棄了複雜的元素，轉而採用方形與圓形。再一次證明，最單純的往往也是最好的。

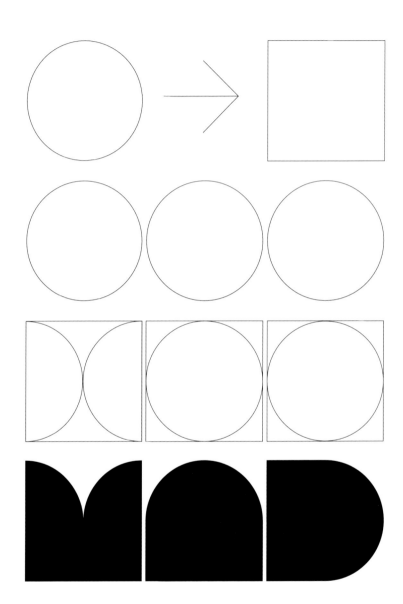

右圖
MAD是專精於工藝的博物館,而商標也可以用許多種材料來展現。彎曲的頂部也精巧地參考了舊大樓的「棒棒糖」柱,翻新後這個元素依然被保留下來。

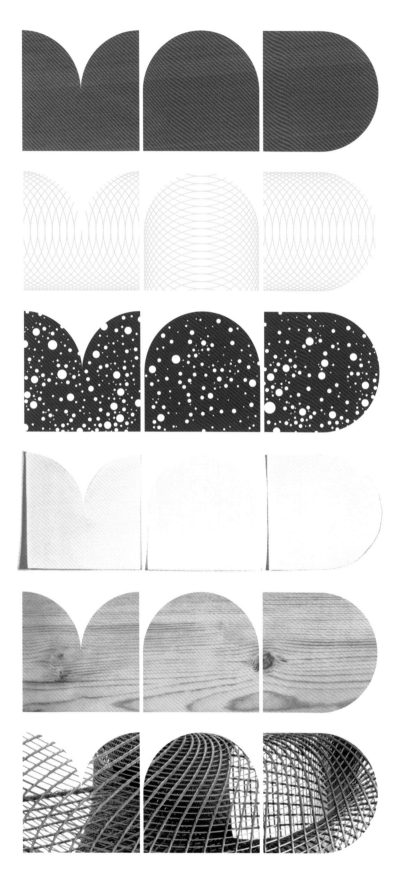

下圖
最初的設計稿需要
特殊處理，但新的
商標理念大不相同，
可以輕鬆運用在任何
地方。

右上圖
這種圖形語言非常適
合重複排列，運用在
商店包裝上。

右中圖
鏤空實心商標，製造
出令人印象深刻的透
視感，是非常適合購
物袋的設計。

右下圖
MAD的周邊商品大
量運用新的商標。五
角星設計的喬‧馬里
亞內將商標的三個字
擴展成一套完整的字
體，名為「MAD-
face」。其中一款T
恤上寫著：「如果你
看得懂，那表示你瘋
（MAD）了。」也間
接評論了這種字體其
實有點難讀懂。

opening on columbus circle september 23 madmuseum.org

museum of arts and design opening on columbus circle september 23 madmuseum.org

museum of arts and design opening on columb

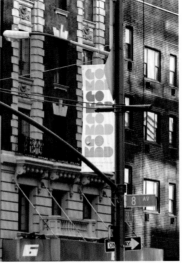

上圖
我們運用MADface字
體創造了融合商標和
訊息的品牌。

最左圖
新的平面形象延伸到
實體建築物裝飾和網
站上。

左圖及下一跨頁
2008年9月，MAD在
新大樓開始營運，紐
約到處都可以見到它
的全新形象廣告。

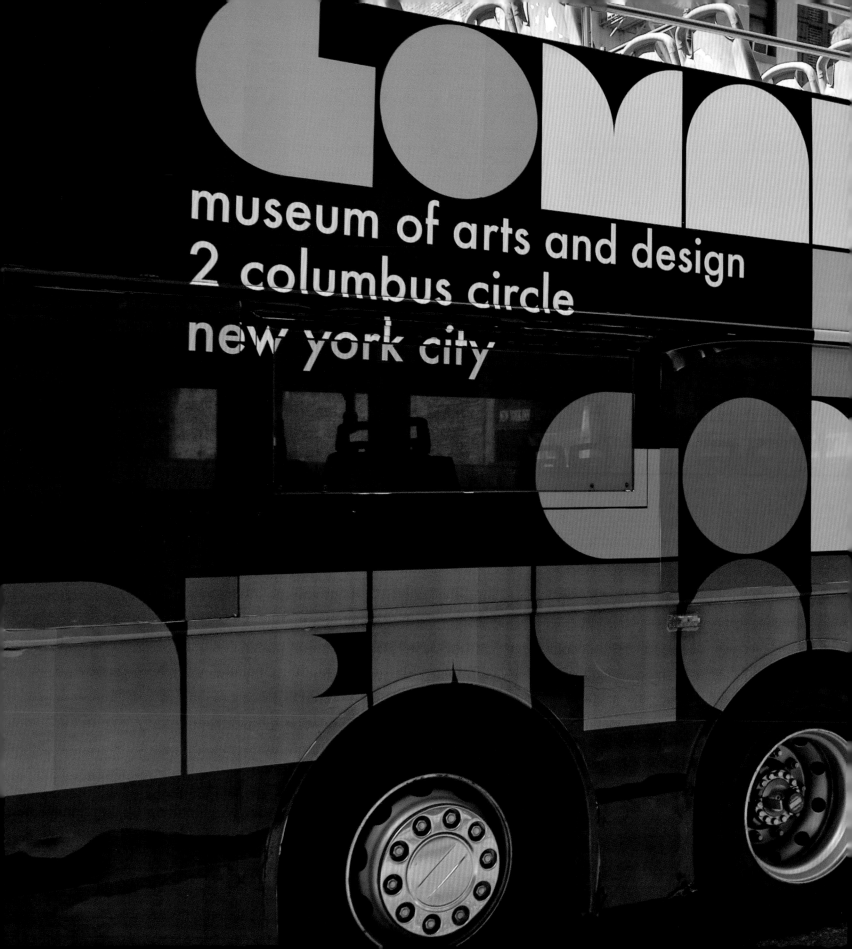

museum of arts and design
madmuseum.org
opening september 27

GRAY LINE

71510

NYDOT: 203061
OWNED: INTERNATIONAL BUS SERVICES
OPERATED: GRAYLINE NY TOURS

GOD

A BIOGRAPHY

JACK MILES

如何評斷一本書

書封與書衣
Cover and Jackets

左圖
前耶穌會神學院學生傑克．邁爾斯（Jack Miles）這本引人入勝的創作，使《聖經》故事成為一部文學作品，並且非比尋常地獲得了1996年的普立茲傳記文學獎。標題的三個字母難以容納於紙頁之上，其宏大不言自明。

在正式上課學習設計之前，我都是站在書店走道上看書自學。從各方面來看，書封設計都非常具有挑戰性。因為它的本質上極其簡潔，無論這本書是48頁還是480頁，都只能有一個封面，並且無論這本書的內容有多艱澀、主題又有多複雜，書封都必須一次就抓住讀者的目光。就如同設計麥片外盒或湯品罐頭一樣，設計師都必須打造出色的外包裝，讓產品得以在競爭對手間脫穎而出。

這個道理至今依然不變，就算真的變了，也是變得比以前更加困難，因為書籍的銷售模式和書籍本身，都已經從實體轉往數位。而我的目標是要讓書封盡可能直接反映書本的內容。

我從小就是個愛書人，到現在都還是，讀書就像我的強迫症一樣。而且你一定猜得到，如果一本書的封面太醜，我就會很難好好享受它。我最討厭的莫過於電影書衣，它們總是搭配「改編為好萊塢大片！」這類的文案，封面使用演員的照片來呈現書中虛構的角色，但我更喜歡在自己腦中想像。電影書衣簡直該被列為非法物品。

至於我最喜歡的，那當然就是只有文字的書封，比如平裝版的《麥田捕手》（*The Catcher in the Rye*）或《美麗新世界》（*Brave New World*）。這樣的書封能打造出一種神祕感與地位，推動我投入閱讀，卻又不會暗示我即將踏入什麼樣的世界。後來我才知道，很多作者和我一樣有偏見，事實上，沙林傑（J. D. Salinger）在他的合約中就有一項條文，禁止他的書封上出現任何形式的圖像。

多年之後，我終於有機會自己設計書封，而毫不意外的是，當我終於有了主導權之後，我就竭盡全力用書中唯一的元素來打造這本書的形象，那就是：文字。

右圖
這本回憶錄是在講述
撫養自閉症孩子的經
歷，封面上，變化的
字體彷彿有「聲音」
，暗示了母親與女兒
之間溝通的困境。

let me
hear
your
voice

a family's triumph
over autism

CATHERINE MAURICE

書封與書衣

右圖
這本回憶錄則講述了
在美國南方種族隔離
政策下長大的過程，
微妙的色彩同時反映
出故事的溫度、書
名的意涵，以及作
者亨利‧路易斯‧
蓋茨（Henry Louis
Gates Jr.）的優雅
文筆。

右圖
弗拉基米爾·納博科夫（Vladimir Nabokov）的多本著作即將推出新的平裝本，面對這項挑戰，藝術總監約翰·蓋爾（John Gall）想出了一個極具啟發性的點子，他挑選了十幾位設計師，每個人分配一本，再給所有人各一個收藏蝴蝶標本的木盒子，用來裝他們的靈感。值得一提的是，納博科夫正是個蝴蝶標本收藏家。每位設計師要找出能令人想起這本書的小物來把盒子填滿，接著，蓋爾將盒子拍下來，再加上作者名字，書封就完成了。我分配到的是納博科夫美麗的回憶錄《說吧，記憶》（*Speak, Memory*）。一開始，我在一張半透明的羊皮紙下鋪滿老照片。我到底在想什麼？設計師凱蒂·巴瑟隆納在準備寄送素材的時候告訴我，不要放老照片，這樣才更能讓人產生聯想，而她是對的。

書封與書衣

右圖
約翰·貝特朗（John Bertram）與尤里·萊溫（Yuri Leving）在撰寫《蘿莉塔：封面女郎的故事》（*Lolita: The Story of a Cover Girl*）這本精彩著作時，找來了80位設計師，要為納博科夫眾多難以圖像化的作品想像書封。我們使用的素材是《曼恩法》（*Mann Act*）的舊影本，這是1910的法律條文，禁止販運「任何賣淫、放蕩或其他具不正當目的之婦女或少女」。我想像這本書的主角正在某個小鎮圖書館查閱法律條文，然後衝動地撕掉書頁，做成詭異的告白卡片。

如何製作商標

商標與符號
Logotypes and Symbols

左圖
2012年世界設計大會
（IDA Congress）
。世界設計大會是一
場聚集世界各地專業
設計組織的高峰會，
每兩年舉辦一次。這
個視覺乍看很抽象，
但實際上是一塊盤古
大陸，也就是所有大
陸連接在一起的古老
陸塊，象徵這場會議
將全球連結在一起。

商標是最簡單的視覺傳達形式。本質上，這就像一種簽名，表達「這就是我」之意。不識字的人隨手畫個「X」就能構成商標，和英國伊莉莎白女王或美國開國元老約翰・漢考克（John Hancock）的草寫簽名是一樣的。同樣的還有代表和平的符號、古老的「卍」字。當然，可口可樂（Coca-Cola）、Nike、麥當勞（McDonald's）和蘋果公司（Apple）的圖像商標也都是如此。

我們用來描述這些東西的詞彙可能會讓人覺得很困惑。有些商標完全是字體排印，我會稱之為標準字或文字商標，比如微軟（Microsoft）的商標。另一些則是形狀或圖案，我會說這是符號。有時候，商標與公司名稱直接相符，像是蘋果公司的商標就是一顆蘋果，目標百貨（Target）的商標就是一個標靶。也有些時候商標會取材自真實事物，卻又與背後象徵的公司沒有直接的關聯。比如服飾品牌Lacoste Crocodile用一隻鱷魚來當作商標，是源自網球選手創辦人勒內・拉科斯特（Rene Lacoste）的綽號，而愛迪達（Adidas）的三條紋原本只是一個裝飾圖案而已。有時商標又是完全抽象的，就像大通銀行（Chase Bank）的「斜切貝果」，或是巴斯酒廠（Bass Ale）的紅色三角形商標，可以追溯到1777年，是世上最古老的商標之一。

大家總是對商標過於期待。如果你開了一家公司，用誠懇、品味與智慧和客戶溝通，這會非常辛苦，需要長期持續投入。設計商標也是如此，只不過比經營公司更像一段有始有終的過程，客戶會事先想好預算，設計師也知道會拿到多少酬勞。因此，設計師和客戶經常會採取簡單修改的方式，取代想破頭重新設計整個商標的艱困挑戰。

看到一個著名的商標時，我們接收到的不僅只是一個單字、一個圖案或一個抽象的形式，而是一整個隨著時間積累而成的聯想世界。也因此，大家經常忘了，全新的商標其實不會只有單一意涵。商標如同一個空的容器，等待著歷史和經驗在其中注入意義，而設計師所能做到最美好的事，就是讓這個容器的外型適合它所要承載的東西。

禾林出版公司（Har-
lequin Enterprises）
，2011年。
言情小説出版社。

紐約市經濟發展局
（New York City
Economic Develop-
ment Corporation）
，1992年。
爬升的天際線。

成功特許學校（Suc-
cess Academy）
，2014年。
算術上的巧合造就了
這個設計。

SUCCESS
ACADEMY
CHARTER
SCHOOLS

21c飯店（21c Ho-
tels），2005年。
充滿藝術感的精品
飯店。

商標與符號

MillerCoors啤酒公
司，2008年。
兩家極具代表性的啤
酒廠合併，持續釀造
好酒。

波丘園（Wave Hill）
，2002年。
紐約布朗克斯的文化
中心及公園。

百老匯書店（Broad-
way Books），1996
年。
對角線象徵著書頁摺
角與極具代表性的街
角位置。

IDEO設計公
司，1997年。
設計大師保羅·蘭德
（Paul Rand）修改
了原始商標。

高譚地產（Gotham
Equities），1992
年。
總部位於紐約的房地
產開發商。

　　　　　　　　　　商標與符號

時尚中心（Fashion
Center），1993年。
這裡就像紐約大蘋果
上的一顆大鈕扣。

美國時裝設計師
協會（Council of
Fashion Designers
of America），1991
年。
字體排印強調出重點
所在。

合併銀行（Amal-
gamated Bank）
，2014年。
最初是為服務紐約的
服飾從業者而創立，
以編織手法呈現縮寫
字母，強調了命名的
意涵。

聖彼德堡清水
區旅遊資訊處
（St. Petersburg/
Clearwater Area
Convention and
Visitors Bureau）
，2010年。
為全美最棒的海灘畫
下溫柔的海浪。

互動廣告協會（In-
teractive Advertising
Bureau），2007
年。
網路世界的閾下訊
息點。

商標與符號

中央車站（Grand Central Terminal），2013年。
時鐘的指針標示著這個地標的誕生時間，也就是晚上7:13分。

熨斗區23街聯合商業促進會（Flatiron/23rd Street Partnership Business Improvement District），2006年。
這個商標的形式讓人聯想到鄰近地區的街道規畫和熨斗大廈的輪廓。

企鵝出版社（Penguin Press），2014年。
出版社的商標靈感來自段落符號，也就是用來代表段落間隔的排版標示。

時尚法研究所（Fashion Law Institute），2011年。
經典的視覺雙關。

沃思堡現代美術館
（Modern Art Muse-
um of Fort Worth）
，1999年。
美術館由安藤忠雄
（Tadao Ando）設
計，池塘映照出建築
物的模樣。

TheModern

斯克里普斯學院
（Scripps College）
，2009年。
續任第八任校長。

米德伍地產（Mid-
wood Equities）
，2014年。
房地產開發商的積
木。

錢伯斯飯店（Cham-
bers Hotel），2001
年。
用花押字呈現出資訊
圖表。

　　　　　　　　　　　　　商標與符號

Families for 好學
校兒童教育促進機
構（Families for
Excellent Schools）
，2014年。
用字母描繪出夥伴
關係。

福爾頓轉運中心
（Fulton Center）
，2014年。
玻璃建築物圍繞成為
一座轉運站。

下東城廉租公寓博
物館（Tenement
Museum），2007
年。
紐約最非比尋常、最
宜人的歷史遺跡。

耶魯管理學院（Yale
School of Manage-
ment），2008年。
會議桌樣式的紋章。

雅虎（Yahoo）
，2019年。
網路世界最悠久的入
口網站之一。

　　　　　　商標與符號

Slack通訊程
式，2019年。
創新、無所不在、令
人上癮的商用通訊
軟體。

泉源食品公司
（Fountain），2019
年。
以雙重花押字象徵加
入大麻萃取物的氣泡
飲料。

疾速汽車（Wildlife
Vroom），2018年。
快速的汽車零售網
站。

電子前哨基金會
（Electronic Frontier
Foundation），2018
年。
自數位時代開始以
來，始終致力捍衛網
路言論自由、隱私權
與創新。

艾奇韋爾慈善基金
會（Archewell）
，2020年。
國際非營利組織。

商標與符號

野生動物保護協會
（Wildlife Conser-
vation Society）
，2015年。
像協會的宗旨本身一
樣，字母中也有野生
動物。

麻省理工電腦
科技學院（MIT
Schwarzman
College of Comput-
ing），2019年。
兩個字母連接起來形
成第三個字母，暗示
了電腦的變革力量。

_able基金，2017
年。
這個投資基金的名稱
既是通用的字尾，也
是一則隱藏創始人姓
名縮寫的字謎。

_able

聖地牙哥動物園野
生動物聯盟（San
Diego Zoo Wildlife
Alliance），2020
年。
由世上最受歡迎的動
物園共組的非營利
組織。

性博物館（Museum
of Sex），2002年。
致力於人類性學的非
營利組織。

museumofse**x**

商標與符號

出生缺陷基金會
（March of Dimes）
，1998年。
致力於嬰兒健康的非
營利組織。

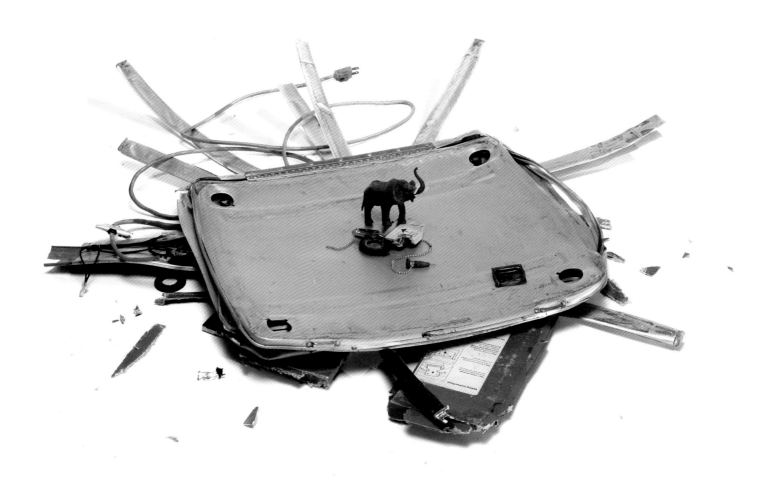

如何對選舉施壓

投票亭計畫
The Voting Booth Project

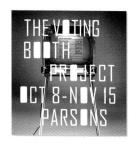

左圖
被壓壞的投票亭象徵
2000年混亂的總統
大選與備受爭議的
結果。

上圖
我們設計了投票亭計
畫和展覽手冊。刀模
裁切的手冊封面上，
文字以打孔的樣式呈
現，顯然就是在諷刺
當時那些「難以辨識
的洞孔」造成大選
後不斷重新計票的
困境。

2000年的那場選舉一團亂，棕櫚灘縣惡名昭彰的「蝶形票」讓選民困惑不已，使得總統大選陷入了遲遲無法結算的困境，之後，佛羅里達州也停止使用Votomatic式的流動投票亭，並放上eBay拍賣。紐約一位名叫安德列・巴拉茲（Andre Balazs）的飯店老闆看到，覺得這是保留歷史物件的機會，就用每件10美元的價格買下100個投票亭，還送一些送給了朋友。那剩下的該怎麼辦呢？時任帕森斯設計學院（Parsons School of Design）院長保羅・戈德伯格（Paul Goldberger）建議，可以用這些投票亭在學校畫廊舉辦一場展覽。大衛・伯恩（David Byrne）、邦妮・西格勒（Bonnie Siegler）、艾蜜麗・奧伯曼（Emily Oberman）、米爾頓・戈拉瑟（Milton Glaser）和梅拉・卡爾曼（Maira Kalman）等逾五十位設計師和藝術家受邀參與，每人都拿到一座投票亭，要對它們進行改造。設計才女契・皮爾曼（Chee Pearlman）負責策展，而我們則受託操刀展覽的平面設計，並且也要改造一個投票亭。這場展覽於2004年10月開幕，正好趕上那年的總統大選。

大多數的設計師以複雜卻美妙又精緻的方式重製了投票亭。我和搭檔詹姆斯・比伯採取的方法則沒那麼美妙：我們開著一輛重達1.5噸的蒸氣壓路機輾過亭子。事實證明，在紐約要租到一台壓路機很容易，甚至不需要駕照就能上路。然而，事實還證明了，看來纖細的Votomatic式流動投票亭居然具備驚人的韌性（也許這是件好事）。投票亭需要多輾壓幾次才能完全變平。整個過程中，內斂的暴力讓人感覺很療癒。

我們的成果是一座雕塑家約翰・張伯倫（John Chamberlain）風格的美麗作品，但這粗暴的的手法似乎還需要加上一個更直白的訊息。何必那麼隱晦呢？我們買了一隻小小的塑膠大象玩具，象徵共和黨，並把大象放在壓扁的亭子上，大家看一眼就會知道是誰在施壓了。

LEVER HOUSE 390

如何穿越時間

紐約利華大樓
Lever House

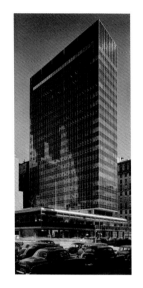

左圖
戈登‧邦沙夫特
1952年的作品「利
華大樓」邁入50周
年，SOM建築設計
事務所與威廉‧喬吉
斯仔細修復這棟建築
物，我們則以相同
的方式調整大樓的
商標。

上圖
利華大樓是一座以玻
璃與鋼鐵打造的摩天
大樓，座落於曼哈頓
中城，為未來半世紀
的紐約辦公大樓樹立
了標竿。

建築師、產品設計師和時裝設計師都有許多素材要處理，像是：鋼鐵與玻璃、塑膠與聚合物、布料與織品。而平面設計師則是沉浸在紙張與像素的世界，並經常發現我們的選擇只剩下一種：到底該用什麼字體？偏偏這個選擇影響甚鉅。「文字能表達意義，字體能呈現精神。」我的搭檔寶拉‧謝爾（Paula Scher）這麼說。所謂的精神可能是有爭議的，也可能難以捉摸，或者難以言喻，但卻是我們的祕密武器和最強大的工具。

1999年，我們接到設計師威廉‧喬吉斯（William Georgis）的電話。紐約地標利華大樓即將迎來50周年紀念，喬吉斯和大樓原本的團隊SOM建築設計事務所正在進行仔細的修復。建築物上所有的舊商標都需要更換，新商標則需要符合21世紀的建築風格。他們想知道，我們願不願意擔任這個案子的平面設計顧問？

利華大樓在1952年落成時改變了紐約。SOM事務所的戈登‧邦沙夫特（Gordon Bunshaft）構思出這座玻璃與鋼鐵建成的摩天大樓，也是整條公園大道上第一棟這樣的建築物，在那之前，路上只有一整排綿延不絕的紅磚屋。這座大樓矗立在一座水平平台上，而平台本身也是一座較矮的建築物，底下有開放、明亮的人行道，整體建築物極為細膩。大樓的室內設計交給了漢斯‧諾爾（Hans Knoll）與妻子弗蘿倫絲‧諾爾（Florence Knoll），而雷蒙‧洛伊（Raymond Loewy）則負責公開展覽，有人認為大樓商標也是出自他的手筆。

只要稍微看一下那破舊的舊商標，就知道這與時下風格不符。我們別無選擇，只能挪出大部分預算，用少數殘存的字母來開發一套全新的字體。強納森‧霍夫勒（Jonathan Hoefler）和托比亞斯‧弗里爾瓊斯（Tobias Frere-Jones）接下任務，要修復這些奄奄一息的字母。最後他們打造出的「Lever Sans」字體，非常完美。人們總說「字體就像時光機」，新字體的確令人想起《廣告狂人》（*Mad Men*）的時代，卻又不落俗套。也有些人說光是一個字母「R」就能把人帶回卡萊‧葛倫（Cary Grant）在《北西北》（*North by Northwest*）裡住過的那個紐約，我認為真的是太誇大了。

右圖
大樓的新功能、新租客和新規範全都需要製作新的標示,此外,所有現行的標示也都要拆除,仔細更換為全新的版本,皆是採用Lever Sans字體,但我們希望沒有人注意到新舊差異。

上圖
如果使用「Futura」或「Neutraface」等現有字體來執行利華大樓一案,事情會容易很多。然而,殘存的商標雖然已經破損,少了一些字母,卻依然如此與眾不同,教人難以忽視。

右頁
強納森·霍夫勒和托比亞斯·弗里爾瓊斯用八個字母開發出一套完整的新字體。在數位時代做設計尤其具有挑戰性,因為往往沒有先例可循。他們創作的字體非常符合需求,也融入整體建築的細節之中。

紐約利華大樓

A B C D E F
G H I J K L M N
O P Q R S T
U V W X Y Z
1 2 3 4 5
6 7 8 9 0

如何打包長途飛行的行李

聯合航空
United Airlines

左圖與上圖
被聯合航空內部同仁稱為「鬱金香」的商標，是由傳奇設計師索爾·巴斯於1973年打造的，原本已經停用，而我們決定重啟。我們與聯合航空的合作還包括嘗試「以非品牌化的手法來建立品牌」，就像丹尼爾·韋伊用商標的幾何形狀來組成機上咖啡杯的曲線。

聯合航空的行銷團隊正在尋找設計顧問。事後他們跟我說，在他們接洽的所有團隊裡，我們是唯一不打算改變他們飛機塗裝的設計師。「因為乘客搭飛機時看不到機身。」我記得我是這樣告訴他們的。事實上，我們從沒接過航空公司的案子，也沒改造過機身的塗裝，所以在面談的過程中，我們只討論了我們過往的設計經驗，包含餐館、雜誌、招牌、咖啡杯等。當時我推斷，這間航空公司真正需要的並不是製作新的宣傳物，而是設計一趟體驗。

於是，我們從此展開了長達15年的合作關係。從一開始，我就找了我們倫敦辦公室的一位同仁加入，他就是擅長多種手法、能說多種語言、又多才多藝的丹尼爾·威爾（Daniel Weil）。丹尼爾要負責立體方案，而我負責平面方案。我們兩人每個月都會飛一趟芝加哥，去聯合航空的總部跟他們各部門團隊見面。光是面對一位客戶就已經是種挑戰，但我們要面對的可是數百位客戶，挑戰艱鉅可想而知。

我們的策略並非設計出一套抽象的品牌指南，而是像遊擊隊一樣深入大大小小的實際方案中，有條不紊地構築出一間當代航空公司的形象和感受。我們為第一批自動售票機設計了外殼和使用者介面，我們還設計了菜單、叉子和湯匙、大廳商標、毯子和枕頭。我們重新啟用了索爾·巴斯（Saul Bass）設計的經典商標。一直到大約8年之後，我們才終於重新粉刷了機身。

很可惜這段合作關係無法持續下去，聯合航空後來與另外一家航空公司合併了。之後的一連串的取捨，與其說是出於行銷考量，不如說是顧及併購交易的條件。他們把自己的名字與新夥伴的商標結合在一起，一個新的時代開始了，而我們也不再屬於那裡，但無論如何，這都是一趟美妙的旅程。

下圖
我們說服客戶省略「航空公司」這個贅詞，並打造了新的文字商標來強調公司名稱的意涵，這個名稱正好強調了一趟成功的航空旅程需要大家同心協力。

聯合航空

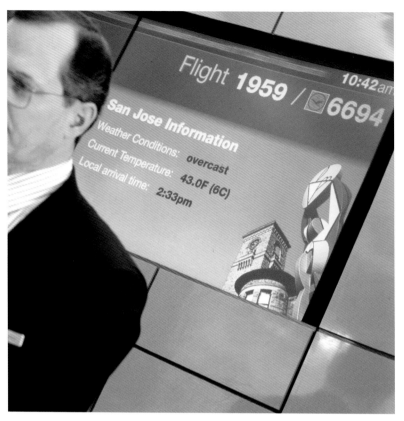

左上圖
只要是可以調整的地方，我們都會努力改善提供旅客資訊的方式，包含登機口。

右上圖
我們重新設計這間航空公司的貴賓室，其中包含了全新的入口標示。

下圖
我們用全新的方式呈現聯合航空的符號，用充滿聯想空間的手法，來表現出航空旅程的故事性。

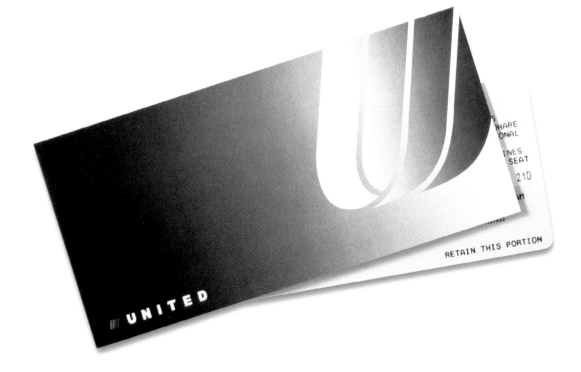

203

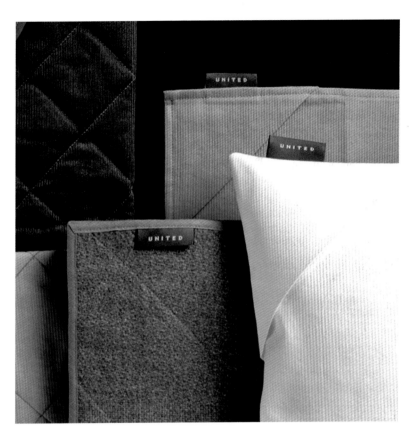

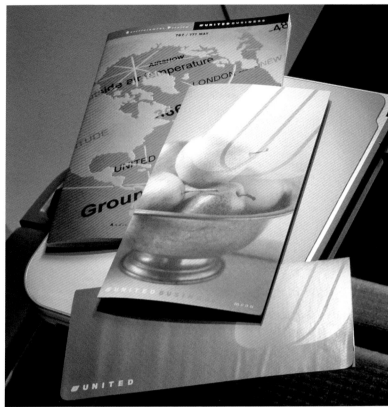

左上圖
品牌並不會影響乘客的飛行體驗，更重要的是過程中觸摸和感覺到的東西。因此，早在提案修改機身塗裝商標之前，我們就建議要製作新的毛毯。

右上圖
以更有效的方式來印製和回收菜單等紙製品，可以減少旅途中不必要的浪費。

下圖
我們設計的盥洗包內有牙膏和眼罩等備品，既輕便又可重複使用。

Building the United Brand

Our Name

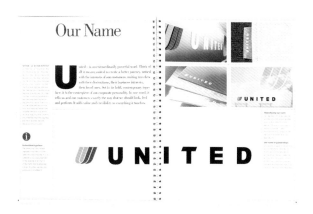

Sweep

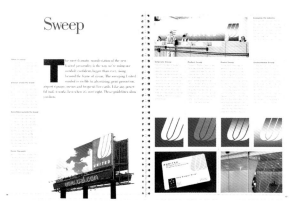

Shape

左圖
這個案子的初期,我
們也製作了一份商標
使用指南手冊,列
出了一些簡單的原則
來展現聯合航空的
風格。

上圖與下一跨頁
最後,經過近8年的
合作,是時候開始重
新打造機身塗裝了,
才能更加符合聯合航
空的新精神。

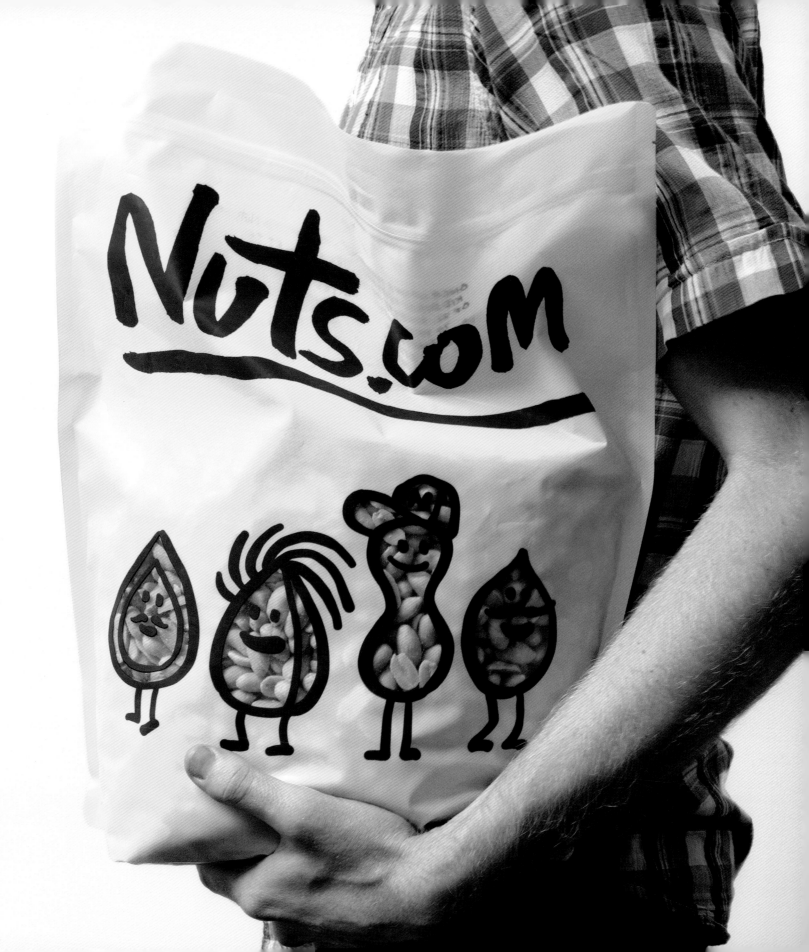

如何讓棕色紙盒變好玩
Nuts.com

左圖
這間公司由創立於經
濟大蕭條年代前，當
時名為紐華克堅果
公司，現在則改名為
Nuts.com，同時販售
果乾、零食、巧克力
和咖啡。

上圖
之前的包裝袋上印
著不太搭調的名稱
「Nuts Online」。

傑夫・布雷弗曼（Jeff Braverman）原本不打算進入家族企業工作。他的祖父「波比」・索爾・布雷弗曼（"Poppy" Sol Braverman）於1929年創辦了紐華克堅果公司（Newark Nut Company），推著一輛手推車，在當地的馬百利街市場賣花生。到了1998年，當傑夫進入賓州大學華頓商學院（Wharton School of Business）念書時，他的父親和叔叔、伯伯將紐華克堅果拓展成一間小規模的零售公司，傑夫自己則想從事銀行業。

不過，他還是利用閒暇時間架設了公司的網站，網站名稱也非常老派：nutsonline.com。「我對這個網站的目標是每天接到10筆訂單。」他這樣告訴公司。但沒想到，線上訂單幾乎是立刻就超過了零售銷售額。於是，傑夫離開了銀行業，接管了堅果公司的業務。12年之內，網站已經擴大到能供應近兩千種商品，年銷售額高達兩千萬美元，而傑夫終於也獲得了他一直想要的網址：「Nuts.com」。有了新的網域名稱，傑夫便邀請我們重新設計公司的包裝。

美國的包裝設計多半很可怕，大公司奉行主流消費觀點，同類包裝占滿實體貨架。畢竟他們要將風險降至最低，而這當然也意味著美感、創意和獨特性都隨之減少。正因如此，傑夫公司簡短的網址讓人耳目一新。他的產品不必在大賣場競爭消費者的注意力，因為客人都在網路上下單，他認為外包裝應該像是裝著禮物的盒子。「我希望客人覺得收到包裹是一件大事，」傑夫告訴我們。Nuts.com沒有大肆投放廣告，反而是將寄送用的紙箱當成快遞手中的活動看板。

我們從傑夫和他的家人身上找到靈感。他們坐鎮於一間6萬平方英尺的倉庫裡，監管著價值數百萬美元的生意，他們沒有大企業的架子又十分風趣，好像還在馬百利街市場用手推車賣東西一樣。因此，我們沒有採用既有字體，而是以我的手寫字來製作成一套名為「Nutcase」的新字體，將文案滿版印製於外盒上，並加上布雷弗曼兄弟的卡通肖像。兩年內，Nuts.com的銷售額增長了50%，好設計是具有力量的，而這次的設計作品既道地又幽默。

ABCDEFGHIJKL
MNOPQRSTUVW
XYZ0123456789
ABCDEFGHIJKLM
NOPQRSTUVWXYZ
123456789ABC
DEFGHIJKLMN
OPQRSTUVWXYZ

左圖
設計師傑瑞米·米克爾（Jeremy Micke）將我手寫字製作成專用字體。

右圖
Nuts.com是一間家族企業，五角星設計的前實習生克里斯多夫·尼曼是一位傑出的插畫家，他畫了一幅全家福，我們的客戶傑夫·布雷弗曼是右邊數來第二位。

下圖
尼曼畫的卡通人物被製作成透明的形式，可以看見包裝袋裡的美味堅果。

下一跨頁
從棕色紙箱到包裝袋，收到Nuts.com的商品時顯得趣味十足。

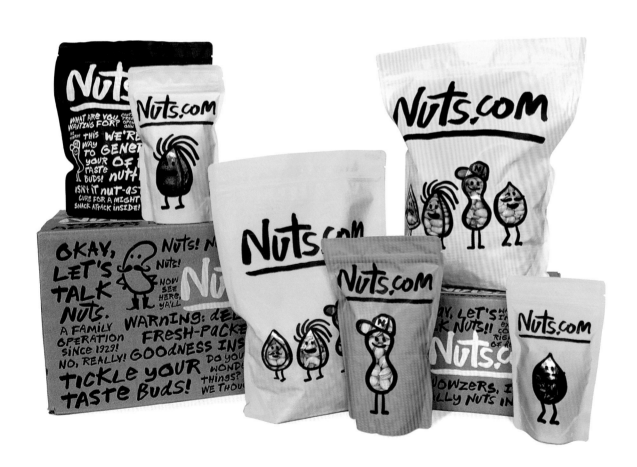

YOU'L

Nuts

Nuts.com

CAUTION: YUMMY HUNGRY
TREATS INSIDE.
OPEN AT YOUR YET?
RISK!

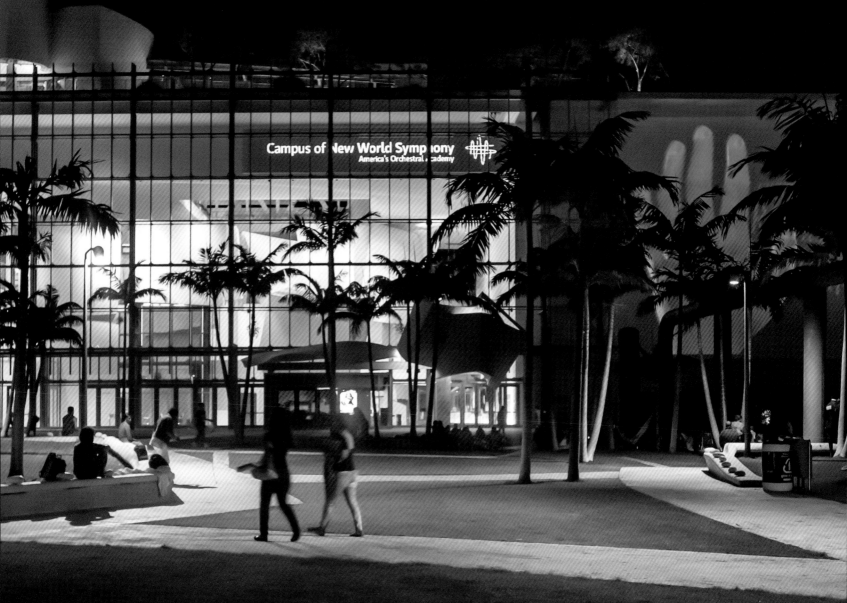

如何閉上嘴巴好好聆聽

新世界交響樂團
New World Symphony

剛開始，整個案子似乎前景大好。麥可·提爾森·湯瑪斯（Michael Tilson Thomas），這位炙手可熱又極富遠見的指揮家、鋼琴家和作曲家，正在為他剛創辦的新世界交響樂團打造一個家。來自世界各地的傑出青年音樂家將會前來佛羅里達州的邁阿密海灘集合，在法蘭克·蓋瑞設計的一座美麗新大樓裡練習。我們受託設計這座交響樂中心的商標，要融合音樂、建築、學習元素，似乎是一個浩大的工程。提爾森·湯瑪斯還要求要有一種「流動」的感覺。

然而，我們遲遲找不到合適的設計。本來我認為自己提出的第一套草稿應該很符合他們的需求，我做了一組彎曲排版的影像變形拼貼，副執行長維多莉亞·羅伯茲（Victoria Roberts）卻非常委婉地告訴我，有些人覺得畫面不太舒服。所以我的第二組提案沒那麼特別，但也可能太過平庸了，我嘗試用樂團名稱的首字縮寫來製作商標，這是我一開始最不想採用的方案，結果確實感覺太中規中矩，讓樂團變得像一間公司。過程中，提爾森·湯瑪斯不斷鼓勵與支持我們，但我也能感覺到他的耐心快要用光了。

最後，我收到了一封包含附件的電子郵件：提爾森·湯瑪斯畫了六張商標的草稿給我。我極其沮喪，因為這彷彿表示他已經厭倦了我不斷猜錯，於是決定直接告訴我答案。而且我無法理解這些草圖，「NWS」三個字母連接在一起，形成了一個類似天鵝的圖案。我應該執行這個點子嗎？我不可能去指導我的客戶如何指揮管弦樂團，怎麼會有人跑來告訴我該如何設計商標！

但後來，我發覺自己其實收到了一份禮物。麥可·提爾森·湯瑪斯一直過著空中飛人般的生活，為了每場演出搭著飛機在世界各地的往返。過程中，他卻願意花時間來思考我的問題，並將他想到的點子畫在紙上。我又看了看草圖，發現連接每個字母之間的線條就像是指揮的手勢，而這就是我所有提案裡都欠缺的元素：流動。他一直以來的訴求就是流動感，但我卻忙得沒時間仔細傾聽。幾個小時之後，我便設計出了最終版本。

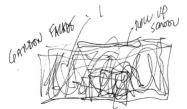

左圖及上圖
法蘭克·蓋瑞的手勢素描濃縮了新世界交響樂位於邁阿密海灘新家的能量。巧合的是，當兩人在洛杉磯成長時，蓋瑞也曾擔任新世界交響樂團的臨時藝術總監。

左圖
我原本很確信自己的
第一個提案就已經解
決了問題,我設計出
一個靈活的商標,以
彎曲的形式重新排列
名字的三個字母,藉
此令人聯想到蓋瑞打
造的建築。但NWS
的維多莉亞．羅伯茲
卻告訴我們,這個設
計「讓人不太舒服」
,跟我們預想中不太
一樣。

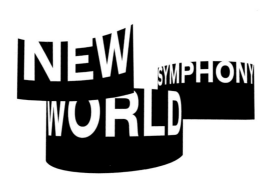

右圖
在我們下一個點子
中,交替採用襯線及
無襯線字體,藉此暗
喻新世界交響樂團在
全新的建築物中,依
然堅守傳統管弦樂團
的風格。這個商標
雖然優雅,卻過於
平淡。

NEWWORLD SYMPHONY

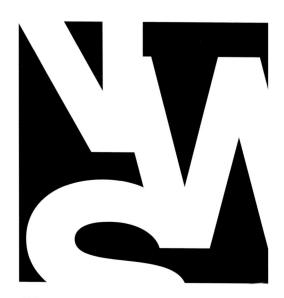

左圖
我並不想使用字母
「NWS」來設計，因
為它的音節數與完整
名稱相同，念起來並
沒有比較節省時間。
我也明確表達自己不
喜歡字首縮寫，儘管
我的客戶本人經常被
暱稱為「MTT」。一
開始用縮寫來進行設
計時，我們還是試圖
呼應建築物的外觀，
而為了有更多「流動
感」，我們還畫了手
繪版本，但這兩個我
們自己都不喜歡。

上圖
三個字母的對比處理
呼應了建築物零碎且
不連貫的內部空間。
我們的設計師葉芙‧
路西維德畫出了很好
看的草稿，但我認為
這個商標更適合化學
公司，而不是文化
機構。

下圖
後來麥可‧提爾森‧湯瑪斯親自畫了草圖給我，剛開始我很不高興，但後來我發現他給了我一把通往答案的鑰匙。

右圖
從指揮棒的動作到聲波科學，再到法蘭克‧蓋瑞的原始建築草圖，用一個手勢連接起這三個字母就能想像出這一切。最困難的就是如何讓N、W和S交織在一起。

下圖
在最終的設計中，我們選擇了適度將線斷開，好讓這三個字母更容易辨識。

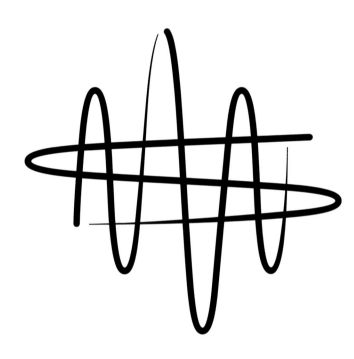

新世界交響樂團

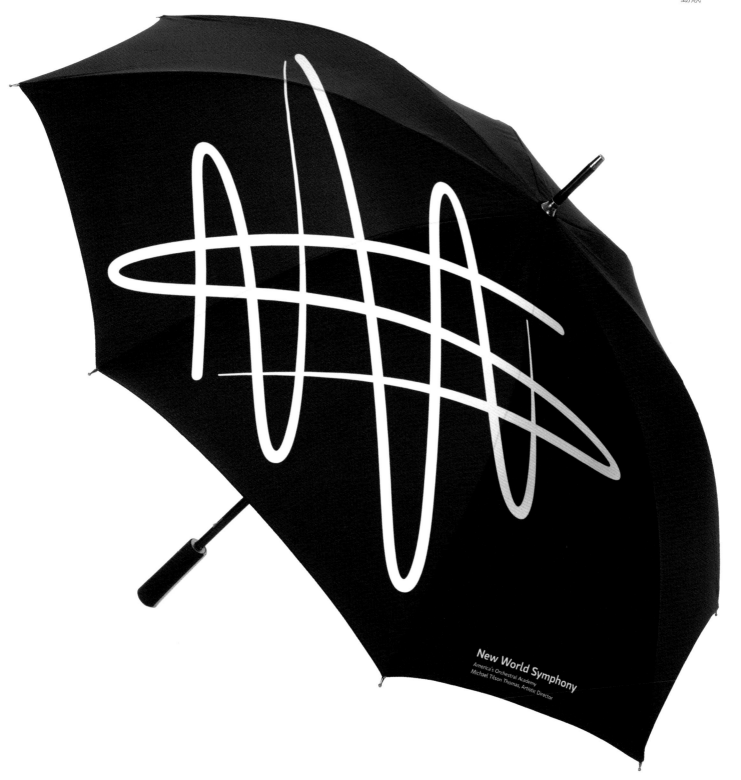

New World Symphony
America's Orchestral Academy
Michael Tilson Thomas, Artistic Director

LAST WEEK	THIS WEEK	TITLE PRODUCER (SONGWRITER)	Artist IMPRINT/PROMOTION LABEL	CERT	PEAK	WKS. ON CHART
1	1	#1 6 WKS **LOCKED OUT OF HEAVEN** THE SMEEZINGTONS,J.BHASKER,E.HAYNIE,M.RONSON (BRUNO MARS,P.LAWRENCE II,A.LEVINE)	Bruno Mars ATLANTIC		1	15
5	2	DG SG **THRIFT SHOP** R.LEWIS (B.HAGGERTY,R.LEWIS)	Macklemore & Ryan Lewis Feat. Wanz MACKLEMORE/ADA/WARNER BROS.		2	15
4	3	**HO HEY** R.HADLOCK (W.SCHULTZ,J.FRAITES)	The Lumineers ▲ DUALTONE		3	32
3	4	AG **I KNEW YOU WERE TROUBLE.** MAX MARTIN,SHELLBACK (T.SWIFT,MAX MARTIN,SHELLBACK)	Taylor Swift ▲ BIG MACHINE/REPUBLIC		2	13
2	5	**DIAMONDS** STARGATE,BENNY BLANCO (S.FURLER,B.LEVIN,M.S.ERIKSEN,T.E.HERMANSEN)	Rihanna ▲ SRP/DEF JAM/IDJMG		1	16
8	6	**SCREAM & SHOUT** LAZY JAY (W.ADAMS,J.MARTENS,J.BAPTISTE)	will.i.am & Britney Spears INTERSCOPE		6	7
11	7	**DON'T YOU WORRY CHILD** AXWELL,S.INGROSSO,S.ANGELLO (J.MARTIN,M.ZITRON,AXWELL,S.INGROSSO,S.ANGELLO)	Swedish House Mafia Feat. John Martin ASTRALWERKS/CAPITOL		7	17
7	8	**BEAUTY AND A BEAT** MAX MARTIN,ZEDD (MAX MARTIN,A.ZASLAVSKI,S.KOTECHA,O.T.MARAJ)	Justin Bieber Featuring Nicki Minaj SCHOOLBOY/RAYMOND BRAUN/ISLAND/IDJMG		5	14
6	9	**HOME** D.PEARSON (D.PEARSON,G.HOLDEN)	Phillip Phillips ② 19/INTERSCOPE		6	29
10	10	**I CRY** THE FUTURISTICS,SOFLY & NIUS,P.BAUMER,M.HOOGSTRATEN (T.DILLARD,	Flo Rida		6	16

The track crowns Hot Digital Songs (2-1), hiking by 18% to 279,000 downloads sold, according to Nielsen SoundScan. It rules the new Streaming Songs survey (see page 66), registering 1.5 million streams (up 17%) and charges 38-22 on Hot 100 Airplay (44 million audience impressions, up 33%), according to Nielsen BDS.

The EDM trio scores its first Hot 100 top 10 with its first chart entry. The cut ranks at No. 2 on the new Dance/Electronic Songs chart (see page 79).

2 WKS. AGO	LAST WEEK	THIS WEEK	TITLE PRODUCER (SONGWRITER)	IM
22	21	24	**LET ME LOVE YOU (UNTIL YOU LEARN TO LOV** STARGATE,REEVA,BLACK (S.C.SMITH,S.FURLER,T.E.HERMANSEN,M.HADFIELD,M.DIS CALA)	
42	34	25	**DAYLIGHT** A.LEVINE,MDL,MAX MARTIN (A.LEVINE,MAX MARTIN,SAMM,M.LEVY)	
28	32	26	**HALL OF FAME** The Script Feat D.O'DONOGHUE,M.SHEEHAN,J.BARRY (D.O'DONOGHUE,M.SHEEHAN,W.ADAMS,J.BARRY)	
38	27	27	**LITTLE TALKS** Of Mon OF MONSTERS AND MEN,A.ARNARSSON (N.B.HILMARSDOTTIR,R.	
30	33	28	**I'M DIFFERENT** DJ MUSTARD (T.EPPS,D.MCFARLANE)	
23	26	29	**CLIQUE** Kanye West, HIT-BOY,K.WEST (C.HOLLIS,S.M.ANDERSON,K.O.WEST,S.C.CARTER,J.E.FAUNTLEROY II)	
19	23	30	**CRUISE** Florid J.MOI (B.KELLEY,T.HUBBARD,J.MOI,C.RICE,J.RICE)	
25	31	31	**WANTED** D.HUFF,H.HAYES (T.VERGES,H.HAYES)	ATLA
46	35	32	**I WILL WAIT** M M.DRAVS (MUMFORD & SONS)	GENTLEMAN OF
39	40	33	**BETTER DIG TWO** T D.HUFF (B.CLARK,S.MCANALLY,T. ROSEN)	
44	36	34	**ADORN** MIGUEL (M.J.PIMENTEL)	
41	44	35	**EVERY STORM (RUNS OUT OF RAIN)** G.ALLAN,G.DROMAN (G.ALLAN,M.WARREN,H.LINDSEY)	
33	37	36	**LITTLE THINGS** J.GOSLING (E.SHEERAN,F.VEVAN)	
34	28	37	**TOO CLOSE** DIPLO,SWITCH,A.RECHTSCHAID (A.CLARE,J.DUGUID)	
29	38	38	**NO WORRIES** Lil Wayne F DETAIL (D.CARTER,N.C.FISHER,B.WILLIAMS,J.A.PREYAN,R.DIAZ)	YO
17	25	39	**WE ARE NEVER EVER GETTING BACK TOG** MAX MARTIN,SHELLBACK,D.HUFF (T.SWIFT,MAX MARTIN,SHELLBACK	
27	29	40	**CALL ME MAYBE** Ca J.RAMSAY (J.RAMSAY,C.R.JEPSEN,T.CROWE)	
51	49	41	**RADIOACTIVE** Im ALEX DA KID (IMAGINE DRAGONS,A.GRANT,J.MOSSER)	

如何登上排行榜

告示牌雜誌
Billboard

左圖
這張「百大」圖表是
雜誌內頁的實際尺
寸，精確縝密又充滿
了細節，好讓讀者仔
細閱讀。

上圖
1996年時我還是個
孩子，當時就已經知
道這本雜誌是音樂產
業的聖經。

就像許多60年代的孩子，我也很愛音樂。但是，與多數好友
不同的是，收音機裡的「40強」排行無法滿足我。所以，我
每周都會去當地圖書館的雜誌室，在那裡花好幾個小時閱讀那
本音樂產業的聖經——《告示牌》雜誌。

《告示牌》是美國最老牌的出版品之一，創立於1894年，原
本是戶外廣告的業內雜誌。後來，雜誌內容擴展到馬戲團、雜
耍、嘉年華等，隨著1930年代自動點唱機的發明，音樂成為
雜誌的最終焦點。後來搖滾樂興起，1958年8月，我一歲生日
的前幾周，這本雜誌推出了傳奇的「百大單曲排行榜」。

我不知道為什麼自己會對百大單曲和兩百大專輯名單如此著
迷。也許是因為，當時還是國中生的我，在學生餐廳裡總像個
邊緣人，後來發現原來受歡迎的程度竟然可以被精準計算，這
讓我感到十分安慰。每次看到我最喜歡的樂團登上第一名，就
彷彿自己也獲得勝利一般。雖然排行榜圖表旁邊總寫滿了我看
不懂的行話，但讀著讀著，我就覺得自己好像也成了一位圈內
人。

因此，40年後，當我受託要在這數位音樂的新世界裡重新設
計《告示牌》，這真是一件令人激動萬分的事。自從1966年
以來，這本雜誌就幾乎沒有任何改變，當年湯米・詹姆斯與桑
德爾樂團（Tommy James & The Shondells）的單曲〈Han-
ky Panky〉登上排行榜第一名。然而，但排行榜的數量卻大幅
增加，涵蓋了墨西哥地區的專輯到手機鈴聲等各種內容。

這是我做過的最複雜的資訊設計專案之一。我們和《告示牌》
的藝術總監安德魯・霍頓（Andrew Horton）合作，設計出14
欄的版型來統一雜誌的整體方向。我們還修改了雜誌商標，強
調簡單的幾何形狀和明亮的原色。原本的圖表彷彿一灘模糊黯
淡的死水，我們恢復了過往的權威感，以黑色、白色和粗體字
來呈現，加強整體的易讀性。

事實證明，即使在數位時代，流行音樂家仍然很重視他們首次
登上告示牌第一名的時刻。而我們的資訊設計十分適用於排行
榜。

右圖
雜誌名稱的每個字母
幾乎都是由圖形和直
線組成，這是設計
師夢寐以求的字母組
合。就算我們完全解
構了這些字母，這些
文字還是能夠辨識。
我們總共設計了好幾
十個版本，最上面的
是舊商標，最下面的
則是我們重新設計的
最終版，中間則是
部分曾納入考量的
設計。

Billboard

billboard

Billboard

billboard

Billboard

billboard

右圖
新封面採用大眾消費
雜誌的設計風格，意
在表明這本雜誌不僅
對業內人士而言不可
或缺，熱情的音樂粉
絲也同樣會喜歡。

01.26.2013 ● billboard.com ● billboard.biz

billboard

ALAN MELTZER The Life & Death Of An
Indie Empire Builder MACKLEMORE &
RYAN LEWIS Why Is The No. 1 Rap Song
Not On Hip-Hop Radio? CES WRAP

PRINCE
American
Idol

$6.99US $8.99CAN

UK £5.50

右圖
內頁標題採用了與雜誌名稱相似的字體，以黑白大膽呈現，也強調了高對比的排版元素。

右頁
經過五角星設計的萊茨·侯和麥可·迪爾（Michael Deal）一番努力，這些圖表恢復了昔日榮光，從雜亂無章的馬後炮變成了指標性的排行榜。

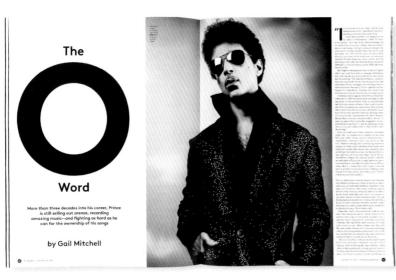

《告示牌》百大排行榜是流行文化指標，在我們重新設計的圖表中，讀者可以輕鬆看到表上每首歌曲的排名，名次快速爬升的歌曲會以白色「圓點」來呈現，而每週獲得最大收益的歌曲旁則會有紅色旗幟標示。每首歌曾獲得過的最佳名次和停留周數則在歌曲名稱的右側。所有資料文字都採用設計師克里斯帝安·施瓦茨（Christian Schwartz）最易於閱讀的「Amplitude」字體，而歌曲名稱則是採用奧雷勒·薩克（Aurèle Sack）正圓型的「LL Brown」字體，雜誌中的所有大標題也是。

2 WKS AGO	LAST WEEK	THIS WEEK	TITLE / PRODUCER (SONGWRITER) — Artist — IMPRINT/PROMOTION LABEL	CERT.	PEAK POS.	WKS ON CHART
53	53	51	I DRIVE YOUR TRUCK — Lee Brice — K.JACOBS,M.MCCLURE,L.BRICE (J.ALEXANDER,C.HARRINGTON,J.YEARY) / CURB		51	11
56	50	52	GET YOUR SHINE ON — Florida Georgia Line — J.MOI (T.HUBBARD,B.KELLEY,R.CLAWSON,C.TOMPKINS) / REPUBLIC NASHVILLE		50	8
RE-ENTRY		53	MADNESS — Muse — MUSE (M.BELLAMY) / HELIUM-3/WARNER BROS.		53	26

After a four-week break, the song returns at a new peak. After setting the mark for the longest reign in the Alternative chart's history (19 weeks), it continues gaining on Adult (14-13) and Mainstream Top 40 (30-29).

2 WKS AGO	LAST WEEK	THIS WEEK	TITLE / PRODUCER (SONGWRITER) — Artist — IMPRINT/PROMOTION LABEL	CERT.	PEAK POS.	WKS ON CHART
60	55	54	SOMEBODY'S HEARTBREAK — Hunter Hayes — D.HUFF,H.HAYES (A.DORFF,L.LAIRD,H.HAYES) / ATLANTIC/WMN		54	17
49	51	--	KISS YOU — One Direction — C.FALK,RAMI (SHELLBACK,R.YACOUB,C.FALK,S.KOTECHA,K.LUNDIN,K.FOGELMARK,A.NEDLER) / SYCO/COLUMBIA		46	12
57	59	56	LOVEEEEEEE SONG — Rihanna Feat. Future — FUTURE (N.WILBURN,R.FENTY,D.ANDREWS,G.S.JACKSON,L.S.ROGERS) / SRP/DEF JAM/IDJMG		55	7
72	68	57	ALIVE — Krewella — RAIN MAN (Y.YOUSAF,Y.YOUSAF,K.TRINDL,N.LIM,I.LUDELL) / KREWELLA/COLUMBIA		57	6
66	62	58	PIRATE FLAG — Kenny Chesney — B.CANNON,K.CHESNEY (R.COPPERMAN,D.L.MURPHY) / BLUE CHAIR/COLUMBIA NASHVILLE		58	6
·	100	59	GONE, GONE, GONE — Phillip Phillips — G.WATTENBERG (D.FUHRMANN,T.CLARK,G.WATTENBERG) / 19/INTERSCOPE		59	2
80	70	60	POWER TRIP — J. Cole Featuring Miguel — J.L.COLE (J.COLE,H.LAWS) / ROC NATION/COLUMBIA		60	5
63	60	61	R.I.P. — Young Jeezy Featuring 2 Chainz — D.MUSTARD (J.W.JENKINS,D.MCFARLANE,T.EPPS,B.DEVAUGHN,A.YOUNG,E.WRIGHT,L.PATTERSON,O.JACKSON,G.HESTER,A.NOLAND,L.BONNER,R.MIDDLEBROOKS,W.MORRISON,M.JONES,M.PIERC) / CTE/DEF JAM/IDJMG		59	6
43	49	--	BETTER DIG TWO — The Band Perry — D.HUFF (B.CLARK,S.MCANALLY,T.ROSEN) / REPUBLIC NASHVILLE	▲	28	20
45	48	--	ONE OF THOSE NIGHTS — Tim McGraw — B.GALLIMORE,T.MCGRAW (L.LAIRD,R.CLAWSON,C.TOMPKINS) / BIG MACHINE	●	32	16
RE-ENTRY		64	22 — Taylor Swift — MAX MARTIN,SHELLBACK (T.SWIFT,MAX MARTIN,SHELLBACK) / BIG MACHINE/REPUBLIC		44	3

Following the start of her Red tour in Omaha, Neb. (March 13), the third pop single from her like-titled album re-enters Hot Digital Songs at No. 57 (32,000, up 163%) and arrives as the highest debut (No. 61) on Hot 100 Airplay (18 million in audience, up 115%).

2 WKS AGO	LAST WEEK	THIS WEEK	TITLE / PRODUCER (SONGWRITER) — Artist — IMPRINT/PROMOTION LABEL	CERT.	PEAK POS.	WKS ON CHART
52	61	--	I'M DIFFERENT — 2 Chainz — DJ MUSTARD (T.EPPS,D.MCFARLANE) / DEF JAM/IDJMG		27	18
70	67	66	IF I DIDN'T HAVE YOU — Thompson Square — NV (S.THOMPSON,K.THOMPSON,J.SELLERS,P.JENKINS) / STONEY CREEK		66	11
73	65	67	NEXT TO ME — Emeli Sande — CRAZE,HOAX (A.E.SANDE,H.CHEGWIN,H.CRAZE,A.PAUL) / CAPITOL		65	4
41	58	--	C'MON — Ke$ha — DR. LUKE,BENNY BLANCO,CIRKUT (K.SEBERT,L.GOTTWALD,B.LEVIN,MAX MARTIN,H.WALTER) / KEMOSABE/RCA		27	13
62	66	--	NEVA END — Future — MIKE WILL MADE-IT (N.WILBURN,M.L.WILLIAMS II,P.R.SLAUGHTER) / A-1/FREEBANDZ/EPIC		52	15
54	57	--	TORNADO — Little Big Town — J.JOYCE (N.HEMBY,D.MAID) / CAPITOL NASHVILLE	●	51	19
71	72	71	GIVE IT ALL WE GOT TONIGHT — George Strait — T.BROWN,G.STRAIT (M.BRIGHT,P.O'DONNELL,T.JAMES) / MCA NASHVILLE		71	11
95	80	72	LOVE AND WAR — Tamar Braxton — D.CAMPER, JR. (M.RIDDICK,L.DANIELS,T.BRAXTON) / STREAMLINE/EPIC		57	8
57	69	--	MERRY GO 'ROUND — Kacey Musgraves — L.LAIRD,S.MCANALLY,K.MUSGRAVES (K.MUSGRAVES,J.OSBORNE,S.MCANALLY) / MERCURY NASHVILLE		63	14

2 WKS AGO	LAST WEEK	THIS WEEK	TITLE / PRODUCER (SONGWRITER) — Artist — IMPRINT/PROMOTION LABEL	CERT.	PEAK POS.	WKS ON CHART
44	64	74	ONE WAY OR ANOTHER (TEENAGE KICKS) — One Direction — J.BUNETTA,J.RYAN (D.HARRY,N.HARRISON,J.O'NEILL) / SYCO/COLUMBIA		13	5
·	98	75	SHOW OUT — Juicy J Featuring Big Sean And Young Jeezy — MIKE WILL MADE-IT (J.HOUSTON,S.W.JENKINS,S.M.ANDERSON) / KEMOSABE/COLUMBIA		75	2
64	71	76	WICKED GAMES — The Weeknd — DOC,C.MONTAGNESE,THE WEEKND (A.TESFAYE,C.MONTAGNESE,C.MCKINNEY) / XO/REPUBLIC		53	20
HOT SHOT DEBUT		77	FREAKS — French Montana Feat. Nicki Minaj — RICO LOVE,E.THOMASON (K.KHARBOUCH,O.T.MARAJ,RICO LOVE,D.L.DAVIS,Q.RILEY,E.BONNER,S.DUNBAR,J.C.TAYLOR,J.D.WILLIS) / BAD BOY/INTERSCOPE		77	1
83	76	78	I CAN TAKE IT FROM THERE — Chris Young — J.STROUD (C.YOUNG,R.AKINS,B.HAYSLIP) / RCA NASHVILLE		76	6
79	78	79	BATTLE SCARS — Lupe Fiasco & Guy Sebastian — PRO J (W.JACO,G.SEBASTIAN,D.R.HARRIS) / 1ST & 15TH/ATLANTIC		73	12
·	96	80	KISSES DOWN LOW — Kelly Rowland — MIKE WILL MADE-IT,MARZ (M.L.WILLIAMS II,M.MIDDLEBROOKS,T.THOMAS,T.THOMAS,K.ROWLAND) / REPUBLIC		80	2
·	84	81	HIGHWAY DON'T CARE — Tim McGraw With Taylor Swift — B.GALLIMORE,T.MCGRAW (B.WARREN,B.WARREN,M.IRWIN,J.KEAR) / BIG MACHINE		59	3
82	75	82	WE STILL IN THIS B**** — B.o.B Feat. T.I. & Juicy J — MIKE WILL MADE-IT,MARZ (B.R.SIMMONS, JR.,M.L.WILLIAMS II,M.MIDDLEBROOKS,C.J.HARRIS, JR.,J.HOUSTON) / REBELROCK/GRAND HUSTLE/ATLANTIC		75	5
58	63	83	HEY PORSCHE — Nelly — DJ FRANK E,D.GLASS,M.FREESH,T.MAZUR,H.KIPNER (D.E.GLASS,H.KIPNER,B.S.ISAAC,J.FRANKS,C.HAYNES, JR.) / REPUBLIC		42	4
86	81	84	LIKE JESUS DOES — Eric Church — J.JOYCE (C.BEATHARD,M.CRISWELL) / EMI NASHVILLE		81	4
74	73	85	WHO BOOTY — Jonn Hart Featuring IamSU! — RAW SMOOV (D.J.GRIZZELL,S.A.WILLIAMS,K.KHARBOUCH) / COOL KID CARTEL/EPIC		66	14
78	82	86	DON'T JUDGE ME — Chris Brown — THE MESSENGERS (C.M.BROWN,N.ATWEH,A.MESSINGER,M.PELLIZZER) / RCA		67	20
NEW		87	DONE. — The Band Perry — D.HUFF (R.PERRY,N.PERRY,J.DAVIDSON,J.BRYANT) / REPUBLIC NASHVILLE		87	1
75	79	88	THE ONLY WAY I KNOW — Jason Aldean With Luke Bryan & Eric Church — M.KNOX (D.L.MURPHY,B.HAYSLIP) / BROKEN BOW	●	40	19
84	87	89	STUBBORN LOVE — The Lumineers — R.HADLOCK (W.SCHULTZ,J.FRAITES) / DUALTONE		70	14
NEW		90	SO MANY GIRLS — DJ Drama Feat. Wale, Tyga & Roscoe Dash — NOT LISTED (NOT LISTED) / APHILLIATES/EONE		90	1
90	83	91	GOLD — Britt Nicole — D.MUCKALA (B.NICOLE,D.MUCKALA,J.CATES) / SPARROW/CAPITOL CMG/CAPITOL		83	3
98	93	92	MORE THAN MILES — Brantley Gilbert — D.HUFF (J.EDDIE,B.GILBERT) / VALORY		92	3
NEW		93	1994 — Jason Aldean — M.KNOX (THOMAS RHETT,L.LAIRD,B.DEAN) / BROKEN BOW		93	1

Aldean's ode to the year that Joe Diffie ruled Hot Country Songs with two No. 1s becomes the eighth Hot 100 hit whose title is a year. Others include Phoenix's "1901," Bowling for Soup's "1985" and Prince's "1999." See the full list in Billboard.com's Chart Beat column. —Gary Trust

2 WKS AGO	LAST WEEK	THIS WEEK	TITLE / PRODUCER (SONGWRITER) — Artist — IMPRINT/PROMOTION LABEL	CERT.	PEAK POS.	WKS ON CHART
99	90	94	LEVITATE — Hadouken! — LOADSTAR (HADOUKEN!,A.SMITH,N.HILL,G.HARRIS) / SURFACE NOISE		90	3
85	85	95	CUPS — Anna Kendrick — C.BECK,M.KILIAN (A.P.CARTER,L.GERSTEIN,D.BLACKETT,H.TUNSTALL-BEHRENS,I.FREEMAN) / UME		64	12
87	86	96	DOPE — Tyga Featuring Rick Ross — M.ROBERTS (M.NGUYEN-STEVENSON,M.L.ROBERTS II,M.ROBERTS,J.JACKSON,C.C.BROADUS JR.,C.WOLFE,A.YOUNG) / YOUNG MONEY/CASH MONEY/REPUBLIC		68	8
91	88	97	LOVE SOSA — Chief Keef — YOUNG CHOP (K.COZART,T.PITTMAN) / GLORY BOYZ/INTERSCOPE		56	14
93	92	98	CHANGED — Rascal Flatts — D.HUFF,RASCAL FLATTS (G.LEVOX,N.THRASHER,W.MOBLEY) / BIG MACHINE		73	4
·	74	99	BUZZKILL — Luke Bryan — J.STEVENS (L.BRYAN,R.THIBODEAU,J.SEVER) / CAPITOL NASHVILLE		74	2
89	94	100	LITTLE THINGS — One Direction — J.GOSLING (E.SHEERAN,F.BEVAN) / SYCO/COLUMBIA	●	33	18

"I'M NOT 'BOUT TO JUDGE YOU, DON'T JUDGE ME. YOU AIN'T GOTTA REALLY SING ABOUT YOUR RAP SHEET."

"BAD"—WALE FEATURING TIARA THOMAS

Q&A

Tiara Thomas

You co-wrote and sang on Wale's "Bad," which jumps 45-38 on the Billboard Hot 100 this week. You're signed to his Board Administration management/label. How did you first link with him?
[A friend] was like, "Hey, let's go to Atlanta for spring break." We went and I had a fake ID; I was under 21 at the time. We wanted to go to the club. It was like, "There's Wale, let's take a picture with him." Afterward, I sent him some YouTube videos I had online. Three months later, he hits me up: "Yo, I'm gonna fly you out to New York."

How did you come up with "Bad"?
There was this rap song called "Some Cut" by Trillville. It used to be one of my favorite songs when I was younger. It's really vulgar; I wanted to find a way to cover the song and make it sound pretty. Seven months after I dropped it on YouTube, Wale listened to it, and he really liked it. He put his verses on it and took the song to a whole new level.

So it started as your YouTube clip, and now it's the lead single on his new album?
It was just a cover at first. I just had other lyrics on there on top of the hook. Wale kind of created a story out of it—it's like a girl anthem. That's crazy. That's what I like so much about it: A rapper puts out a girl anthem. —Chris Payne

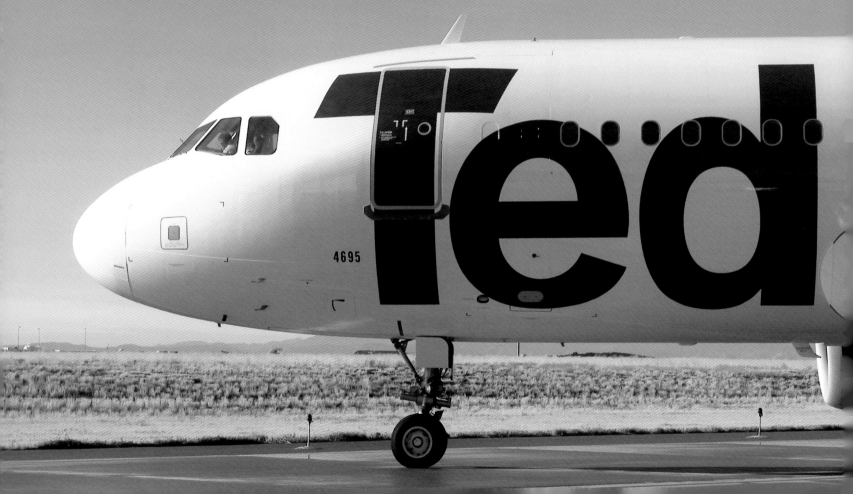

如何說服別人

泰德航空
Ted

左圖
對於泰德航空這個品牌，我們的設計前提很簡單：白色的機身、簡單的商標，而且要非常巨大。正如我在品牌正式推出時告訴《紐約時報》的那樣：「我們靈機一動，就知道這應該會有效果……聯合航空（United）的全名裡就藏著Ted這三個字，這真是個剛剛好的奇蹟。」

剛從設計學校畢業時，我一直相信只要是好點子，自然就會有效果，但其實不然。事實證明，找到正確方案來解決設計問題，這只不過是第一步而已。至關重要的下一步，是要讓別人相信你的解決方案是正確的。但為什麼這麼難呢？

首先，雖然有時我們很幸運，遇到很相信我們的客戶，但通常我們還會需要說服其他人。案子越重要，團隊就越大，也越難控管。其次，一個設計決策究竟是否正確，也不是用計算機就能驗證的。相反地，這要仰賴直覺和品味等模糊的感受。最後，好的設計決策最終勢必要放手一搏。比如要拯救一間形象搖搖欲墜的保守公司，我們經常不得不把死板會議室改造成活潑的帳篷。

2003年，我們的客戶聯合航空決定投入廉價航空市場，與捷藍航空（JetBlue）、西南航空（Southwest），以及達美航空（Delta）旗下的頌恩（Song）和加拿大航空（Air Canada）的探戈（Tango）等新進對手競爭。他們要求我們設計新機身，而且還給了我們一個更困難的挑戰，要我們想出一個品牌名稱。他們大概是認為，設計固然困難，但只要是養過寵物的人，都一定很會取名字，哪怕只是養了條金魚。

經過幾個月的努力，考慮了一百多個名稱，並數度提案失敗之後，我的搭檔丹尼爾·威爾與同事大衛·吉布斯（David Gibbs）終於幫聯合航空想出了一個完美的子品牌名稱，有魅力、友善又隨興，就像個小跟班一樣，名叫「泰德」（Ted）。這個名字的確是個暱稱，源自於老大哥著名商標的最後三個字母。

我們對此十分篤定，但我們也知道，說服客戶可能會有點困難，因為客戶包含了他們公司各個部門的人，比如行銷總監約翰·帝格（John Teague）及董事長葛蘭·堤爾頓（Glenn Tilton）。我們做了一份65頁的簡報，顯示出這個名稱勢在必得，而且又趣味感十足。直到今天，在我做過的所有簡報中，這是我最喜歡的。

左圖
我們希望新的子品牌是渾然天成地納入聯合航空團隊，而不是太晚進入別人已經投入的廉航戰局。為了盡量生動地展現出與眾不同的感覺，我們的簡報從兩篇虛構的《華爾街日報》報導開始。

WSJ.com

Air-Apparent

United Joins the Low-Cost Fray

New Carrier to Compete with JetBlue, Southwest

Analysts Skeptical

United Airlines, subsidiary of the UAL Corporation (UAL) announced additional details this week regarding their bid to launch a new low-cost carrier. With the current trend in the industry of smaller planes and improved per-seat efficiencies, United believes that they will be able to effectively compete with front-runners JetBlue, Southwest, and Frontier. The launch of the yet-to-be-named airline will come on the heels of Delta's Song, which beat United to the punch when it began service this past July.

WSJ.com

Sky's The Limit

For United, a Truly Bold Transformation

A New Vision of "Customized Travel"

Goal: Everywhere You Want, Any Way You Want

"It's different than anything they've ever tried before–the creation of a family of branded travel products to meet the specific needs of their customers." says Airline expert Robert Hogan, Professor at USC and former PanAm executive. Fundamental to its success will be the launch a new low-cost carrier that, while competing with the likes of JetBlue and Southwest, will have the distinct advantage of United's route network.

眾所皆知，一場好演講的必備條件就是說故事，要有開場白、中間過程和最後結局。當我們受託執行這個案子之前，我們的客戶其實已經在聯合航空的廉價航空商業提案上花了一整年的時間。因此，我們要提醒他們，外界對他們的戰略一無所知，也不一定關心他們是否成功，這點十分重要。

對聯合航空來說，推出新品牌最大不同就是，往後這個子品牌將會整合進他們舊有的龐大體制之中。子品牌的設計必須與母牌的所有細節相互協調，包括機身塗裝在內。因此，在規畫時，我們刻意將設計風格和名稱分開來討論，畢竟同時發想兩個東西往往會導致會議毫無重點，有的人可能會喜歡這個名字，但卻不喜歡相對應的設計。

我一遍又一遍地向公司的個個團隊進行簡報，而且每一次都十分成功，這很少見。一份有效解決方案，對提案過程的確很有幫助。

CORPORATE VIEW

LCO brand profile

Brand advantages

Competitive pricing
Mileage Plus benefits
Options and frequency
Connected network
A United brand

CUSTOMER VIEW

Brand attributes

Trustworthy
Reliable
Good service
Customer first
Understanding
Open
Energized

上圖
我們使用兩個圖表來
讓客戶知道，組織內
部觀點是基於營運部
門角度，但對消費者
來説，每個細節都是
相互關聯的網絡，兩
者並不相同。

右圖
每個現有的運營部門
都有既定的外觀設
計。新品牌要如何融
入呢？

Brand experience

Retail
Friendly
Active
Engaging
Entertaining
Attractive
Simple
Changing
Social

上圖
我通常比較喜歡用圖
片來呈現簡報，而不
是一長串文字清單，
但對這個客戶來説，
文字比較有共鳴。

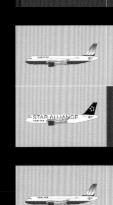

Close-in vs. further out

<div style="display:flex;">
1 2 3 4 5
</div>

上圖
品牌名稱和設計風格
應該是相互關聯但各
自獨立的決策。我們
把名稱暫時保留,並
展示了重要的選項:
新的子品牌外觀看起
來應該要與母品牌相
近,還是要完全不
同呢?

右圖
我們的建議使用聯合
航空原本的字體,並
保留「鬱金香」商
標,但採用新的顏
色,也就是橙黃色,
與原本的藍色形成對
比。足夠的相似度能
帶給顧客安心感,同
時又有足夠差異,製
造出驚喜。

泰德航空

Approach

No invented words (Allegis, Avolar)
Be energetic and inspiring
A clear relationship with United
Avoid "me too" options
Manage expectations

DEFINITION:
One who flies
PROS:
Passenger-focused
Simple and familiar, but hip
Participatory, energetic
Comfortable fit with current culture
FlyerFares, I'm a Flyer, Be a Flyer
CONS:
Vaguely retro

DEFINITION:
A variable color averaging a dark, silvery blue
PROS:
Indi (as in independent) + go
A shade of (United) blue
Sounds modern
Direct spanish translation
CONS:
Unfamiliar word to most

Indigo!

Expected vs. Unexpected

1	2	3	4	5

ATA Freedom Air jetBlue Tango
America West AirTran Spirit Virgin Blue
West Jet Frontier Easy Jet Song
Southwest Ryanair

WUNITEDRED

DEFINITION:
The color at the long-wave extreme
of the visible spectrum
PROS:
The energetic "other half" of United
Clear implications for visual rollout
Takes on Virgin Blue and jetBlue
Easy to say, remember, pronounce
Means "network" in spanish
CONS:
In the red, seeing red

WUNITEDRED

LOOP
A WUNITED BRAND

DEFINITION:
A curved line forming a closed or
partly open curve; a circuit
PROS:
Describes the flight network
Sounds fun
Additional meaning in Chicago area
Easy to say, remember, pronounce
CONS:
Whimsical, "loopy"

LOOP
A WUNITED BRAND

上圖
我們不能光是關在辦
公室裡紙上談兵，一
定要了解大環境的趨
勢。因此在簡報中，
我們列出現有的各家
廉價航空，這些業者
都是聯合航空旗下
新品牌的未來競爭

上圖
我們總共考慮了5個
品牌名稱，簡報上比
較了它們的優缺點。
其他4個都各有優
點，但我們把最喜歡
的留到最後。

UNITED

TED

Ted
A **UNITED** BRAND

DEFINITION:
Short for Theodore (Greek, "Divine Gift")
A literal "part of United"

PROS:
Friendly, "first name basis"
Unique to the industry
Easy to say, remember, pronounce
Trus**ted**, exci**ted**, libera**ted**, res**ted**
"Ted E-fares", I'm with Ted

CONS:
Unorthodox, riskier

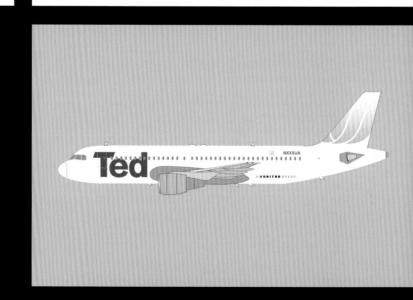

上圖
整場簡報中,我最喜歡的一段就是揭開我們最推薦的名稱。「過去75年間,各位在品牌推廣上投入了多少資源?」我問道。「10億美元?如果告訴您,這個新的子品牌名稱,已經繼承其中的5億美元。各位覺得如何?」席間聽眾對新名稱和我們提到的數字莞爾一笑,但重點是:這個新名稱一直藏在如此顯眼之處。

右圖
客戶立刻明白,用人名兼暱稱來當作名稱的好處,強調子品牌更為個人化的服務。因而其他四個名稱相形之下也顯得有些牽強了。而新商標的字首則挪用了聯合航空原本的大寫「T」。我們後來還將標語改為「聯合航空的一部分」,在各方面更加直接、簡單與真實。

Ted means business.

It's all about who you know...

It's true in the business world, and in the air as well. With a specially structured fare knack, Ted can take you to a board meeting in L.A., a convention in Las Vegas, or all of the above. Call 1.800.HELLO TED.

Ted E-fares:
1. $119, no restrictions
2. $96, limited restrictions
3. $86, restricted fare

Book your ticket online at www.flywithted.com

Ted
A *UNITED* BRAND

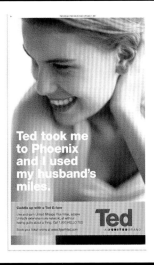

Ted took me to Phoenix and I used my husband's miles.

Cuddle up with a Ted E-fare.

Use and earn United Mileage Plus miles, access United's extensive route network, all without feeling guilty about a thing. Call 1.800.HELLO TED.

Book your ticket online at www.flywithted.com

Ted
A *UNITED* BRAND

ConnecTed

Check flights
Fly with Ted
The United network
Ted E-fares

Have a look around. We're glad you're here.

Who is Ted?
United was the first airline to announce it was reconfiguring its fleet to add more inches of legroom in the air, and the only airline to focus this benefit on our most frequent fliers. The idea for Flyer Points section came straight from our customers.

Ted E-fares
Our business travelers told us they wanted more room in the Economy cabin. It was their number-one request. So we listened, and began removing seats from the planes to provide space.

Our promise
United was the first airline to announce it was reconfiguring its fleet to add more inches of legroom in the air, and the only airline to focus this benefit on our most frequent fliers. The idea for Flyer Points section came straight from our customers

A *UNITED* BRAND

TasTed

CommunicaTed

Ted's inflight journal
December 2004
Volume 1, issue 12

Your photos.
our planes.
23

Ted turns 1
37

A *UNITED* BRAND

Ted
A *UNITED* BRAND

A STAR ALLIANCE MEMBER

Ted would love to hear from you.

Ted@ted.com

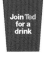

Join Ted for a drink

I love to shop with Ted

A *UNITED* BRAND

Ted

Ted sent me

Ted is my friend

Ted Blo
Kodak

上圖
在這份提案中，我們
還將新名稱和商標運
用於各項虛擬製作物
中，好讓客戶了解實
際使用這些商標時看
起來會是什麼樣子。
五角星設計的設計師
布列特‧泰勒製作的
網頁廣告上寫著「我
搭泰德航空去鳳凰
城，使用我丈夫的里
程數」，後來真的被
客戶採用了。

右圖

法倫國際廣告公司（Fallon Worldwide）的史都華·德羅薩里奧（Stuart D'Rozario）及巴布·巴里（Bob Barrie）為泰德航空的推出設計了一連串巧妙的預告活動。泰德正式亮相的前幾個月，他們先是讓超過一百位泰德的分身四處製造謎團：在市中心的小餐館請每個人喝咖啡、向當地慈善機構捐款、贊助馬拉松選手，一切都是神祕的泰德所為。等到2004年2月，泰德航空在丹佛正式推出時，謎團也終於解開。這個廉航品牌後來只經營了4年，就被重新納入母公司聯合航空的主要業務範疇之中了。

但營運期間，泰德不斷獲利，在聯合航空宣告破產又重新復甦之際，它的許多創新也為母公司做出了貢獻。此外，從零開始參與這個專案的聯合航空同仁，也因為它而擁有了無可取代的經驗，繼續運用在往後的職業生涯中。

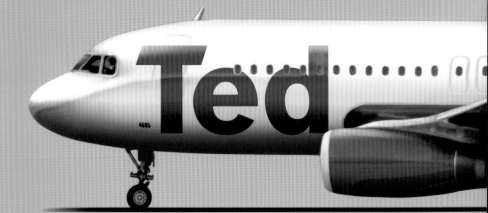

Be on a first-

Meet Ted. A new, low-fare service that flies to fun d

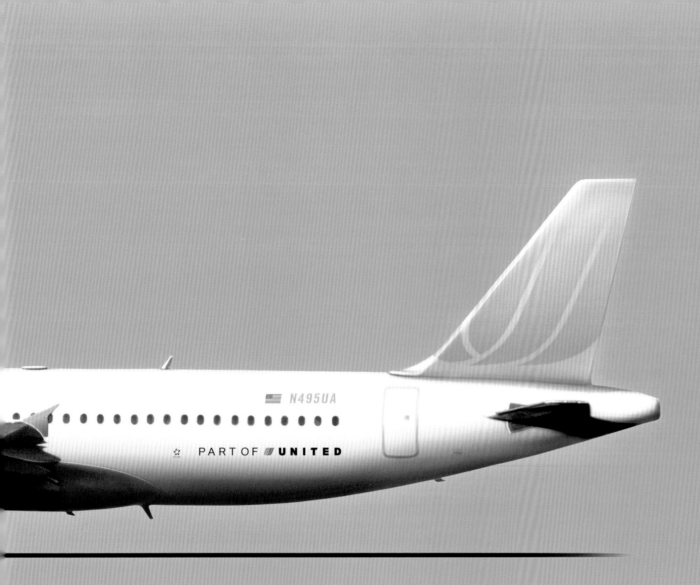

N495UA

★ PART OF ✈UNITED

...ne basis with an airline.

...ons. You can book now for flights that start February 12. Ted. Part of United.

www.FlyTed.com

Times Square

W 42 Street

Theaters

Theaters

5 Times Square Ernst and Young

Nederlander Theater

Graduate School Journalism, University New York

Parsons the New School for Design

W 41 Street

W 40 Street

Fashion Walk of Fame

Fashion Center Information Kiosk

W 39 Street

Fashion District

W 38 Street

W 37 Street

W 36 Street

W 35 Street

Macy's

W 34 Street

34 St-Penn Stn
A C E 1 2 3

Penn Station Amtrak, LIRR, NJT, PATH

New York Hotel Pennsylvania

Manhattan Mall

Building

Tower

Bush Tower

Metlife

Times Sq 42 St
1 2 3 7 N Q R S

Broadway

7 Avenue

The Haier Building

Broadway

Avenue of the Americas

🚶 5 minutes

🚶 6 minutes

Herald Square

You

6 Avenue

42 St Bryant Park
B D F M

5 Av
7

Bryant Park

Fountain Terrace

Upper Terrace

The New Community College at City University of New York

American Standard Building

5 Avenue Terrace

New York Public Library

Fortitude: Library lion

Patience: Library lion

5 Avenue

Grand Central 42 St
4 5 6 7 S

E 42 Street

E 41 Street

Mid-Manhattan Library

E 40 Street

E 39 Street

Lord & Taylor

E 38 Street

Midtown

E 37 Street

E 36 Street

E 35 Street

Graduate Center, City University of New York

Science, Industry and Business Library

Empire State Building

🚶 5 minutes

E 34 Street

34 St-Herald Sq
B D F M N Q R

E 33 Street

W 33 Street

Greeley Square Park

33 Street PATH

W 32 Street

of New York College of Optometry

Building

E 32 Street

Koreatown

如何抵達目的地

紐約交通局
New York City Department of Transportation

左圖
在這個專案中，我們加入了規畫顧問「City ID」所帶領的團隊，他們負責制定出基礎的尋路策略。另一個團隊「T-Kartor」則負責開發地圖資料庫，工業設計師比令斯・傑克森（Billings Jackson）確立了商標與地圖的結構，而RBA集團則提供了專業土木工程，使我們得以在這嚴峻的大都市環境中安裝這套複雜的系統。

紐約市是一個複雜的地方。曼哈頓街道呈現井然有序的棋盤狀，其中的街道和大道編號都是由「1811年委員會計畫」（Commissioners' Plan of 1811）制定。然而在市中心一帶，有一塊歪斜之處，西4街與西11街在此交會，而在皇后區，你還會發現另一條11街依序穿過44道、44路和44大道。整個紐約的布局布就是這樣自有一套邏輯。至於布魯克林，就像人們說的：算了吧。

多年來，紐約的每個區域試圖使用各自創建的標示和地圖引導困惑的行人。1990年代，我們首先為擁擠和混亂的金融區打造了一套地圖系統，採用獨特的平面設計風格，在區域內有效運作，但卻沒有和週遭其他數十個區域的系統同步。到了2011年，紐約交通局決定要製作一套名為「WalkNYC」的全市系統，把五大行政區的路線圖統一起來，這次我們加入了一個由不同專家所組成的團隊，準備先在5個試驗性據點推出新的地圖和標示。

我們很快就發現自己置身於一個全新世界，所有人的導航習慣都發生了天翻地覆的變化。一直以來，城市路線圖都像一件藝術品，是一張巨大的靜態地圖，所有東西都固定在適當的位置，最上方是北方。但如今，擅長使用GPS系統的旅人，希望手中的地圖除了能定位出自己目前的旅行位置外，還可以放大瀏覽更多細節。我們在整個城市裡設置的實體地圖能滿足這些需求嗎？於是，我們的團隊運用了更加靈活且可以無限修改的資料庫來打造數位地圖，內含多種方向和密集的細節，藉此提供傑出的數位體驗。

2013年，紐約市有了美觀、便利的全新路線系統，共享單車、地鐵站、客運站全都可以看到這些地圖。雖然手機無所不在，但在這座美麗而混亂的大城市裡，設有地圖站的人行道上，依然總是擠滿了找路的旅人。

製作城市路線圖是一項非常複雜的工作，需要和大量不同的專家合作。使用者究竟是如何在複雜的城市中找到自己的路？他們會需要什麼樣的資訊？應該如何、在何處提供給他們？若要解答這些問題，必須經過幾十次的研討會和訪問，請行人在路上停下來，問問他們要去哪裡，又如何抵達目的地。

紐約市交通局告訴我們，「WalkNYC」不僅會影響行人找路，透過鼓勵人們步行，也會影響到公共衛生，而人們只要在路上走得更久，就越有可能進行消費，進而也影響到經濟發展。系統務必要簡單明瞭，但要能做到這一點也不容易。我們的任務是要將製圖資料轉換成地圖，並且希望這些地圖不僅能有效運用，也能自紐約的平面風格中脫穎而出，就像馬西莫‧維涅里的地鐵商標，或米爾頓‧格拉瑟的「我愛紐約」（I Love NY）商標一樣。

右上圖
顧問公司City ID帶領我們的團隊，與當地居民和企業主一起進行了一系列的社區行腳，幫助我們確立地圖站的位置和內容。

右中圖
要理解旅人找路的方式就已經十分複雜，像是在機場這樣的地方。但這裡的每個人都從同一個地方入境，也全都準備要從同一個地方進入市區。那就更遑論在一座大城市裡，旅人可能從任何地方出發，也可能要前往任何地方，有的人是旅客，有的人是久居市民，有的人匆匆忙忙，有的人快要迷路，要解決如此複雜的問題，勢必要做出深思熟慮的選擇。

右下圖
曼哈頓北部應該稱為上城嗎？要如何確定步行的距離？哪些地標有資格出現在地圖上？白天和晚上什麼顏色最容易辨認？要考慮的細節似乎無窮無盡。

右頁
打造系統時，我們考慮了許多不同的字體，但沒有任何一種字體像Helvetica那樣正宗。這一點也不奇怪，畢竟紐約地鐵系統的使用者從1970年代就開始信賴它了，那麼，何不在地面上繼續使用同樣的平面風格呢？但我們還是做了一點修改，多年來我一直暗自希望能這樣改動：把所有的方點都改成了圓形。因為紐約市交通局的簡稱正好是「DOT」（圓點），這是我們不易察覺的一點小巧思。

紐約交通局

Midtown
Tribeca
Chinatown
Flatiron
You are here
ij!?;;.

左圖
由於要處理密集的資訊叢林，我們深知每一個平面元素都需要完美的設計。比如，1974年美國平面設計協會的羅傑・庫克（Roger Cook）和唐・沙諾斯基（Don Shanosky）為美國交通部開發的符號系統，其中就有一些我們所需要的圖示，但並非全部，我們修改了一些符號，像是改變腳踏車的圖形，使它與紐約共享腳踏車系統的風格更加搭配，我們也打造了一些新的圖示，像是印有紐約知名口號的購物袋。

下圖
我們希望資訊圖示與排印風格一致，設計師傑西・里德為此修改了數百次。

右頁
設計師哈米許・史密斯帶領我們在「WalkNYC」專案中的工作，包括設計每張地圖上的建築圖示。雖然有技術，但有些事情是無法自動化完成的，因此一大群實習生協助我們手工繪製了一百多張圖，每一張都很珍貴。

左上圖
大家對於地圖的配色
方案持不同意見。我
們推薦柔和的灰色
調，與這座城市本身
十分相配。

左下圖
各種不同形狀和大小
的地圖站遍布整座城
市；重要地點會設
置大型地圖站，而空
間寶貴的擁擠地區則
設置小地圖來充當路
標。實際上，商標的
大小也與周圍環境相
互搭配。

右頁
每個商標都傳達了驚
人的資訊量。地圖印
在乙烯基塑料材質
上，並安裝於玻璃面
板後方，需要更新時
可以輕鬆拆除。

下一跨頁
這些地圖原本是紐約
市第一個共享腳踏車
專案的一部分，設
置在曼哈頓和布魯克
林後，立刻普及開
來。數千人使用腳踏
車，數百萬人會使用
地圖。

「平視地圖」（Heads-up mapping）是一種製圖
方式，地圖的方向會取決於觀察者面對的方向。
在傳統地圖上，北方總是在上方。但在平視地圖
上，如果觀看者面向南方，地圖就會轉向，南方
就位於最上方。包含我在內的許多人都很懷疑，
這樣的系統究竟能否在這樣的城市中運作，畢竟
對紐約人來說，「布朗克在上方，砲台公園在
下方。」

但在前期測試階段我就被說服了，因為測試結果
顯示，高達84%用戶喜歡新的方法。顯然，數位
地圖和全球定位系統已經改變了我們的導航方
式。後來，《紐約時報》報導這套地圖時又進行
了一次非正式的街訪，發現路上高達60%的人根
本不知道北方是哪裡。平視地圖已經普遍為人所
接受了。

左上圖
我們認為，地圖站
只在必要時才需要
數位化，比如紐約
SBS 公車（Select
Bus Service）的自
助服務站就會提供
即時時刻表資訊。

左圖
紐約所有地鐵站都
安裝了地圖站，地
圖的配色方案也因
應24小時照明而進
行了調整。

右上圖
這些地圖站被設計
成可以抵禦碰撞、
破壞和紐約的寒
冬。

右頁
地圖站的外型設計
與紐約現代主義建
築相呼應。

如何調查謀殺案

錯誤荒原
A Wilderness of Error

左圖與上圖
《錯誤荒原》一書深入調查了一起謀殺妻子與兩個孩子的案件，書封與書衣分別繪製了麥唐諾家的平面圖，以及隔天早晨調查人員在案發現場發現的血跡模式。非比尋常的是，這一家四口成員的血型全都不同，這提高了破案困難度。

電影導演埃洛‧莫里斯（Errol Morris）執著於探討真相。他所有電影的核心角色都包含了知道真相的人、不想知道真相的人，想阻止別人了解真相的人，或者想揭開真相的人。他還曾經當過私家偵探，非常了解證物如何支持或挑戰有爭議的證詞。因此，他電影中的各種物件，像是檔案、照片、雨傘、茶杯等等，往往都承載了巨大的意義。在他1988年的突破之作《正義難伸》（*The Blue Line*）中，莫里斯採用採訪與重演（reenactment）的手法，深入調查美國達拉斯員警遭不明槍擊背後的衝突故事，這部引人入勝的電影後來也為當年受到不公正定罪的死刑犯洗脫了罪名。

埃洛‧莫里斯才華洋溢，而且用之不竭，他還是位作家。2012年，他決定追查另一起塵封數十年的犯罪，這個案件也十分難解。1970年2月17日，陸軍軍醫傑佛瑞‧麥唐納（Jeffrey MacDonald）的妻子與孩子慘死在北卡羅來納州布拉格堡的家中。雖然麥唐納堅稱他們是被入侵者殺害，但他還是被判有罪。自1982年以來，他一直被關在監獄裡，並始終堅稱自己是無辜的。在那之後，就有好幾本書和兩部電視電影在討論這個案子。但莫里斯相信，一定還有更多待查的細節。

他寫了一本書名為《錯誤荒原》，對這起懸案進行了鉅細靡遺的研究。在書封設計上，我們決定要避開真實犯罪類書籍的老套的風格，轉而聚焦案發當晚所留下的詭異物證：一張咖啡桌、一個花盆、一個兒童玩偶、一匹搖搖馬、一件睡衣，它們都是這起懸案中無聲的證人，被反覆檢視了無數次，對於熟悉案情的人而言，它們極具代表性。我們將這些物證簡化為簡單的黑白線稿，莫里斯發現，這些物證直接且中立的特質，很適合用來當成這本書的主視覺，我們製作了接近50個物證線稿。最終的書封上印有麥唐納公寓的平面圖，代表著這起懸案發生的地點，如同一座幽閉而恐怖的「荒原」，同時也是真相存在的地方。

右圖及下一跨頁
埃洛‧莫里斯的紀
錄片《戰爭迷霧》
（*The Fog of War*）
曾獲得奧斯卡與麥
克阿瑟基金會天
才獎（MacArthur
Foundation genius
grant）。《正義難
伸》是我第一次接觸
他的作品，這部片和
我看過的其他電影都
不一樣。片中有對於
罪犯、員警、律師和
證人直率又難以應付
的採訪，描繪犯罪時
採取了前所未見的超
現實重現手法，還有
許多獨特的題外話，
以及菲利普‧葛拉斯
（Philip Glass）那
繞梁三日的配樂，這
一切加起來，就是一
場紀錄片革命。到現
在我已經重看過許多
次，我最喜歡其中一
段安排好的場面，畫
面中，一杯巧克力奶
昔在空中慢動作墜
落，最後撲通一聲落
在地上，為惡夢般的
犯罪加上一個平淡無
奇的句點。
麥唐納一案中充滿這
些極具代表性的日常
物件，每一件都與可
怕的罪行有所關聯。
莫里斯鼓勵我們在書
中穿插這些鮮明的
物件圖案，交織出複
雜的真理和正義的主
題。五角星設計的葉
芙‧路西維德主導這
本書的設計，而尼
可‧斯科蒂斯帶領團
隊創作這些圖案。

錯誤荒原

THE IMPOSSIBLE COFFEE TABLE

*You'd better think less about us and what's going to happen
to you, and think a bit more about yourself. And stop making
all this fuss about your sense of innocence; you don't make
such a bad impression, but with all this fuss you're damaging it.*
—Franz Kafka, *The Trial*

When Jeffrey MacDonald was brought in for questioning on April 6, 1970, less than two months after the murders, he was read his rights, declined to have an attorney present, and a tape recorder was turned on. The interview was conducted by CID chief investigator Franz Grebner, Agent William Ivory, and Agent Robert Shaw. Grebner first asked for MacDonald's account of the events of February 17.

And I went to bed about—somewheres around two o'clock. I really don't know; I was reading on the couch, and my little girl Kristy had gone into bed with my wife.

And I went in to go to bed, and the bed was wet. She had wet the bed on my side, so I brought her in her own room. And I don't remember if I changed her or not, gave her a bottle and went out to the couch 'cause my bed was wet. And I went to sleep on the couch.

And then the next thing I know I heard some screaming, at least my wife; but I thought I heard Kimmie, my older daughter, screaming also. And I sat up. The kitchen light was on, and I saw some people at the foot of the bed.

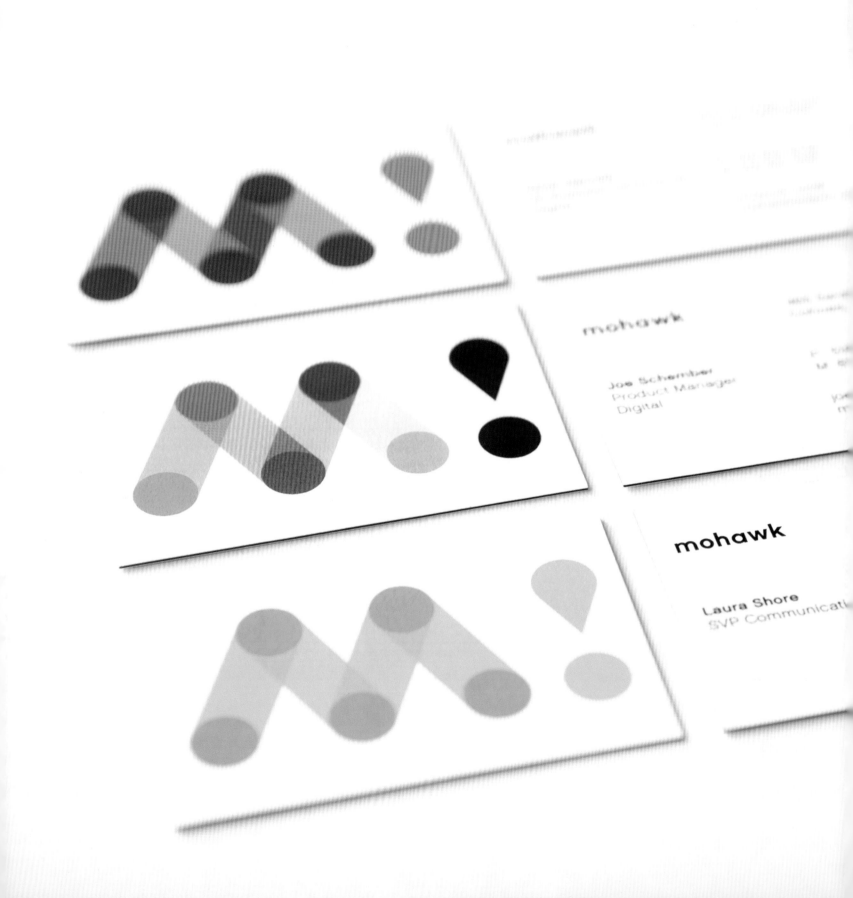

mohawk

Joe Schember
Product Manager
Digital

mohawk

Laura Shore
SVP Communicati

如何做自己

莫霍克紙業
Mohawk Fine Papers

左圖
這間公司的新商標是一個充滿變化的首字母，可以運用於各種尺寸和材質，既能保持基本幾何形狀，又可依據使用方式加以修改。

上圖
在整個20世紀，莫霍克紙業的商標都是以印第安莫霍克族的人物形象來做各種變化，這些商標的確很尊貴，但已經越來越不合時宜。從1990年代初開始，我與莫霍克的行銷主管蘿拉·肖爾（Laura Shore）合作，為公司打造更符合現狀的企業形象。

曾經，企業商標是不可動搖的。有些企業從未改動商標，也確實應該如此。然而到了這個時代，許多公司都必須盡快調整步調，才能因應新的挑戰或避免被人們遺忘，以往有效的形象或許也開始發揮不了作用。企業形象必須具有代表性，而且與理念一致，但絕對不能停滯不前。

莫霍克紙業是歐康納家族於1931年創辦，位於紐約北部莫霍克河及哈德遜河的交會之處，至今已交棒至第三代。在數位時代，造紙仍是不折不扣的工業生產過程，巨大的紙漿桶不斷旋轉，直到製出光滑的紙張，任何參觀過造紙廠的人一定都對紙張誕生的過程非常難忘。在這些古老藝術的從業者之中，很少有造紙公司像莫霍克紙業這般具有創新精神。他們在1940至50年代，以紋理紙與彩色紙張主宰了印刷世界，80至90年代則開發了一套流程，確保膠印與數位印刷品質，緊接著，他們又成為全美第一家以風力發電來降低碳排放量的造紙廠，這家小公司以想像力與沉著的步調迎接每一項挑戰。

銷售紙張也是一項複雜的工作。過去，像莫霍克這樣的造紙業者會將紙張賣給經銷商，經銷商再賣給印刷廠，而印刷廠則是根據設計師和藝術總監的需求下單。但銷售流程到了21世紀變得更加複雜，隨著企業電子化，來自企業製作年報手冊等公司文件的大筆訂單也隨之蒸發。與此同時，少量訂購和手作的風潮，也使得造紙業者需要開始直接面向消費者。

順應這個潮流，我們三度為莫霍克重新設計了品牌形象，或者應該說是每十年就重新設計一次。最新的標識以風格化的字母「M」為主軸，可以變化為多種不同的形式，將公司定位於數位世界的中心，同時確立他們對工藝和連結的承諾。

好的企業形象設計一定要與公司的真實核心有所連結，歌手桃莉·巴頓（Dolly Parton）曾經給音樂人晚輩一個建議，我認為那也是我聽過最好的品牌哲學。她說：「了解自己是誰，然後刻意為之。」我很幸運，因為這個客戶非常了解自己。

右圖
這個符號可用線稿呈
現，或以各種單色及
多色來組合。

上圖
字母M的筆觸總共有
四個意象，分別是工
廠地上未切割的紙
卷、膠版印刷技術、
數位電路，以及連結
的概念。

莫霍克紙業

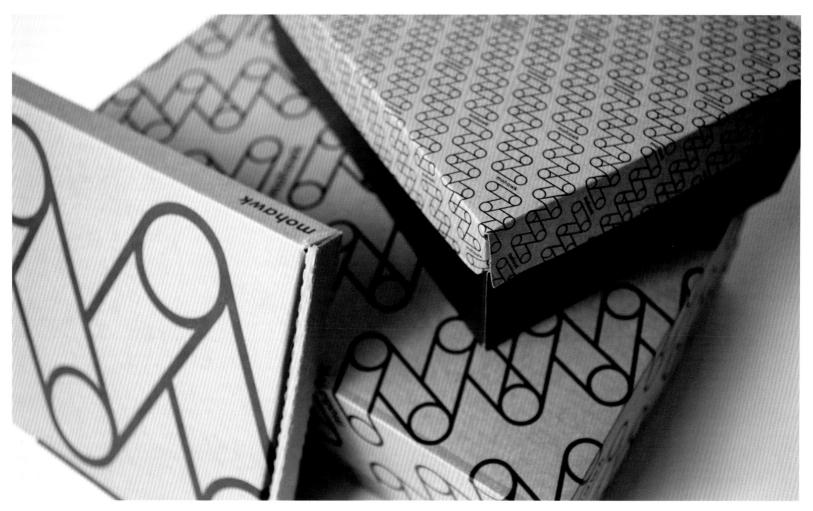

左圖
字母M符號也可以重
新排列，組成各式各
樣的符號，從驚嘆號
到算術符號都可以。

上圖
莫霍克牢固的紙箱
上，印製著簡單的黑
色圖案。

WHAT WILL YOU MAKE TODAY?

左圖
隨著新形象推出，我們也融入了一個新的主題：「你今天要製作什麼？」藉此表達莫霍克的產品注重交流想法，並能將想法付諸實現。

右頁
活潑的包裝紙有助於莫霍克的產品在店內和倉庫中脫穎而出。

右上圖
莫霍克的新銷售資料上強化了主題，並擴展了視覺形象。

右下圖
紐約北部經常可見莫霍克的送貨車。

莫霍克紙業

AIA

A[]A

A[WE]A

如何重新燃起熱情

美國建築師學會
American Institute of Architects

左頁
我們為美國建築師學會設計出活力十足的商標，強調團結的力量將支持每一位學會的成員。

上圖
原始的商標設計，將重點放在美國建築師學會的權威感，並傳達建築公會的守護。

美國建築師學會成立於1857年，至今已累積超過八萬名會員，是美國最具歷史和規模的設計協會。物換星移，當學會迎來第160周年時，當初創始的十三位留著大鬍子的白種男人已不足以代表協會的形象。美國建築師學會近年面臨前所未有的考驗：全球的經濟衰退、科技的革命性變化，以及更加多元的潛在會員。為因應這些變化，審慎且堅定的領袖羅伯特·艾維（Robert Ivy）決定大刀闊斧，為當今的美國建築師學會重新定位；而我們受到委託，打造美國建築師學會的全新形象。

重新塑造這樣一個老牌又具規模的組織，想必是充滿艱辛且令人戒慎恐懼的。和所有的案子一樣，我們的任務是找出問題的癥結點。起初美國建築師學會希望提升大眾對於建築師的關注，但這卻不是問題的癥結所在，因為根據同事亞瑟·柯恩（Arthur Cohen）的調查，其實人們是喜歡建築師的，真正的問題在於建築師不喜歡自己。大多數時候，他們必須面對四面八方的批評指教，洩氣的建築師鮮少有機會喚回初入職場的熱忱與活力。當他們加入美國建築師學會時，通常會希望進修自己的專業，並且獲得學會的支持與肯定；但與此同時，我們也希望能夠重新燃起他們的熱情。

儘管我們的成果將在不同的人面前呈現，但最關鍵的還是建築師，因為他們正是最擁護建築價值的人。我們開始統合美國建築師學會以及各個分會的資訊，使用一致性的語調傳達全新的理念。我們不僅設計專屬的商標字體，以多立克柱式的大寫「I」直立其中；除此之外，我更親自撰寫193字的宣言，揭示激勵建築師持續前進的關鍵，以及為何相聚於此能使我們更強大。當成果首次展現在他們面前時，不少會員都感動到哭了，因為他們感覺失去的熱情似乎又被重新燃起！

下圖
由拉普拉卡・科恩
公司（LaPlaca Co-
hen）的夥伴所發想
的廣告，將重點放在
「為建築服務的人」
，而非建築本身。

右頁
AIArchitype是為美國
建築師學會設計的新
式字體，將組織的溝
通調性統一起來。字
體由傑瑞米・米克爾
繪製，整體感偏向寬
鬆，垂直結構粗壯、
水平結構狹窄。

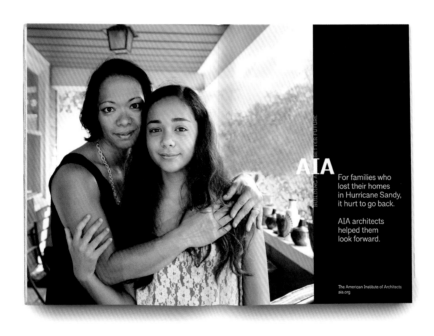

TECTONIC STRENGTH

God is in the Details

BUILDING COMMUNITIES

Cantilevered Support Structure

2419 Design Iterations

One Corbusier Lamp

Mister Wright

PRESERVING LANDMARKS

Computer Aided Design

右圖和右頁

2014年，美國建築師學會的年會在芝加哥舉行，這裡正是全美最大的建築之都，無疑是發表品牌新氣象的最佳時機。為了讓充滿活力的文字商標完美融入其中，五角星設計的哈米許‧史密斯直接進駐美國建築師學會，與行銷團隊一同工作。廣告和商品也引用改編芝加哥都市計畫大師丹尼爾‧伯納姆（Daniel Burnham）的金句：「千萬不要把計畫做小，因為它們並沒有擾動靈魂的神奇魔力。」

下一跨頁

我們耗費數月進行調查，找出是什麼持續激勵著建築師，以及他們對學會的期許和盼望，最後精簡成200字的宣言。

CHIC
AIA
GO!

CHICAIAGO!
AIA Convention 2014
June 26-28, Chicago

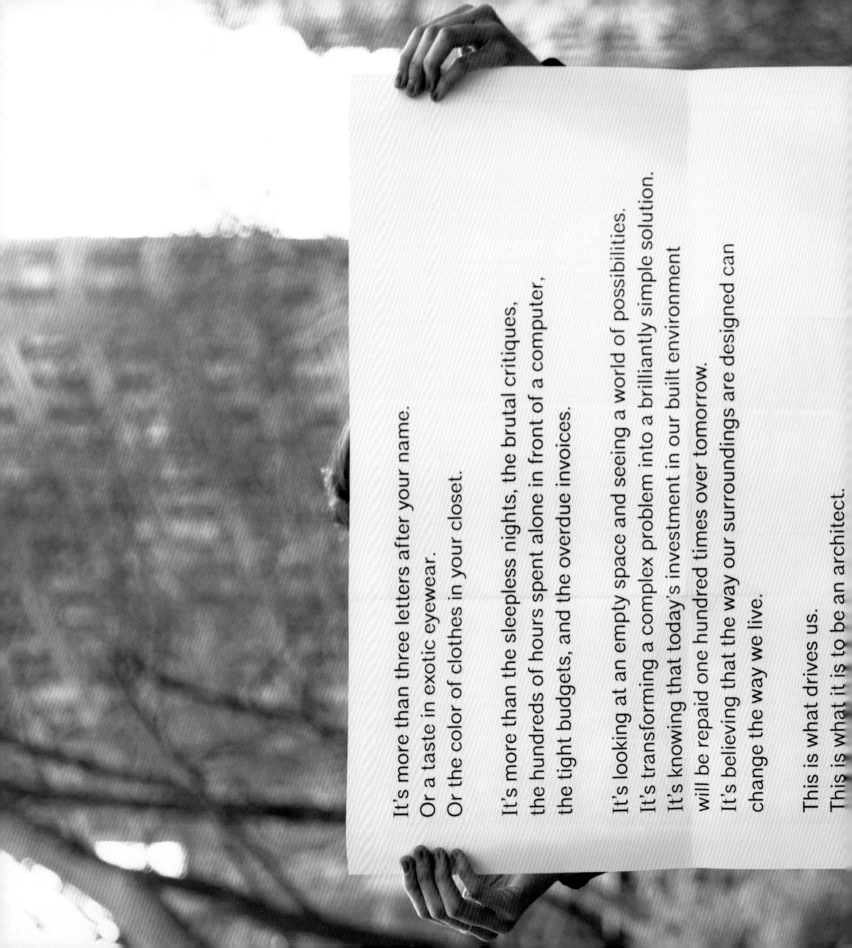

It's more than three letters after your name.
Or a taste in exotic eyewear.
Or the color of clothes in your closet.

It's more than the sleepless nights, the brutal critiques,
the hundreds of hours spent alone in front of a computer,
the tight budgets, and the overdue invoices.

It's looking at an empty space and seeing a world of possibilities.
It's transforming a complex problem into a brilliantly simple solution.
It's knowing that today's investment in our built environment
will be repaid one hundred times over tomorrow.
It's believing that the way our surroundings are designed can
change the way we live.

This is what drives us.
This is what it is to be an architect.

We need clients who can believe in the power of a reality
that doesn't yet exist.
We need to listen to the people who will live, work and play in
the places we create.
We need leadership in our communities, and in our profession.
We need each other.

We are America's architects.
We are committed to building a better world.
And we can only do it together.

如何設定影像的框架

紐約國際攝影中心
International Center of Photography

左頁
國際攝影中心的新商標，利用阿諾·薩克斯在當年開幕時所設計的花押字母，無限延伸出不同規格的文字，反映當代影像文化的多元特色。

上圖
康奈爾·卡帕的攝影幫助我們理解二十世紀的面貌。他曾説過：「只要影像發揮它的真摯與熱忱，就足以與文字匹敵。」康奈爾在1974年創立國際攝影中心。

從業之初，我喜愛「文字」勝過於「影像」。當時我對文字全然著迷，因為它們似乎能夠觸發更深層的概念；相對之下，影像則是較忠實的記錄，儘管它們能夠明快地傳達訊息，但是對我而言影像能夠發揮的空間就比較少。因此，我經常只是將圖片放入頁面後就置之不理。一直到多年以後，我的想法才有巨大的翻轉——即使影像只表現一個簡單的訊息，設計師也能夠延伸玩出新花樣！

康奈爾·卡帕（Cornell Capa）則用一輩子思索這個問題。根據他在1968年出版的《充滿關懷的攝影師》（*The Concerned Photographer*），20世紀中期他曾與一群熱血的攝影記者寫下信條：「影像應傳遞最真摯的情感，而非服務於商業的犬儒主義和無趣的形式主義。」康奈爾與他知名的戰地攝影師弟弟羅伯·卡帕（Robert Capa）一樣，認為影像不僅能夠捕捉世界，而且可以改變世界。秉持著這樣的精神，康奈爾在1974年創立「國際攝影中心」，結合了學校、博物館、資料中心等功能，標舉影像具有重要的藝術價值與改變社會的力量。接下來的四十多年，國際攝影中心雖然多次更換商標和營運地點，但是他們的核心精神從未改變。

國際攝影中心在2020年搬至紐約的下東城，從此開始穩定地活動；我們也是在此時接到任務，為他們設計新的形象商標。與此同時，全球的攝影界正在經歷一場革命性階段——由於人手一支智慧型手機，現今的影像創作不再是攝影師的獨門技術，就連素人也有機會拍出具有影響力的作品。儘管如此，這也驗證了康乃爾的理念：每一個記錄世界的人，都有機會改變世界。

回到國際攝影中心的新商標，我們沿用康奈爾在1974年委託阿諾·薩克斯（Arnold Saks）設計的幾何花押字母並進行調整，使它不再只是方正的字體，而能夠適應各種尺寸和比例。這些豐富的尺寸變化，就像是攝影師在捕捉影像時不斷調整焦距，而每個人終將做出不同的判斷與抉擇，最終顯示出多元眩目的當代影像文化。

左圖
無論是對攝影師或是排版藝術家，如何裁切素材都是最基本的技術。什麼需要留下？什麼需要排除？這個技術從過往的實體機台一直延續到現在的手機軟體。我們設計出一套模組將這個技術推展到極致：無論你設定任何的高度或寬度，商標都不會失真而無法辨識。

右圖
由強尼・斯科夫重新設計的花押字，被設計師德爾達・莫菲和蘇珊・梅運用在國際攝影中心的環境商標及印刷品上。

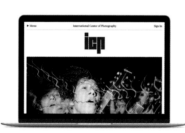

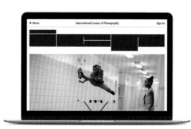

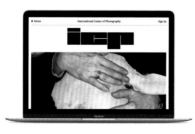

左圖
國際攝影中心可縮放的商標，讓它能依據不同的數位平台調整不同的規格。

上圖及右圖
運用在報紙及雜誌的無襯線字體，再次展現圖像與文字的關聯性。

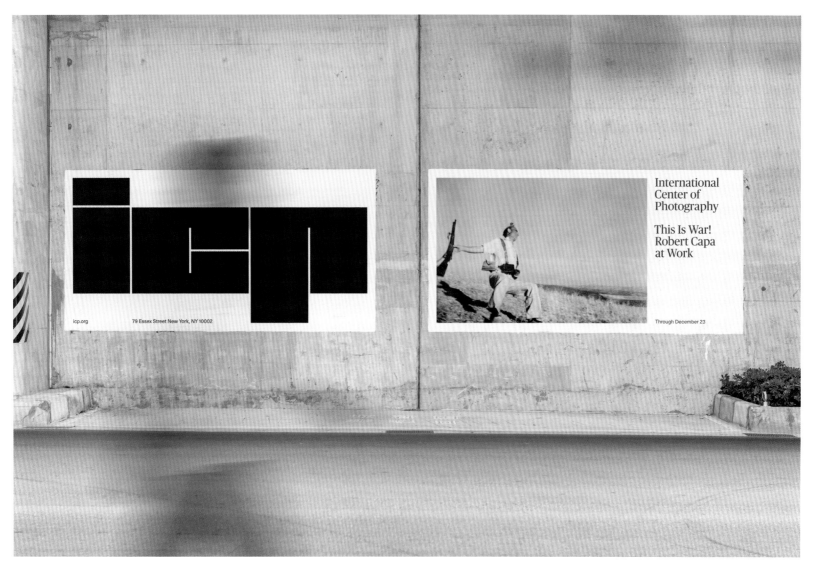

icp

icp.org 79 Essex Street New York, NY 10002

International
Center of
Photography

This Is War!
Robert Capa
at Work

Through December 23

左圖
國際攝影中心的新總
部位於曼哈頓下城的
埃塞克斯街，兼具藝
廊和學校的功能，使
它在最熱鬧、最有活
力的社區中，成為真
正的影像匯聚之地。

上圖
國際攝影中心的博物
館，展示著影像創作
的過去與未來。

如何布置一張餐桌

巴比福雷的餐廳
The restaurants of Bobby Flay

左頁
主廚巴比・福雷幾乎
將所有的餐廳交給我
和我的夥伴設計，包
含他在曼哈頓的新餐
廳「迦多」。

幾年前非常流行「體驗式設計」。設計師、廣告業主和行銷人員突然發現，只透過商標和廣告並無法形塑消費者對品牌的印象；相對地，透過全面的「接觸點」（touchpoints）提供消費者360度的實際體驗，可以讓他們對企業或產品的印象更加深刻。一般人甚至將其視為現實生活的一環。雖然這對自我感覺良好的傳播人才而言是個驚喜的發現，但是對於長期經營餐廳的人，這可不是什麼新聞。

好的餐廳經營者都明白，他們的餐廳必須提供消費者五感的體驗。入門的迎賓技巧和餐桌上的美味餐點一樣重要，整個用餐過程就像進入一座劇場，登門的顧客是觀眾同時也是演出者。

巴比・福雷（Bobby Flay）是全球最知名的主廚之一。這位料理神童出生成長於美國紐約，他不僅在梅沙燒烤餐廳（Mesa Grill）擔任西南料理的主廚，並且在亞美利坎因酒吧（Bar Americain）重新打造顧客的餐飲體驗。他與他的夥伴勞倫斯・克倫奇弗（Laurence Kretchmer）十分了解如何經營一間美味又成功的餐廳。

我們發現，成功關鍵在於對目標消費者擁有絕對精確的了解和溝通。我們必須明白顧客對餐廳有什麼期待？而我們又該如何提供超越這個期待的服務？舉例來說，巴比的漢堡皇宮（Bobby's Burger Palace）就希望提供消費者「輕便快速」的服務——好吃的漢堡、薯條、奶昔永遠最快速、美味地送到你的面前。餐廳的設計全都圍繞著這項體驗：環抱四周的甜點吧檯，輔以流線設計加強速度感的印象。除此之外，我們的商標設計也借用這個概念，將餐廳的名字製成一個美味漢堡，就像麵包、生菜、漢堡肉的完美搭配。

巴比在紐約曼哈頓的諾荷區經營的高檔餐廳「迦多」（Gato）則是完全相反的概念——創新且客製化的美味餐點，從點餐到上菜，隨處展現廚師的料理熱情與創意；而他們的商標設計也是俐落優雅。迦多餐廳和巴比的漢堡皇宮，兩間餐廳，兩款視覺語言，兩種顧客體驗；與他們共事讓我們明白，最後端上桌的都是料理的初衷。

巴比的漢堡皇宮是巴比·福雷在年輕時打造的漢堡連鎖品牌。當年他耗費心力，跑遍美國各地蒐羅各種食譜，例如費城漢堡（普羅沃洛內起司、烤洋蔥、辣椒）、達拉斯漢堡（辣味肉餅、涼拌菜絲、蒙特里傑克起司、烤肉醬、醃黃瓜），以及洛杉磯漢堡（酪梨醬、西洋菜、切達起司、番茄）。2008年第一間餐廳在紐澤西的郊區開幕，如今全美已有18間分店，但2022年因疫情影響剩4家。

右圖和右頁
巴比的漢堡皇宮所有的視覺設計都是明亮且充滿活力的。我們的設計是基於建築設計公司羅克韋爾集團（Rockwell Group）明亮的室內裝潢，他們也能根據空間的大小和尺寸調整室內規畫。此外，巴比更在他的漢堡中添加「酥脆」的祕訣，那就是加入一整層炸洋芋片！我和設計師喬·馬里亞內則試圖在平面設計中向顧客揭露這個祕密。

BOBBY'S BURGER PALACE

上圖
巴比的漢堡皇宮的商標設計，文字像餡料塞滿其中，就像是他們可口的產品。同時，商標也能垂直使用首字母縮寫成BBP，意思是「小漢堡」。

巴比福雷的餐廳

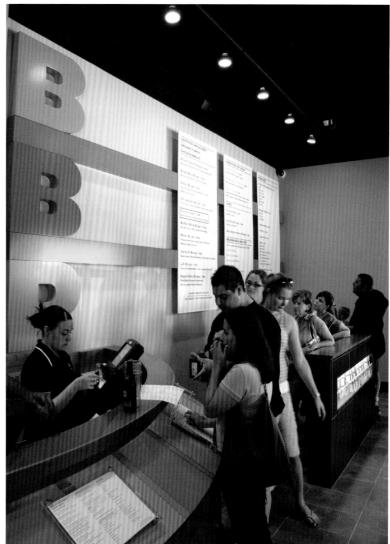

迦多餐廳在2014年於曼哈頓下城的拉法葉街開幕，這是巴比‧福雷睽違十年後開的新餐廳。店頭改裝自一間1897年的倉庫，主要經營地中海風味料理，為饕客提供西班牙、義大利、法國和希臘等各國美食。空間的設計同樣由羅克韋爾集團打造，完美地融合紐約的奢華和下城的剛韌，而我們的視覺設計也期望達到同樣的效果。

右圖及右頁
每項設計細節都必須拿捏奢華與剛韌的平衡感。第二種字體我們選用Pitch字體，它是一種固定寬度的優雅字體，搭配和店面磁磚輝映的深藍色。由五角星設計的傑西‧里德擔任執行監督，從窗戶上的金色商標，到廁所的手工標語「員工請務必清潔手部」等，每項細節都不能馬虎。

下一跨頁
位於拉法葉街的迦多餐廳，從右側的窗戶可以窺見裡頭的廚師。

GATO

上圖
迦多餐廳的商標使用的是安東尼‧布里爾（Anthony Burrill）設計的字體「Lisbon」，這個字體主要受到葡萄牙里斯本的街景及其他地中海城市的啟發。

巴比福雷的餐廳

如何在孤島上求生

紐約總督島
Governors Island

左頁及上圖
儘管距離曼哈頓下城
的河岸不到一英里，
過去卻鮮少有遊客造
訪總督島。現在它已
開放給一般的遊客，
夏季時人們可以透過
渡輪登島遊逛，沿
著河岸享受紐約的
美景。

下一跨頁
位於碼頭的巨型門式
起重架，就像是對遊
客敞開的大門，它的
結構給了我們指標設
計的靈感。

總督島距離紐約曼哈頓下城的碼頭大約457公尺，僅能搭乘渡輪登島，耗時7分鐘左右。總督島就像一座世外桃源，島上沒有汽車，也沒有大量的人潮。島嶼的北面是一座廢棄的百年軍事基地，既高雅又神祕；南面則是一片毫無生氣的垃圾掩埋場，面對著曼哈頓、布魯克林、紐約港和自由女神像等各種壯麗景色。

我們的客戶是蕾思莉·柯琪（Leslie Koch），當時她被市長指派再造總督島上約70公頃的垃圾掩埋場。他們舉辦競賽，徵求團隊將其改造成全新的市民公園。最後由阿德里安·荷茲（Adriaan Geuze）所領導的荷蘭West 8都市景觀設計建築事務所勝出，而我們的任務是負責總督島的指標設計，讓遊客可以輕易找到他們想去的地方。

這座小島只有兩個「入口」，分別是從曼哈頓和布魯克林過來的渡輪碼頭。由於島嶼並不大，遊客並不容易迷失，而且四周又有紐約的景色與地標供遊客辨別方向，我們感覺任務並不困難。

但事實上，我們卻遇到困境。原先我執著於一個目標，希望能設計出像島嶼一樣的360度巨大環形圓柱。隨著一次又一次的造訪，我在設計中又增加許多細節；但是每次增加新的細節，我就更加不喜歡它，而且我感到其他人也有同感。最後，我終於承認自己失敗了。

「可以請你看看嗎？」我向我的夥伴寶拉·謝爾求救。我向她展示幾個月來的成果，包含許許多多拜訪總督島的考察照。「這才是你們應該設計的樣子。」從未踏足總督島的寶拉指向其中一張照片，那是一台立在碼頭的巨型門式起重架，「這個案子的關鍵是島上的風景吧？如果是這樣，你們應該設計出可以透視的指標。」

短短三分鐘，事情就這樣解決了。我立刻拜訪West 8的夥伴並說服他們放棄之前的設計，一切從頭再來；原先我以為他們會感到擔憂，沒想到他們卻反而鬆了一口氣。之後，我們的設計就順利許多，向蕾思莉展示我們的成果時，我能感到我們已找出正確的答案。時至今日，她仍盛讚我們的作品為「紐約最美麗的指標」。

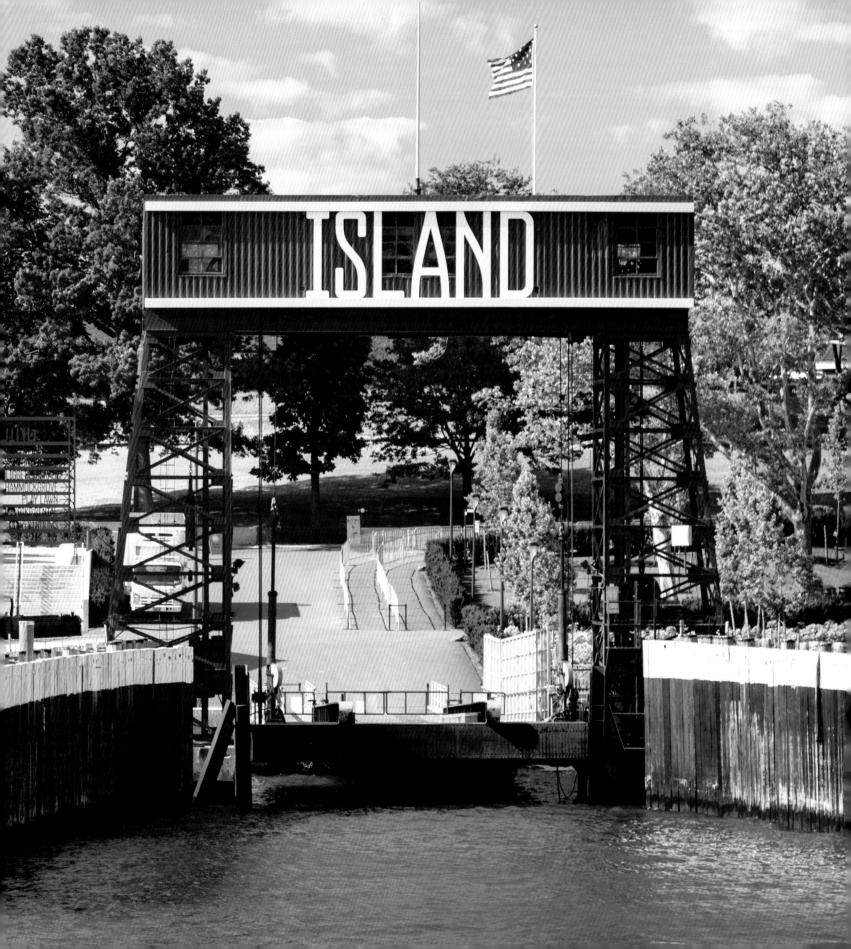

上圖
島上的指標需要看起來堅固又兼具趣味性，大到足以從遠方清楚辨識，但是又不會干擾周遭的環境。阿德里安‧荷茲、傑米‧瑪斯琳‧萊森（Jamie Maslyn Larson）和West 8的夥伴一起創作出這個指標結構，包含將友善環境的鏤空文字鑲嵌其中，使它能在空曠的公共空間被遊客看見。

上圖
我們為總督島設計的無襯線字體叫作「Guppy Sans」，它融合了原始粗曠的無襯線字體（以反映總督島過往的實用功能），以及裝飾性的字體（以顯示未來的都會公園樣貌）。五角星設計的布里特‧柯布和哈米什‧史密斯是這套字體的設計總監，當時他們花了無數小時在島上騎車、走路，四處勘查地景。

紐約總督島

上圖
指標設計最大的挑
戰，是預期總督島未
來會發生的變化。指
標牌需要能夠長久使
用，也需要配合每週
的活動更新，以及每
季的新企畫。因此，
指標牌被設計成能
夠簡易更換內容的
模組。

上圖
無論指標系統多麼複
雜，這個指標必然是
最重要的。

　　　　　　紐約總督島

左上、左中、左下圖
為了和紐約其他地區
作出區隔與特色，總
督島的街道指引、資
訊商標、解說牌，全
部使用一致的客製化
字體。

上圖
蕾思莉‧柯琪堅信好
記憶的名字是指引的
關鍵。島上有些延
用的舊名如柯諾思路
（Colonels Row），
也有新創的名稱如漢
默克吊床園（Ham-
mock Grove），這
些名字在地圖上交
織出總督島的全新
景象。

下一跨頁
這些指標的特殊架
構，以及它們所處的
地點（如公園、草
地），都讓它們成為
很好的棚架。我不禁
偷偷幻想，有朝一日
它們會被藤蔓攀爬，
成為自然與人工完美
結合的最佳設計。

如何連上線

威訊
Verizon

左頁
比起設計新的商標，我們更傾向調整舊的符號。勾勾的符號不僅能以像素形式在平面的手機呈現，也能以立體的方式出現在店頭。

上圖
威訊應該展現的企業形象為簡潔、值得信賴、容易使用的。但是原本的商標卻看起來繁複、缺乏協調、含糊不清，顯然與其目標不相符。

1969年，當我還在克利夫蘭市就讀六年級時，貝爾電話公司（Bell Telephone System）推出新的企業形象，而當時我們在地的子公司「俄亥俄州貝爾電話公司」（Ohio Bell）還在使用80年來幾乎沒有更換的舊式商標。如今電話簿、電話亭、廣告和運送車都已換上摩登新潮的商標，是用流暢的無襯線字體所設計；而這項品牌再造計畫無論在當時美國或甚至今日，都是史無前例的規模。

我不太記得當初怎麼留意到這件事的。新商標由知名設計師索爾·巴斯（Saul Bass）設計，穩健又俐落，但是卻沒有驚豔之處——舊設計是一個笨重的鐘在一個圓圈中，而新設計只是變成一個精巧的鐘在圓圈中。當時12歲的我只著迷於專輯封面和電影海報，一間電話公司的新商標根本引不起我的興趣。

但事實並非如此。貝爾公司的任務是提供全國普及、穩定且不間斷的電話服務，他們的公眾形象應該是沉穩、信賴、穩定，且永遠為顧客存在的。儘管他們最終沒有做到。在1984年，歷經多年的反托拉斯抗議以後，貝爾公司的母公司「美國電話與電報公司」（AT&T）被迫拆成數間公司繼續營運。其中的「紐約電話公司」和「新英格蘭電話公司」合併成「紐約新英格蘭電話公司」（NYNEX）；最後，他們又與「大西洋貝爾」（Bell Atlantic）合併，和「通用電話電子」（GTE）共同創造一間新公司，取名「威訊」。千頭萬緒實在難說清。

在當時，威訊的商標可說是無所不在，儘管我並不是很喜愛。他們的商標使用侵略感十足的粗斜體，老式且過大的「Z」，並結合角度詭異、意義不明的勾勾。所以當多年以後，他們的新任行銷總監迪亞哥·史考迪（Diego Scotti）與我約談時，我非常興奮地和他談論重新設計商標的可能性。

這個挑戰是很特殊的。我們要如何為一個無所不在的品牌，設計出能夠適應各種大小變化的商標？我們又要如何設計出一個能夠承載歷史，同時注入創新意義的商標？我想，我們必須像巴斯設計出的貝爾商標那樣，運用簡潔又極富彈性的元素，創造出沉著有力的作品。我們開始精簡元素，加強使人一眼就能辨識出「Verizon」的特殊亮點——一個亮眼的紅色勾勾，那是人們在完成任務時會使用的慣用符號。而這個新符號在科技、傳播、文化都有所轉變的現代，仍持續帶給人們一種穩定且創新的感受。

Hans Vestberg
CEO

5G
PALO ALTO
LAB

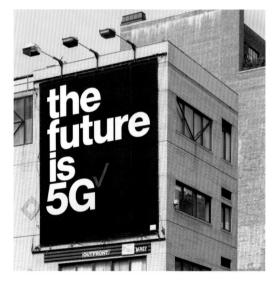

the
future
is
5G

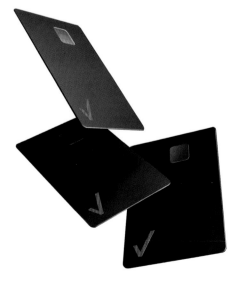

上圖
字體選用克里斯帝安‧施瓦茨所設計的 Neue Haas Grotesk。這套字體源自於經典的Helvetica字體，而Helvetica正是四十年前索爾‧巴斯在設計貝爾公司識別系統時所使用的字體。如今，Neue Haas Grotesk已成為威訊最主要的字體。

右上圖
威訊的子品牌如5G實驗室，利用品牌字體的變化創造出差異。

右中圖
紅色勾勾能夠串起威訊的企業識別系統，諸如產品、功能、服務等，儘管品牌名稱沒有出現也足以辨識。

右下圖
由威訊發行的信用卡，上頭只有紅色勾勾獨立出現。

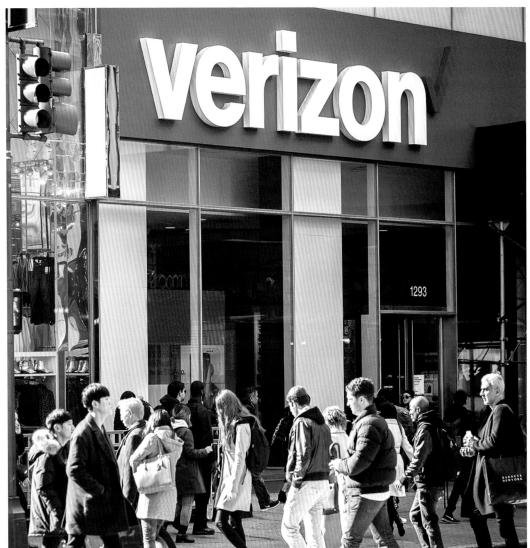

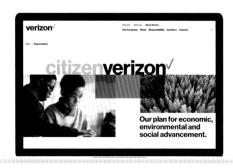

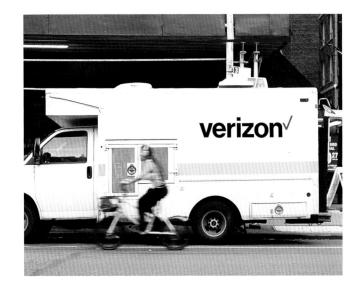

左圖
品牌的識別字體出現在全美超過2000間門市。

下一跨頁
我們與威訊一起工作超過5年，由代理商夥伴建立出一套完整的線上平面設計標準，這裡所展示的只是一小部分。

第二張跨頁
威訊的服務在人們生活中無所不在，我非常高興能為他們重新打造品牌識別。當然沒有我的夥伴，我無法順利完成這項任務，他們是桑索斯·阿爾瓦雷茲、薩奇·錢德勒馬尼、布里特·柯布、艾倫·菲、克里斯·格雷羅、強尼·斯科夫，以及優秀的專案管理人艾比·瑪斯托克。

最左圖
將近25000台的工程車在路上奔馳，儼然是品牌的移動廣告，這是美國各地隨處可見的景象。

左圖
同樣的識別元素運用在產品和包裝上。

上圖
「威訊公民」是威訊為多方履行企業的社會責任所創建的平台。

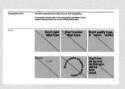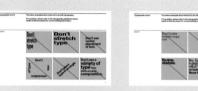
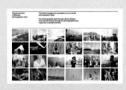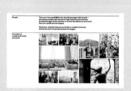
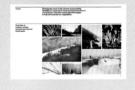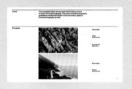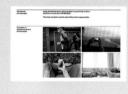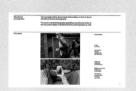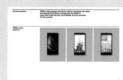
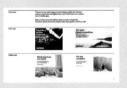

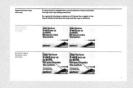

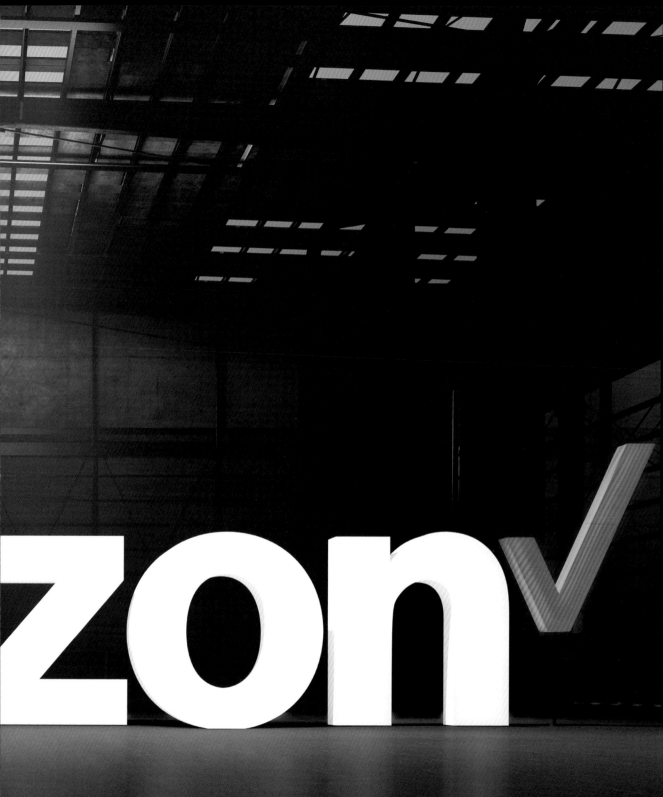

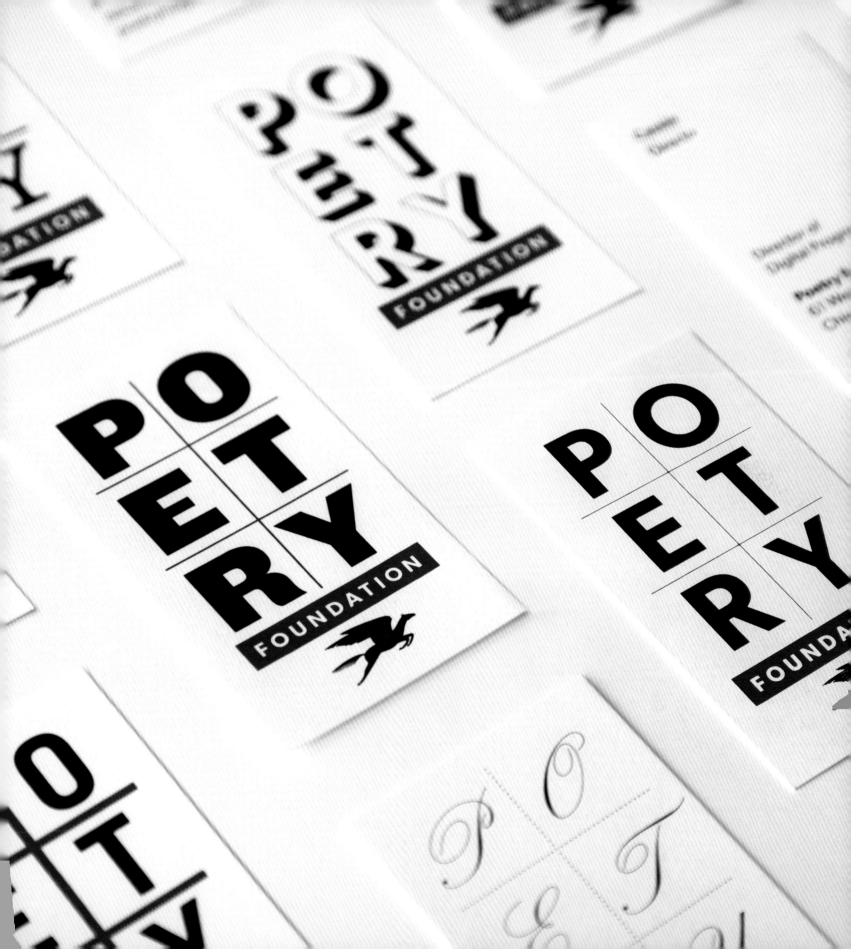

如何寫一首十四行詩

詩歌基金會
Poetry Foundation

左頁
詩歌基金會的視覺形象，運用文字這個古老的傳統媒介，變化出有別以往的創新性格。萊茨·侯設計出一套系統並應用在基金會的傳播素材上，包括每一位員工獨有的名片設計。

下一跨頁
我們並沒有幫詩歌基金會的指標性刊物設計一個固定商標，反而創造一個新的版型，兩行三列的文字排版，就像是詩歌基金會的品牌、主張、封面故事，並且每期更換。我請設計師伊莉莎白·古德斯皮德（Elizabeth Goodspeed）和瑪麗亞·許（Mariah Xu）設計出五年份的雜誌封面，讓客戶能夠一次了解它的趣味及可行性。

當我在尋求靈感的時候，我傾向從「音樂」找尋而非視覺藝術。在有限的五線譜上編排出無限的可能，會使你想起一場激烈的衝突或是逝去的愛情。目前音樂已發展出一套公式與原則（至少西方音樂中的自然音階如此），無論是貝多芬（Beethoven）或查克·貝里（Chuck Berry）都能夠使用它們。而音樂創作所面對的兩大挑戰──「有限的手法」和「嚴格的規範」，我認為對設計師也並不陌生的。

我最喜歡的音樂是巴哈在1741年寫的《郭德堡變奏曲》（*Goldberg Variations*），一段主旋律變化出三十種變奏，從最簡單的詠歎調發展出令人驚歎的多種表現方式，也沒有偏離原來的合聲結構。將一首曲子改編成不同的演出，這是人人都很熟悉的，就算你對巴哈的創作沒有涉獵，你可能也聽過吉米·亨德里克斯（Jimi Hendrix）和惠妮·休士頓（Whitney Houston）改編美國國歌。傳奇節奏藍調歌手威爾遜·皮克特也曾分享他的哲學：「先求和諧，再求獨特。」意思是我們必須先踏實地了解音樂的架構，再進一步創造獨特的觀點。

主旋律和變奏的關係，在平面設計也是非常基本的概念。舉例來說，一本書籍的頁面提供固定的版型限制，但是透過每一頁的翻閱，還是可以發現不同的驚喜。詩歌創作也是如此。無論是簡單的五行打油詩（limericks），還是複雜的十四行詩（sonnets），它們的規則都被嚴謹地設計和遵行，但又能包容各種意義的解釋。

當我們被委託打造「詩歌基金會」的全新品牌形象，以及改版他們發行超過兩百年的刊物時，我首先想到的就是主旋律和變奏的概念。文字是詩歌的基礎，而它激發了數百年來無數詩歌的靈感。我們開始創作兩行、三列，共六個字母的「圖像詩」，從中看到許多主旋律和變奏的出現──常規與破格、保守與前衛、大膽與精緻。最終的成果顯示出詩歌基金會的臉龐，既永恆，又常變，就像詩一樣。

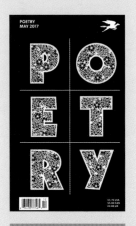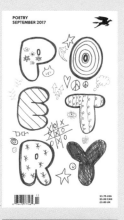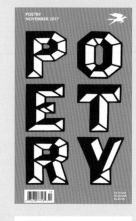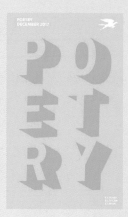

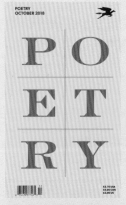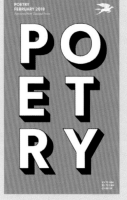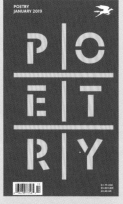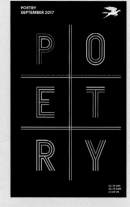

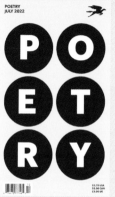
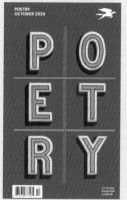
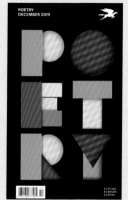
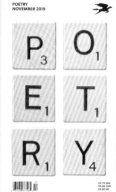

如何保持精簡

萬事達卡
Mastercard

左頁
兩個圓圈，三種色
彩，一個品牌。

上圖
雖然萬事達卡的風格
曾經有過變化，但是
基本的視覺語言仍然
穩固地延續至今。

我總是對簡潔的力量感到神祕。為何某些造型或色彩能夠激發人們的情感呢？獲得諾貝爾獎的神經科學家艾力克‧肯德爾（Eric Kandel）就發現，抽象與具象的圖像，會以不同的方式刺激我們的大腦。他在2016年出版的書籍《藝術與大腦科學簡化論》（*Reductionism in Art and Brain Science*）中，他提到「抽象」會讓觀看者使用「初級思考歷程」（也就是潛意識的語言），它能夠將不同的事物和概念輕易地連結，且不受時間、空間影響；相對而言，「次級思考歷程」（也就是自我意識的語言）則比較偏向邏輯思考，並且需要時間和空間的配合。儘管具象的事物可以使我們即刻理解，但是抽象的事物卻可以創造更深的連結。當萬事達卡的團隊與我們接觸的時候，我正在思索這件事情。

50多年來，萬事達卡的商標一直都是兩個交集的紅色圈圈和深黃色圈圈，但是我身邊沒有人知道緣由為何。有人猜測是南、北半球的影射，但我更傾向兩個團體的利益交集這種說法。如今經過多年耕耘，萬事達卡已經從一間發行塑膠信用卡的公司，轉變成為大型企業，事業橫跨兩百多個城市、一百五十多種幣值，在全世界的金融市場服務超過二十三億客戶，每分鐘交易筆次高達七萬多筆。他們的系統相當數位化，而且規畫將手機媒介當作交易的入口。為了因應這樣的變化，我們受到委託，希望在沒有任何預設立場下，重新設計萬事達卡的商標。

當開始發想設計時，我們很快地發現一項事實：就算沒有任何的品牌名稱，還是有超過4/5的消費者能夠透過紅、黃圓形商標，辨識出萬事達卡。這個驚人的辨識度實在太過珍貴，若加以拋棄就太浪費了！因此我們的結論也就無可避免了：萬事達卡在經過數十年的持續投資後，已將這兩個原色和世界上最基本的幾何圖形變成他們的重要資產；所以我們的設計任務不在於變動這個商標，而是如何簡化它。我們建立出一套設計系統，更審慎地處理色彩和圖形，包括字體、圖示和排版。現在它的商標獨立出現在消費者眼前——絕對的簡潔和有力——突顯萬事達卡在全球的影響力。

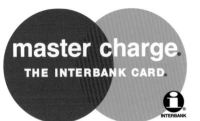

左圖
這是萬事達卡在1968年和1996年的商標。隨著越來越多元的商業挑戰,企業在修改商標時也增加複雜的元素,例如條紋、色彩和陰影。

上圖
在發想新的商標時,我們將紅色、黃色交疊的地方修改成較亮的橘色。期間主導的設計師哈米許‧史密斯嘗試數百種顏色的搭配,最後達到最佳的視覺效果。

右上、右中、右下圖
簡潔的新商標被設計成適合在各種版面出現,大至戶外看板,小至手機螢幕。

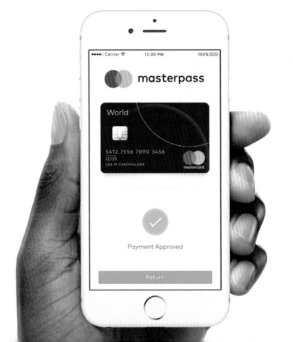

左圖
我的夥伴盧克‧海曼和設計師安德莉亞‧特拉布柯（Andrea Trabucco）共同領導萬事達卡的品牌識別的全球推行，我們公布線上的品牌使用指南，以確保全球的代理商能夠維持一致的品牌識別。

上圖
我們受到藝術家索爾‧勒維特（Sol LeWitt）的創作啟發，利用商標的幾何圖形建立一套規則，使它可以被彈性且廣泛地運用在不同的版面；選用漢內斯‧馮‧德倫（Hannes von Döhren）和克里斯托夫‧科伯林（Christoph Koeberlin）設計的FF Mark字體，也能加強品牌圓的概念。

下一跨頁
就算在複雜的視覺環境中，萬事達卡的簡潔商標還是能被一眼辨識出來。

mit
media
lab

E14-464

tangible
media

viral
spaces

macro
connections

如何一次設計兩打商標

麻省理工媒體實驗室
MIT Media Lab

左頁
麻省理工媒體實驗室
的商標融合靈活、不
過時的精神,由我
們和麻省理工學院的
團隊共同設計,成員
包含尼古拉斯·尼
葛洛龐帝(Nicho-
las Negroponte)
、奈瑞·奧克斯曼
(Neri Oxman)和
艾倫·霍夫曼(Ellen
Hoffman)。

上圖
設計師穆里爾·庫珀
是麻省理工學院視覺
語言工作坊的領導
人,當時她對媒體實
驗室的商標不甚滿
意。她在1962年為
麻省理工學院出版社
所設計的商標極具當
代性,後來也成為
我們設計時的參考
範本。

數位科技已經永遠改變我們的溝通方式,同時也改變我們如何決定一個好的商標。接下來就是數位媒體的興起——過去的測驗是問你會不會使用傳真,現在則是問你會不會繪製動畫。新科技無疑創造了更動態、更複雜的可能性,而且已成為當代的特色。

自從1985年以來,麻省理工媒體實驗室的研究小組,一直全球數位創新的中心。實驗室的第一代商標由賈桂琳·凱西(Jacqueline Casey)設計,是一個可延展的彩色條紋,靈感來自於藝術家肯尼思·諾蘭(Kenneth Noland)為初代建築所製作的裝飾。這個商標被使用了24年,在實驗室創立的第25週年,設計師理查·德(Richard The)設計出新的商標,可以運用演算系統排列出超過四萬種炫目的組合。以上兩種都是動態十足的識別設計,足以產生無限的變化。但是與此同時,麻省理工學院出版社也出現強大的設計,是由傳奇設計師穆里爾·庫珀(Muriel Cooper)製作的經典商標——極簡的七條黑色直線,從1962年發表以後從未更改過。此時,麻省理工媒體實驗室尋求我們的協助,希望將兩個靈活、經典的設計結合成一個新的商標。

我不斷思索這個問題。我嘗試創作一些充滿動態感和非傳統的商標設計,但是卻對它們的影響力感到懷疑——儘管它們看起來有許多變化,但盡是一些混亂又無意義的改變。相較之下,庫珀和他的夥伴所設計的商標,就展現出美國企業黃金時期的那種自信與明朗。

經歷多次失敗,我們的解方才逐漸浮現。我們用7×7的方塊繪出一個簡單的ML花押字,正巧可以成為媒體實驗室的商標;而利用這個概念,我們也用方塊編排出實驗室底下23個研究小組的名稱縮寫,使它們共享一組視覺語言。最後,這些商標變成一個大家族,不僅可整合又具變通性,顯示出多元豐富的團隊讓媒體實驗室更加強壯!

右圖
我們為麻省理工媒體實驗室設計的商標，是將簡易的ML花押字填入7×7的方塊中。

右頁
媒體實驗室的符號沒有改變，只有調整文字與符號的相對關係。

下一跨頁
同樣的7×7方塊也被運用在其他研究小組的商標設計，從「情感運算」（Affective Computing）到「病毒行銷」（Viral Communications），每一個團隊都擷取他們的首字母編排成獨一無二的商標。

第二張跨頁
所有的商標都使用同樣的幾何規則，讓它們看起來就像同一個家族，表現出齊心協力、眾志成城的感覺。

mit media lab

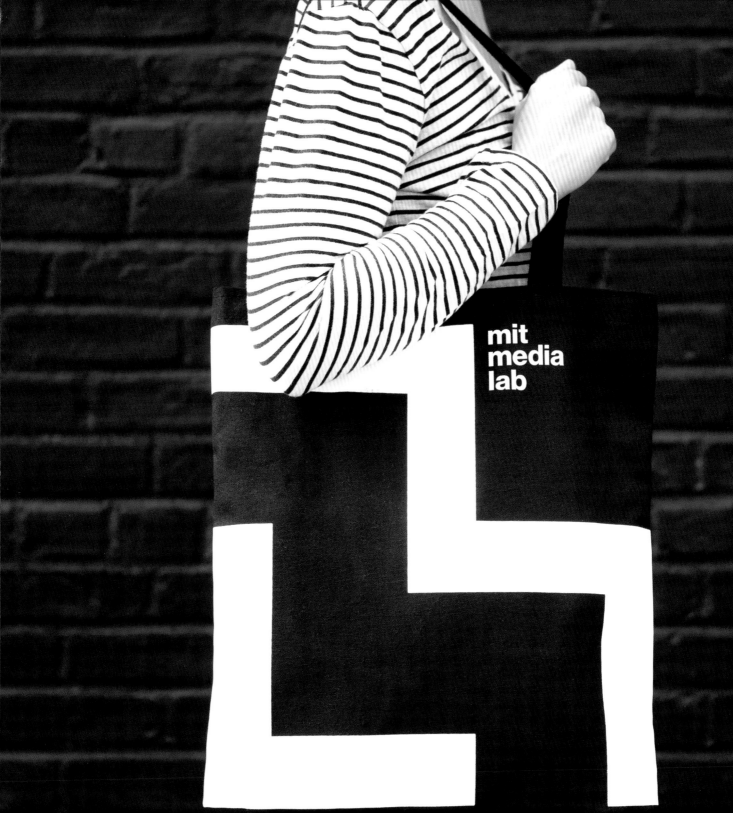

 mit
media
lab

 affective
computing

 biomechatronics

 design
fiction

 fluid
interfaces

 human
dynamics

molecular
machines

 object-based
media

 opera of
the future

 social
computing

 social
machines

 speech +
mobility

camera culture

changing places

civic media

lifelong kindergarten

macro connections

mediated matter

personal robots

playful systems

responsive environments

synthetic neurobiology

tangible media

viral communications

右上圖
1960年代起，麻
省理工媒體實驗室
的平面設計就經常
使用Helvetica字
體，因為這個時期
國際主義設計風格
的簡約風潮剛從瑞
士吹入美國，設計
師如賈桂琳‧凱西
（Jacqueline Ca-
sey）、穆里爾‧庫
珀、拉爾夫‧柯本
（Ralph Coburn）
和迪特馬爾‧溫克
勒（Dietmar Win-
kler）都受其影響。
我們將它應用在辨
識系統中，並延伸
設計出實驗室的各
種指標。

右下圖
麻省理工媒體實驗
室的商標重新編排
後，前往高樓層的
引導指示變成趣味
十足的箭頭。

右上及右下圖
互動式的觸控螢幕，除了能引導訪客在複雜的實驗室中找到正確的路，也能公告當期的專案和未來的活動。

下一跨頁
媒體實驗室新的品牌識別將在2014年的秋季會員活動盛大公開，當時定了相當符合的主題：「布署」（Deploy）。

第二張跨頁
由設計師艾倫·菲主導這個複雜的專案，包括符合新的識別系統的活動海報設計。

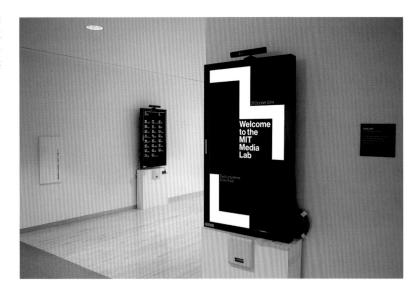

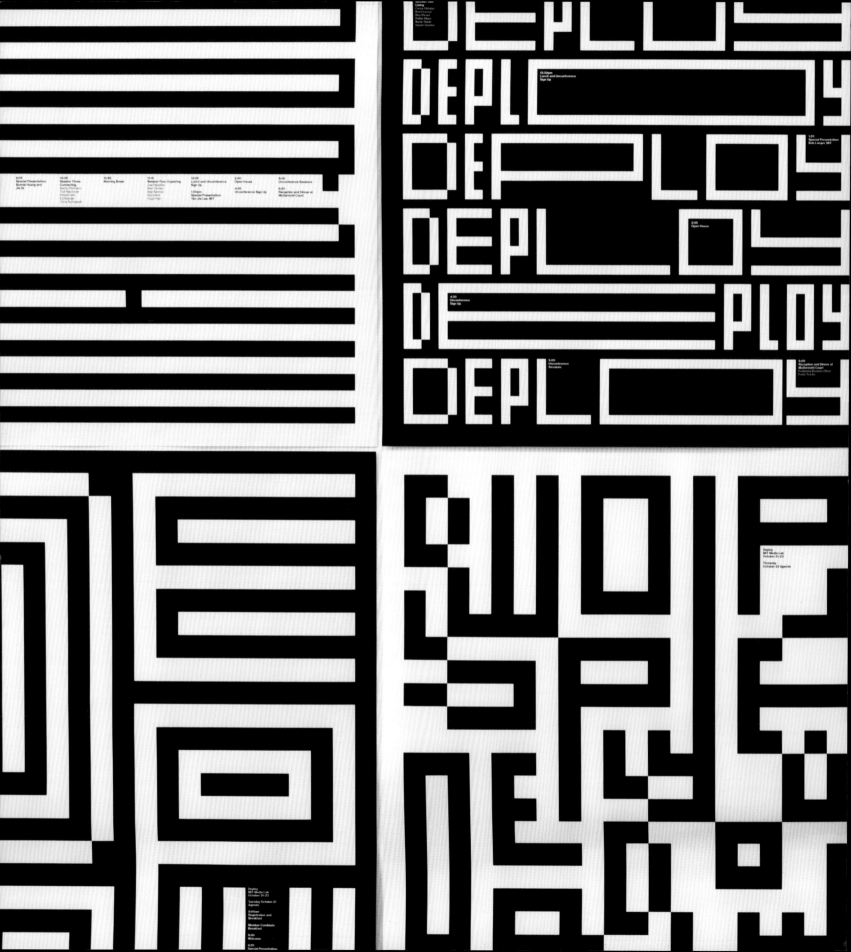

Listing
Cesar Hidalgo
Bert Larson
Roy Picard
Pattie Maes
Ramir Sbah
Goren Gordon

12:30pm
Lunch and Unconference
Sign Up

1:20
Special Presentation
Bob Langer, MIT

2:05
Open House

4:30
Unconference
Sign Up

5:00
Unconference
Sessions

8:00
Reception and Dinner at
McDermott Court
Featuring Boston's Best
Food Trucks

9:05
Special Presentation
Bunnie Huang and
Jie Qi

10:05
Session Three:
Connecting
Sandy Pentland
Ted MacInnes
Hiroshi Ishii
Ed Boyden
Chris Schmandt

10:55
Morning Break

11:15
Session Four: Exploring
Joel Paradiso
Neil Gershan
Seiji Kaminer
Sputniko!
Hugh Herr

12:05
Lunch and Unconference
Sign Up

1:00pm
Special Presentation
Yan-Jie Lee, MIT

2:00
Open House

4:30
Unconference Sign Up

5:00
Unconference Sessions

Deploy
MIT Media Lab
October 21–23

Tuesday October 21
Agenda

8:00am
Registration and
Breakfast

Member Candidate
Breakfast

9:00
Welcome

9:20
Special Presentation

Deploy
MIT Media Lab
October 21–23

Thursday
October 23 Agenda

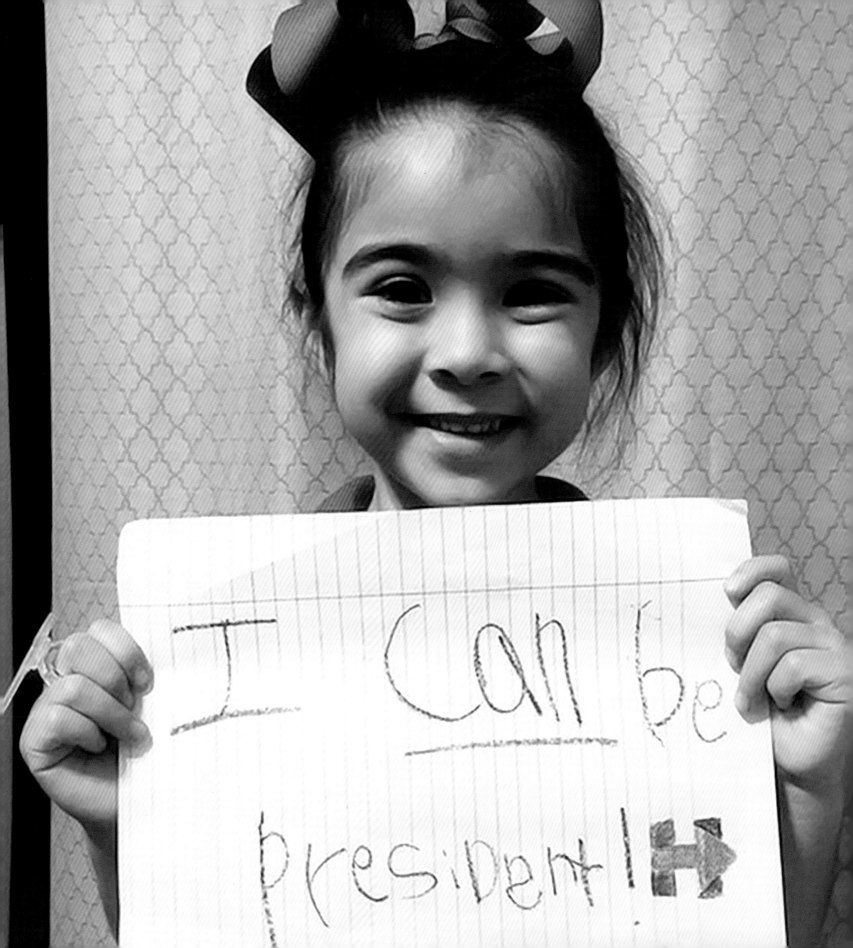

如何玩轉政治

希拉蕊，為美國而生
Hillary for America

左頁
我們的目標是創造一個簡單的標誌，簡單到可以用圖畫紙畫出來，或是用兒童剪刀剪出來。看到它被這麼多人用雙手製作出來真是令人興奮！

上圖
這是我的第一版草稿，將希拉蕊的首字母H與箭頭符號結合在一起。

「我們的競選人擁有百分之百的知名度！」這就是事情的開端。2015年1月，我被私下邀請聽取一份簡報，那就是為美國前國務卿及前參議員希拉蕊・柯林頓（Hillary Clinton）設計總統競選標誌。

一項研究顯示，人類有兩種相反的欲望：一種是對熟悉安定的追求，另一種是對新鮮刺激的渴望。設計正好可以調和它們，創造出一種新的事物，使人感到既熟悉又能從中發現驚喜。前國務卿希拉蕊女士已在公眾領域服務三十多年，此時的她正在尋求一個有力的競選標誌，向美國的公民重新介紹自己。

希拉蕊的首字母「H」可以被畫成一個完美的方形，這與前總統歐巴馬（Barack Obama）的O形標誌完全不同。然而我們並沒有打安全牌直接使用H的造型，為了加強它的動態感，我們用箭頭取代H中間的橫槓。我們希望設計出一個大家都能輕鬆畫出或是自己改造的圖像，就像是笑臉符號或是和平符號那樣；雖然歐巴馬的標誌也很美，但就顯得複雜許多。希拉蕊絕對是我遇過最好的聆聽者。過程中她詢問一些重要的問題，提供我們務實的建議，並且迅速同意作業的進行；沒隔幾個禮拜，她的標誌設計就在競選活動中閃亮登場。

起初我們收到很多的批評，說標誌不夠簡單，反而有點粗糙。有人還說：「我3歲就可以畫出這種東西了！」但那正是關鍵之處，因為接下來的18個月，這個標誌就被人們改造成數以千計的模樣。看見自己的手繪圖案出現在總統候選人提名大會，再被各大電視台轉播到全美國，我感到既緊張又興奮；更棒的是後來我的朋友傳來一些照片，希拉蕊的競選標誌還被人們裝飾在沙雕、蘋果派上！沒錯，這正是我們原先的期望：一個既令人感到熟悉，又能創造驚喜的設計。只不過始料未及的是，我們即將面臨一個更強大的對手──希拉蕊的團隊花了一年半的時間設計新的競選標誌，她的對手川普（Donald Trump）卻用一輩子建立個人的品牌。我並不期望一個平面設計可以創造勝利，但我不確定是否因它導致失敗。無論如何，最終的敗選都是使人灰心喪志的。

我和設計師傑西·里德、專案經理茱莉亞·萊姆麗（Julia Lemle）一同為「希拉蕊，為美國而生」祕密設計競選標誌，我們都是無償為競選活動擔任志工。指引我們的是機智的專案顧問泰迪·高福（Teddy Goff），以及出色的廣告從業人員溫蒂·克拉克（Wendy Clark）。我與希拉蕊有過三次的會面，對於她驚人的專注力留下深刻印象，尤其是當其他人因為行銷細節開始分神時。她敏銳、溫暖、幽默又極富個人魅力，無疑是最理想的客戶。我相信她一定會是位優秀的總統。

當專案起跑後，我建議他們雇用我的前同事珍妮佛·基農擔任設計總監。珍妮佛和她的團隊持續透過設計與大眾溝通，一直奮戰到選舉日當天，無疑是我看過最棒的設計之一。選舉結束以後，他們的戰鬥並未落幕，她在2016年所招募的團隊至今仍在為組織服務與發聲，充分展現一位設計師如何透過自身專業參與公共事務。

右圖
希拉蕊的競選標誌刻意避免像企業商標那樣太過複雜，而是簡潔的幾何標誌。它的造型甚至能在電話中用一分鐘描述出來。這個專案由設計師盧卡斯·夏普（Lucas Sharp）設計客製化的字體「Unity」，詳盡的準則都被收錄在設計指南當中。

右頁
一如所有近代的商標，希拉蕊的競選標誌被設計成能夠適應各種尺寸，小至手機的社群軟體呈現，大到足以製作成舞台。這張照片是紐約羅斯福島上的競選起跑活動。

下一跨頁
雖然官方的標誌使用的顏色是紅色與藍色，但是它能夠被改成任何色彩。這張照片是希拉蕊在費城獲得總統候選人提名的夜晚，現場群眾舉起繽紛的旗幟，展現出十足的活力！

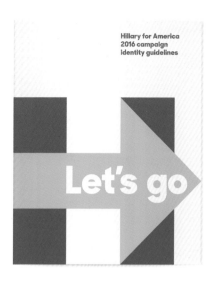

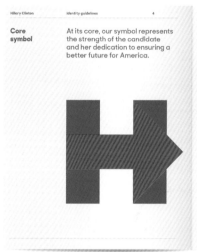

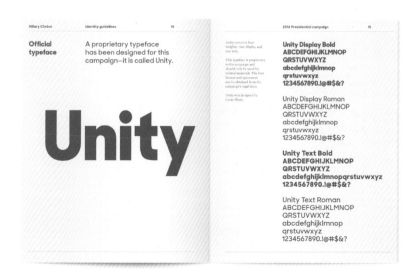

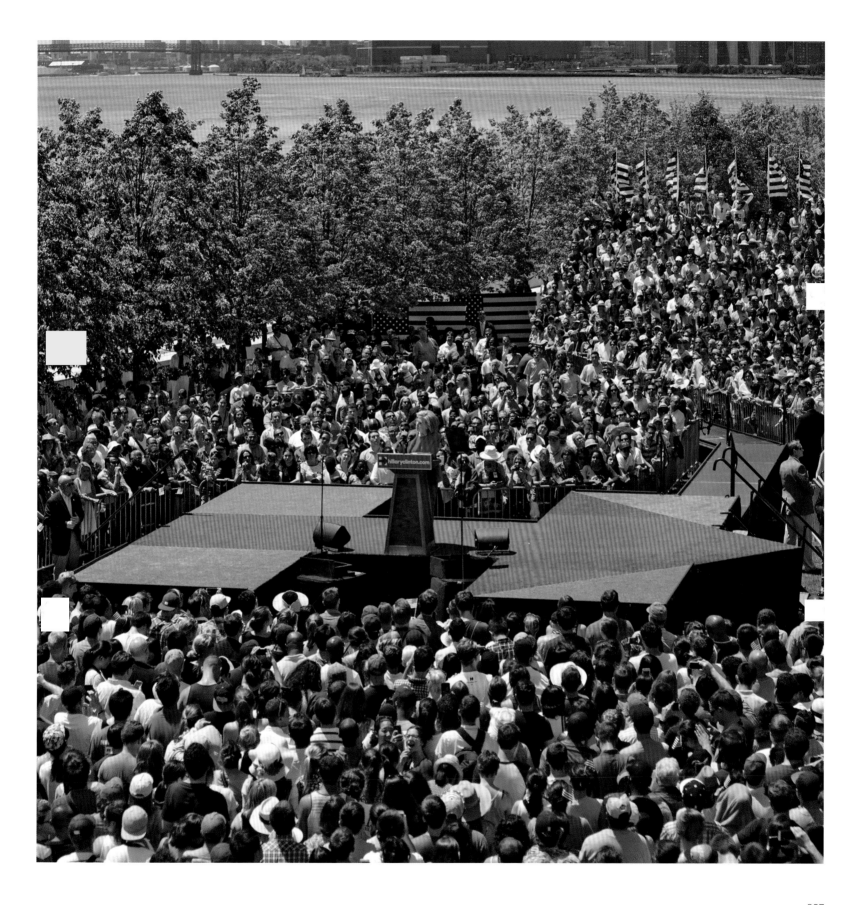

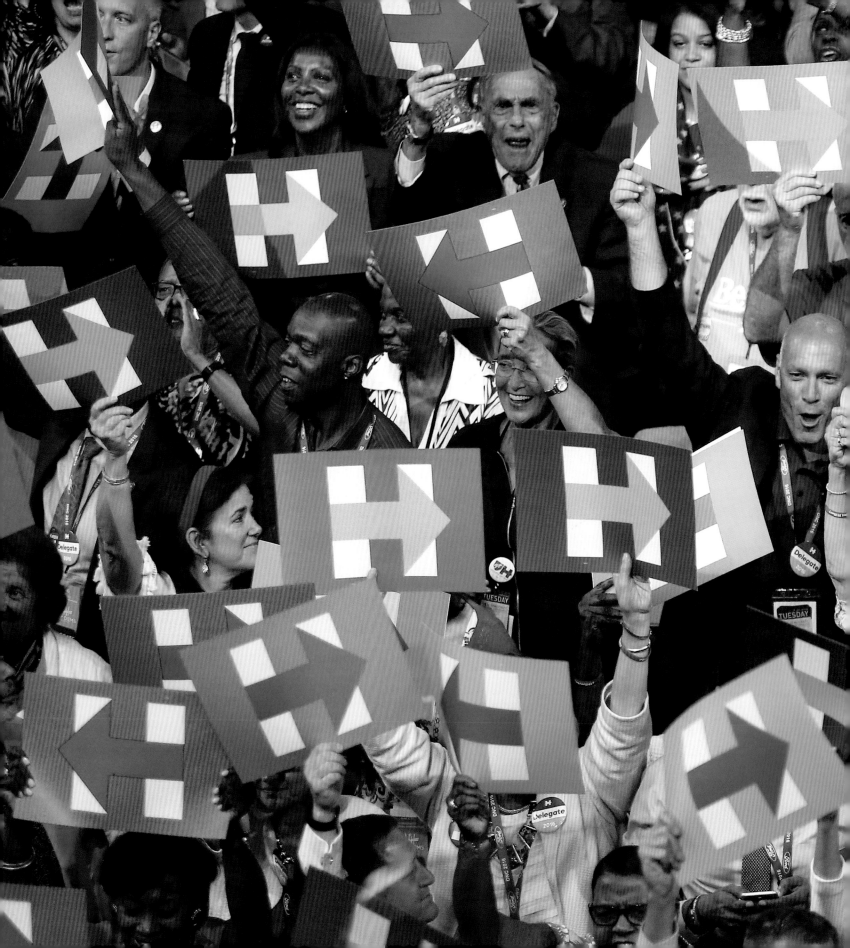

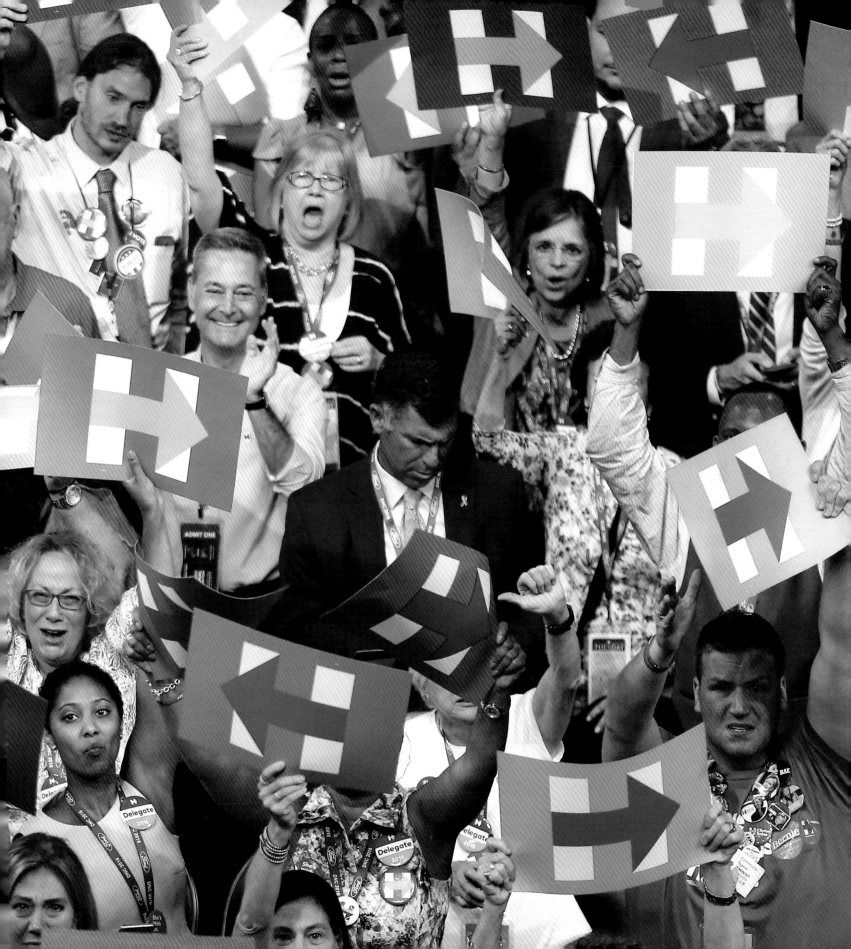

左圖
「H是因為希拉蕊的姓名以H開頭，箭頭是因為她期盼國家能夠持續前進，而紅色、白色和藍色的組合，則是來自我們的國家——美國。」每當有人邀請我解說這個全國性標誌的設計時，我總會憶起當初的情境。

希拉蕊，為美國而生

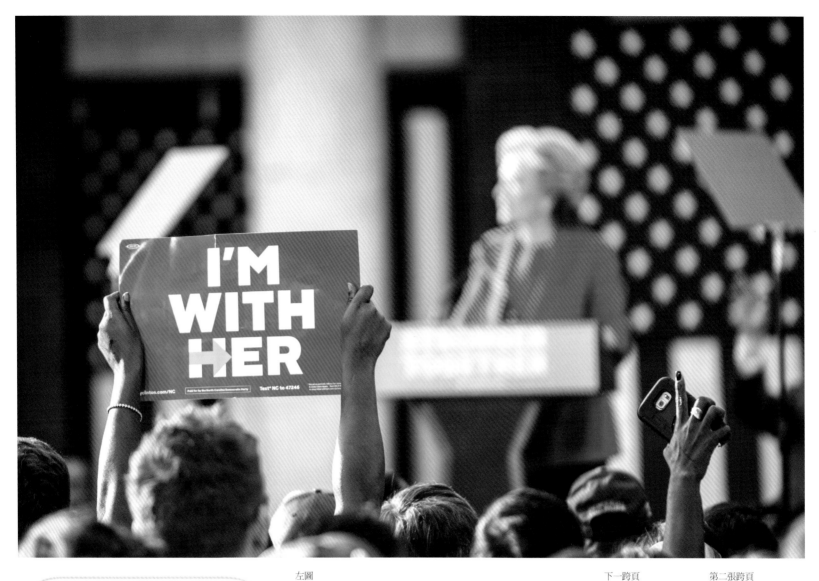

12:09 PM

"Let's do that again"
With her— September 8, 2016

左圖
當團隊的Podcast節目開張時，幾乎不需要任何的解說文字，大家都能馬上領會這個節目標誌。

上圖
某一天，「希拉蕊，為美國而生」的設計師伊達·沃爾德邁克（Ida Woldem-ichael）在繪畫箭頭符號時靈光一閃，想出「HER」這個從H開頭的單字。自此以後，這個單字幾乎變成競選團隊的主要標語。

下一跨頁
競選活動後期，客戶告訴我們有一位凱倫·陶德，她不僅是希拉蕊的擁護者，也是這個競選標誌的支持者！凱倫每天發揮創意將競選標誌做出各種變化，並且將它們分享到臉書，連續好幾個月。她的天才之作不僅趣味十足，也能啟發人們的創意！

第二張跨頁
雖然總票數超越對手將近三百萬張，但因為選舉人團制度，希拉蕊最終仍因輸掉中西部的三個州而敗選。這個結果實然令人心碎，但是我對於經歷過的一切仍感到驕傲。一如既往，我無愧於自己的本心。

希拉蕊，為美國而生

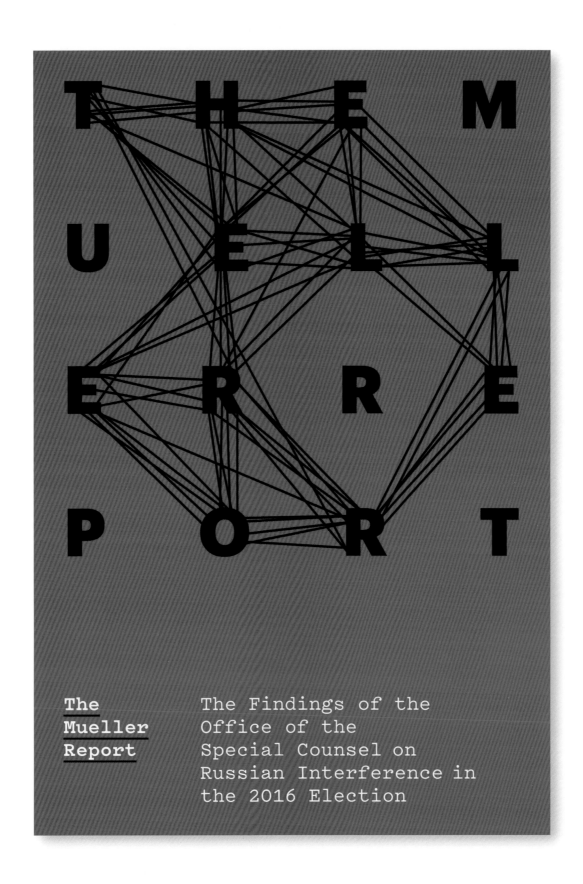

THE MUELLER REPORT

The
Mueller
Report

The Findings of the
Office of the
Special Counsel on
Russian Interference in
the 2016 Election

如何隱藏真相

穆勒報告
The Mueller Report

左頁
紐約客雜誌的尼可拉斯‧布萊克曼（Nicholas Blech-man）邀請我、珍妮特‧漢森（Janet Hansen）、金娜（Na Kim）、艾力克斯‧默托（Alex Merto）和保羅‧薩爾（Paul Sahre）設計「穆勒報告」的專題封面。你能從我們的提案中找到隱藏的文字嗎？

自從2016年總統大選過後，這幾年的生活總有些令人失望的事情，卻也有值得期盼的地方——各種社會行動結合人們的創意在各地迸發，包括氣候變遷、槍枝暴力、種族平權等議題。每一天公民都在製作標語、塗鴉、影音，或是一張教人如何編織粉紅帽子的傳單[註1]。這些令人難忘的影像不斷傳播擴散，最後觸及到數百人、數十萬人，甚至數百萬人！現在的社群媒體已非傳統的媒體守門人，反而成為推波助瀾的角色；儘管這樣的轉變讓許多的設計人感到緊張，但我卻認為它非常值得期待。

經歷前一次的選舉，我不太確定設計能在政治中發揮什麼樣的效果。從許多層面來說，至今我依舊不是相當肯定；但是我選擇相信透明公開比打模糊仗來得好，保持智慧開明比蒙昧愚痴好。如果一件事情是有價值的，那麼它就值得被好好地對待。我仍在思考（至少在政治領域），專業能夠取代激情嗎？再細緻的謊言是否都不能取代真相呢？有時最好的對應，就是盡其所能將真誠與熱情放大。最終，當時的我拒絕了許多邀約，選擇讓其他人去表達。

這段期間，我曾接下一項與政治相關的工作，一方面是出於理性的判斷，一方面是宣洩累積的不愉快。那是在美國特別檢察官勞勃‧穆勒（Robert Mueller）公布2016年「通俄門」（Russia Gate）[註2]醜聞調查之前，紐約客雜誌（New Yorker）希望能找幾位設計師來試著設計《穆勒報告》的封面。事實證明，陰謀總是由精細的計算與奇怪的巧合所組成。我挑選十六個英文字母，用最簡樸的方式排版，並畫上絲線將它們串聯成網絡，使那些心術不正的傢伙激起不祥的感受。我又想到有些字母如果被排除在網絡外，也許看起來會更有效果；因此最後有五個字母被獨立出來，就像是人們在一張通靈板[註3]上做占卜，卻觸碰不到那些最重要的字眼。這絕對是一場令人沮喪的占卜，但也再一次提醒我們，我們的選票就是我們能夠做出的最重要的選擇。

註1：「貓帽計畫」（PussyHat Project）是由兩位加州的女士發起，邀請大家戴上粉紅色的手工毛帽上街，預計在川普就職後隔日舉行反川普的「華府女人大遊行」，呼籲川普政府正視女性的權益。最後這個活動透過社群媒體迅速傳播並產生重大的影響。
註2：俄羅斯干預2016年美國總統選舉（俗稱通俄門）是指美國情報體系指控俄羅斯對2016年美國總統選舉所作出的一系列操作干預。
註3：通靈板（Ouija board）是在歐美流行的一種占卜方式，起源於古代巫術，外型為一種平面木板，上面標有各類字母（或文字）、數字及其他一些符號，目的在於讓使用者與鬼魂對話，與碟仙性質類似。

如何用平面設計拯救世界

羅賓漢基金會的圖書館倡議
The Robin Hood Foundation's Library Initiative

左頁
我最喜歡的專案從一項技術性的挑戰開始。為了協助紐約市各所學校的圖書館進行平面設計，我們發現這些建築都非常古老，而且天花板的高度非常高；相對之下，孩子的身高就顯得嬌小，頂多能搆著牆壁的一半，因此圖書館的書櫃就只能設計到這個高度。那麼，剩餘的牆面該如何運用呢？我們在布魯克林區的P.S. 184小學做了嘗試，由我的妻子桃樂西親自拍攝孩子們的身影，大型輸出在牆面上。

羅賓漢基金會承攬一項重大的挑戰，要在紐約一些較困苦的社區翻轉教育的不平等，希望透過學校圖書館的興建，幫助孩子提升學習的專注力。一群建築師收到空間設計的委託，而我們則志願協助平面設計的部分。

我們的任務非常明確，需要幫整體專案設計一個商標，並且為每間參與的學校設計他們的指標。就在我們近乎完成設計任務時，其中一位圖書館的建築師想請我們協助填滿兒童書櫃到天花板中間的空間。我心中浮現出的景象是一幅現代版的高壁畫，以歡愉的孩子取代古代的眾神像，由我的妻子桃樂西親自掌鏡。出乎意料地，這個創意竟然變成廣受喜愛的設計，幾乎每一間合作的學校都希望有一幅自己的壁畫。

新規畫的圖書館遍及紐約市的哈姆林、東布魯克林、南布朗克斯等區域，服務上百位學童和當地的社區居民。我們決定讓每一幅壁畫都長得不一樣。我們邀請插畫家琳恩·保利（Lynn Pauley）和彼得·阿克爾（Peter Arkle）一同繪製，設計師克里斯多夫·尼曼（Christoph Niemann）、查爾斯·威爾金（Charles Wilkin）、拉斐爾·埃斯克（Rafael Esquer）、施德明（Stefan Sagmeister）和梅拉·卡爾曼（Maira Kalman）也都同意參與這項任務。

有一天，我們參加已完工的圖書館的實體導覽，現場看到這麼多的孩子使用圖書館真是令人驚喜！我想，他們可能在此發現自己的未來，就像多年前我在自己學校的圖書館受到啟發一樣。我們抵達最後一站時，已經是學校的放學時間，正在閉館的圖書館員突然問我們：「你們會想看我們如何熄燈嗎？」我遲疑了一下，回答當然想。她接著說：「我總是最後關上這盞燈，因為它總是提醒我為何堅持做這件事情。」我看見那是一盞明燈，照亮著高壁畫上的孩子們的臉龐。

此刻我終於明白這個專案的目標，就是協助像她這樣盡責的館員能更好地完成他們的工作。某方面來說，這也是我的作品唯一能做到的部分。是的，設計並無法拯救世界，只有活著的人們可以；但是設計能夠給帶給我們靈感、工具和意義，而使人們擁有不怕嘗試的決心。

羅賓漢基金會是紐約市最具知名度的公益組織。一如其名，他們向城市中最有錢的公民募捐，用來幫助最貧窮的人們。他們善於將募款的效益最大化，比如透過設計發揮巨大的影響力。圖書館倡議就是一個很好的例子，它聚集了出版、營造、建築等各界人才，一起組成聯盟完成任務。身為此案的設計總監，我們邀請了紐約最出色的插畫家與設計師，一同改造圖書館這個學生聚會與學習的公共空間。

下圖
由於新的創意需要一個新的名稱，我曾經浪費時間取一些花俏的名字，例如雙關語「紅色禁區」（The Red Zone），或是縮寫字「OWL」（這個縮寫來自Our World Library或其他東西）。指導專案的朗尼・透納（Lonni Tanner）非常討厭這些名字。我辯稱孩子們覺得圖書館很無聊，應該要為他們取些好玩的名字才好！但是朗尼卻提醒我：「麥可，其實大多數的孩子都還沒有見過真正的圖書館。」於是我們決定直球面對，設計一個直率的圖書館商標，只在裡頭藏了一個小小巧思提示孩子們：其實圖書館是很有趣的！

右頁
由於我們的空間設計不是連鎖複製，我們決定為每間圖書館規畫專屬的平面設計。這個艱困的目標在執行期間一直挑戰著我們！但是結果證明，客製化的空間設計更能讓人印象深刻，就像這一間由建築師亨利・邁爾柏格（Henry Myerberg）所設計的布朗克斯區P.S. 50小學的圖書館正門。

下一跨頁
我們邀請紐約最棒的藝術家一起加入圖書館的專案。插畫家彼得・阿克爾採訪了學生，並將這些對話加入他的黑白插畫中。這間圖書館位於布魯克林區的P.S. 287小學，由建築師理查・路易斯（Richard Lewis）所設計。

L!BRARY

• Sliding into my brain which gobbles them.

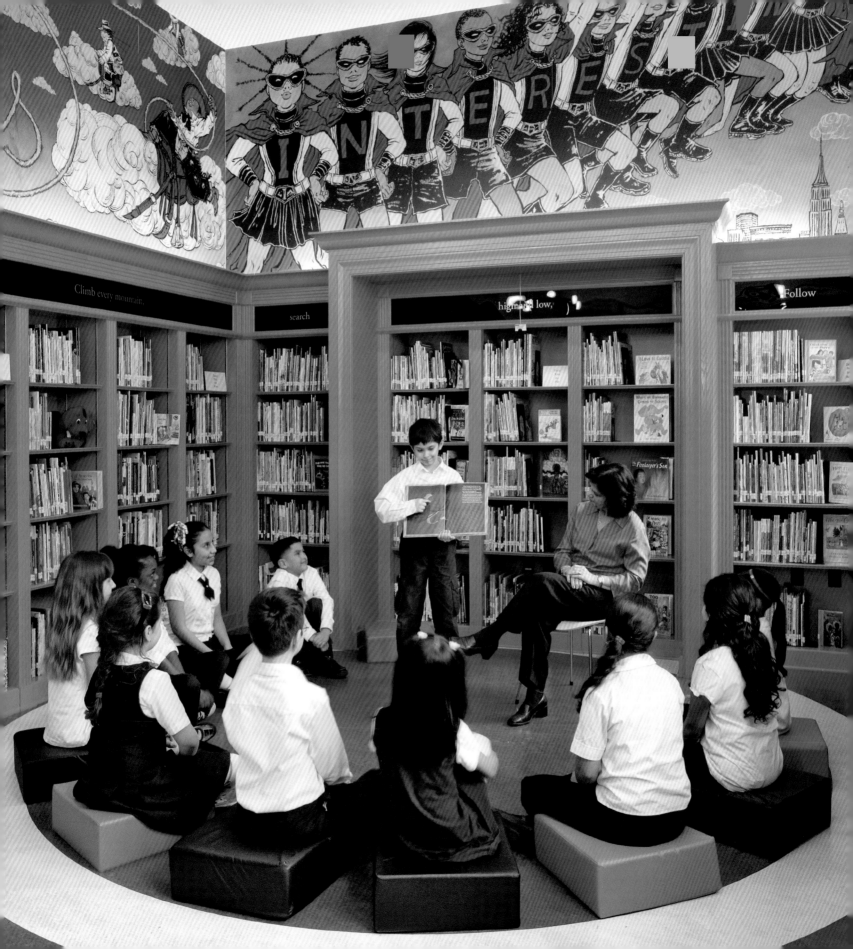

左圖
由設計師施德明和插畫家清水裕子（Yuko Shimizu）合作，將「真誠的人必風趣」（Everybody who is honest is interesting.）這句話展現在布朗克斯區P.S. 96小學的圖書館牆上。

右上圖
插畫家琳恩‧保利服務許多學校，將孩子們的臉孔用不同風格的手法繪畫下來，其中包含這間位於布朗克斯區P.S. 36小學的圖書館。

右下圖
位於布魯克林區P.S. 196小學的圖書館，由設計師拉斐爾‧埃斯克繪出千百種小小人物的剪影，向孩子訴說他們的故事。

下一跨頁
設計師克里斯多夫‧尼曼在布朗克斯區P.S. 69小學的圖書館，將書本巧妙地結合《白鯨記》的鯨魚、老鷹的翅膀、美國國旗等各種圖像。

第二張跨頁
作家兼插畫家梅拉‧卡爾曼在這間圖書館使用立體裝置手法，包含圖像、物件，以及她特殊的手寫字。

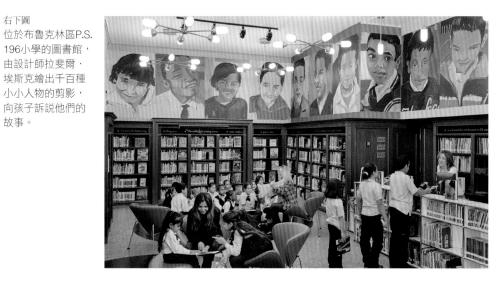

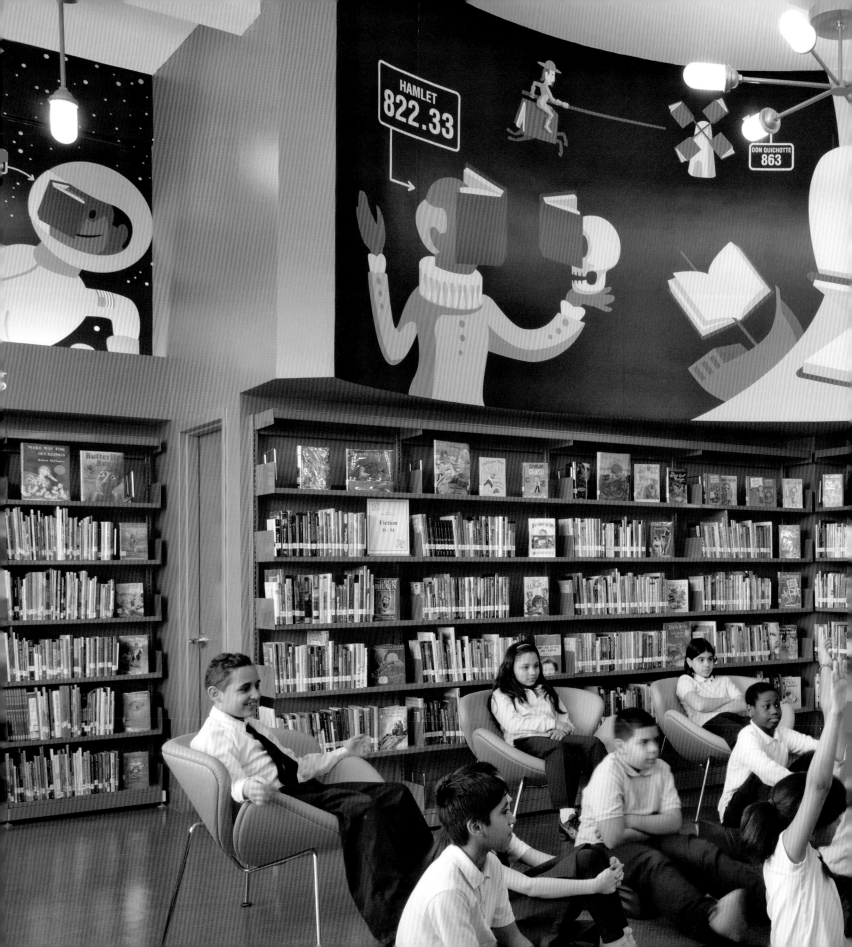

致謝詞

本書要獻給兩位值得尊敬的男人：馬西莫‧維涅里和威廉‧德倫特爾（William Drenttel）。從馬西莫身上，我學會如何當一名設計師；而從威廉身上，我學到一位設計師如何無私地奉獻給世界。我不斷地努力，希望能夠達到他們所設立的標竿。

早在我踏入平面設計的圈子，我的父親李奧納德和母親安‧瑪麗‧貝汝就鼓勵我成為一名藝術家。我的父母與我敬愛的兄弟羅納、唐納，他們必定發現過我的疑惑與掙扎，但卻總是選擇安靜地陪伴。我在克里夫蘭成長的過程，他們無疑是我最棒的禮物。

從國中、高中到大學，我遇見許多盡責奉獻的師長，例如蘇‧安羅尼（Sue Ann Neroni）、約翰‧柯西斯（John Kocsis）、戈登‧薩爾喬（Gordon Salchow）、喬‧伯托尼（Joe Bottoni）、安‧谷里—古德瑪（Anne Ghory-Goodman）、斯坦‧布羅德（Stan Brod）、海因茨‧申克（Heinz Schenker）和羅伯‧普羅斯特（Robert Probst）。當我初入職場還是一位實習生的時候，克里斯‧普爾曼（Chris Pullman）和丹‧比特曼（Dan Bittman）是我的第一位主管和導師。

感謝我的妻子，在我成為五角星設計公司的合夥人時，以設計師的身分與我共同奮鬥超過三十年。我也感謝柯林‧富比士（Colin Forbes）、伍迪‧皮特爾和彼得‧哈里森（Peter Harrison），他們在我事業起步時給了我信念。我很榮幸成為團隊的一份子，包括優秀的設計師羅倫佐‧亞皮瑟拉（Lorenzo Apicella）、喬迪‧哈德森—鮑威爾（Jody Hudson-Powell）、安格斯‧西蘭（Angus Hyland）、多明尼克‧里帕（Domenic Lippa）、薩沙‧勒伯（Sascha Lobe）、喬恩‧馬歇爾（Jon Marshall）、賈斯圖‧奧勒（Justus Oehler）、哈利‧皮爾斯（Harry Pearce）、盧克‧鮑威爾（Luke Powell）、納雷許‧拉姆查達尼（Naresh Ramchandani）、約翰‧拉斯沃思（John Rushworth）、威廉‧羅素（William Russell）、DJ‧史托特（DJ Stout）、亞斯垂‧斯塔夫羅（Astrid Stavro）、鈴木由里（Yuri Suzuki）、瑪麗娜‧韋勒（Marina Willer），以及最後是我的最佳旅行良伴丹尼爾‧威爾。

最重要的是從過往到現在，每一天都在啟發我們的紐約夥伴：詹姆斯・比伯、麥可・格里克（Michael Gericke）、盧克・海曼（Luke Hayman）、任黛珊（Natasha Jen）、喬治亞・盧琵（Giorgia Lupi）、亞培・米勒（Abbott Miller）、艾蜜莉・歐柏爾曼（Emily Oberman）、艾迪・歐普拉（Eddie Opara）、麗莎・斯特勞斯福德（Lisa Strausfeld）和麥特・威利（Matt Willey）。寶拉・謝爾與我同期進入公司，至今我仍致力做出能夠受到她肯定的作品。

那些以我為名受到讚賞的設計，其實背後都有許多重要的推手。我們的團隊曾有無數優秀的設計師加入，於此奉獻他們的創意，其中包含娜歐蜜・亞伯（Naomi Abel）、桑索斯・阿爾瓦雷茲（Sonsoles Alvarez）、凱蒂・巴瑟隆納（Katie Barcelona）、喬許・伯塔（Josh Berta）、里昂・伯德（Rion Byrd）、翠西・卡麥隆（Tracey Cameron）、塔利亞・柯頓（Talia Cotton）、艾蜜莉・海斯・坎貝爾（Emily Hayes Campbell）、麗莎・塞維尼（Lisa Cerveny）、薩奇・錢德勒馬尼（Sachi Chandiramani）、布里特・柯布（Britt Cobb）、卡拉・科（Karla Coe）、伊麗莎白・艾利思（Elizabeth Ellis）、艾倫・菲（Aron Fay）、安吉・福斯特（Angie Foster）、莎拉・福里斯克（Sara Frisk）、艾格尼絲・格拉特維德（Agnethe Glatved）、克里斯・格雷羅（Chris Guerrero）、桑尼・古列爾默（Sunnie Guglielm）、麗莎・安德森・希爾（Lisa Anderson Hill）、李達海（Daisy Dal Hae Lee）、萊茨・侯（Laitsz Ho）、伊麗莎白・霍茲曼（Elizabeth Holzman）、梅麗莎・君（Melissa Jun）、瑟哈・基爾（Sera Kil）、珍妮佛・基農（Jennifer Kinon）、茱莉亞・萊姆麗（Julia Lemle）、蜜雪兒・梁（Michelle Leong）、喬恩・萊曼（Jon Leuhmann）、朵莉茨・列芙（Dorit Lev）、茱莉亞・琳恩潘娜（Julia Lindpaintner）、葉芙・路西維德（Yve Ludwig）、喬・馬里亞內（Joe Marianek）、艾比・瑪斯托克（Abby Matousek）、蘇珊・梅（Susan May）、泰絲・麥肯（Tess McCann）、凱蒂・米尼（Katie Meaney）、德爾達・莫菲（Delta Murphy）、艾莎・帕拉托娃（Asya Palatova）、凱倫・帕羅萊克（Karen Parolek）、卡蜜拉・佩雷斯（Camila Pérez）、凱麗・鮑威爾、傑西・里德（Jesse Reed）、妮可・李察森（Nicole Richardson）、凱蒂・羅明傑（Katie Rominger）、凱・薩爾梅拉（Kai Salmela）、珍娜・謝爾（Jena Sher）、強尼・斯科夫（Jonny Sikov）、尼可・斯科蒂斯（Niko Skourtis）、哈米許・史密斯（Hamish Smyth）、崔希・索爾薩（Trish Solsaa）、勞勃・史騰、潔西卡・史文森（Jessica Svendsen）、賈桂琳・索（Jacqueline Thaw）、布列特・泰勒（Brett Traylor）和艾明・維特（Armin Vit）。我想特別感謝塔瑪拉・麥肯納（Tamara McKenna），是她的功勞，讓這一切能夠順利地連結在一起。

謝謝每一位夥伴協助我成為更好的作者，特別是史蒂夫・海勒（Steve Heller）、契・皮爾曼、里克・波諾（Rick Poynor），及我的指路明燈潔西卡・赫爾芬德（Jessica Helfand）。

我知道這本書是泰晤士和哈德森出版社（Thames & Hudson）的盧卡斯・迪特里希（Lucas Dietrich）大力促成。謝謝你，盧卡斯。安德莉亞・蒙德里弗（Andrea Monfried）則鼓勵我答允這個計畫，並且在我最恐懼時給我全力的支持。也謝謝哈珀設計（Harper Design）的麗茲・沙利文（Liz Sullivan）與她的團隊。

克洛伊・謝夫（Chloe Scheffe）對於本書的前期設計有莫大的幫助，而桑索斯・阿爾瓦雷茲（Sonsoles Alvarez）則是偉大地將它完成。茱莉亞・琳恩潘娜（Julia Lindpaintner）、柯特・科普弗勒（Kurt Koepfle）和克萊兒・班克斯（Claire Banks）協助追蹤本書近百張的照片版權，蕾貝卡・麥克納馬拉（Rebecca McNamara）則是最優秀的文字編輯，約書亞・賽斯勒（Joshua Sessler）和茱蒂・雪爾（Judy Scheel）提供我們最專業的建議與指教。

最後，我要感謝這個世界上最美好的人，四十年來將她的愛無私地奉獻給我，並養育三個出色的孩子伊莉莎白、德魯和瑪莎。我的妻子桃樂西，謝謝妳一直陪伴在我的身邊。

麥可・貝汝

351

第二版增註

非常感謝泰晤士和哈德森出版社（Thames & Hudson）與哈珀設計（Harper Design）協助更新及擴編本書。五年過去，有許多的事物已經改變，修正的內容與新加入的作品都反映了這些變化，它們更如實呈現我對設計的想法與脈絡。

我要感謝布里特・柯布和勞倫・福克斯（Lauren Fox）將任務完成，以及負責資料研究的卡蜜拉・佩雷斯（Camila Pérez），還有負責專案管理的塔瑪拉・麥肯納（Tamara McKenna）。最後，我同樣要將最大的感謝致贈給我的設計師、客戶、朋友，以及合作夥伴們。他們永遠提醒著我，平面設計是一種社會行動，而團隊合作永遠是最美好的部分。

麥可・貝汝

圖片來源

Peter Aaron/OTTO: 54 – 59; Richard Bachmann: 68 (above); Bob Barrie and Scott D'Rozario/Fallon: 236 – 237; Benson Industries: 158; Jim Brown: 170 – 171; Courtesy of Bulletin of the Atomic Scientists: 107; Cornell Capa, [Robert F. Kennedy campaigning for the Senate, Elmira, New York], 1964. International Center of Photography, The Robert Capa and Cornell Capa Archive, Gift of Cornell and Edith Capa, 1994 (155.1994): 271; Robert Capa, [Death of a Loyalist Militiaman, near Espejo, Córdoba front, Spain], 1936. International Center of Photography, The Robert Capa and Cornell Capa Archive, Gift of Cornell and Edith Capa, 2010 (2010.86.629): 273 (top); Emilio Callavino: 214; Courtesy of the Cathedral of St. John the Divine: 131, 136; Kevin Chu and Jessica Paul: 344, 345 (bottom); Brad Cloepfil: 166 (left top); Commodore Construction Corp: 283; Fred R. Conrad/The New York Times/Redux: 155 (bottom); Whitney Cox: 49 (bottom), 50 – 51; Steve Freeman, Christopher Little, and Rita Nannini: 66 – 69 (Princeton University "With One Accord" photographs); Michael Gericke: 15 (bottom); Mitchell Gerskup: 52; Gori910/Shutterstock: 266 (top); Timothy Greenfield – Sanders: 44 (hand photograph); David Grimes: 46 – 47; Andrew Harrer/Bloomberg/Getty: 328-329; Peter Harrison: 15 (top); David Heald: 165 (above right); Hillary for America: 324, 330 (top right), 331 (bottom); Ronnie Kaufman/CORBIS: 235 (top left); Robert King/Getty: 36 (below); Barbara Kinney/Hillary for America: 331; Dorothy Kresz Bierut: 100; Richard Levine/Age Foto Stock: 295 (top right); Cocu Liu: 267; Courtesy of Mastercard: 305 – 309; Peter Mauss/Esto: 115 (top & bottom left), 116 – 117, 154, 159 – 163, 196, 198 (right), 282, 284 – 291, 338, 341 – 343, 345 (top), 346 – 349; OK McCausland: 272 (middle bottom); Doug Mills/The New York Times/Redux: 334 – 335; Daniel Mirer/CORBIS: 235 (bottom right); Courtesy of Mohawk: 257, 258 (top left), 260 (right); Courtesy of PentaCityGroup: 240, 244 (left top), 248 (above right); Pentagram: 16, 18 – 35, 38 – 39, 40, 41 (bottom), 42, 44, 48 – 49, 62 – 65, 68 (left), 69 (left), 70, 72 – 79, 86, 88 – 99, 106, 108 – 111, 118, 120, 122 – 124, 126 – 129, 132, 134 – 135, 137, 164, 168 – 169, 172 – 177, 200, 203 (bottom), 204 – 205, 208 – 209, 211 – 213, 219 – 220, 223, 224 (middle & bottom), 225 (middle left & top right), 226 – 227, 230 – 235, 246 – 247, 248 (top left & bottom left), 249 – 256, 259 (top right & top left), 261, 264, 266 (middle & bottom), 268 – 269, 272 (bottom left, middle, bottom right), 276 – 277, 292-297, 300, 302-303, 306-307, 310, 313, 316-323, 325; Jesse Reed: 330 (left); Antonov Roman/Shutterstock: 254 (bottom left); Courtesy of Saks Fifth Avenue: 112 – 113, 114 (right), 115 (right), 116 – 117, 119, 121; Nick Sansone: 272 (middle top); Adam Schultz/Hillary for America: 331 (top); Martin Seck: 245, 274, 278 – 281, James Shanks: 224 (top), 225 (top left, bottom left, middle right, bottom right); Boris Spremo/Getty: 53; Ezra Stoller/Esto, 165 (above left), 197 – 198; Takito/Shutterstock: 258 (top row, third from left); Sean Thorenson: 272 (top left); The New York Times: 156 – 157; Karen Todd: 332-333; Courtesy of United Airlines: 203 (above left & above right), 207 – 208, 228; Courtesy of Verizon: 298 – 299; Massimo Vignelli: 41 (top); Lannis Waters/The Palm Beach Post/ZUMAPRESS.com: 36 (above); Anna Watts: 272 (middle center); Stephen Welstead/LWA/CORBIS: 235 (top right); Don F. Wong: 101 – 105; Reven T. C. Wurman: 80 – 85. Special thanks to Claudia Mandlik for Pentagram project photography.